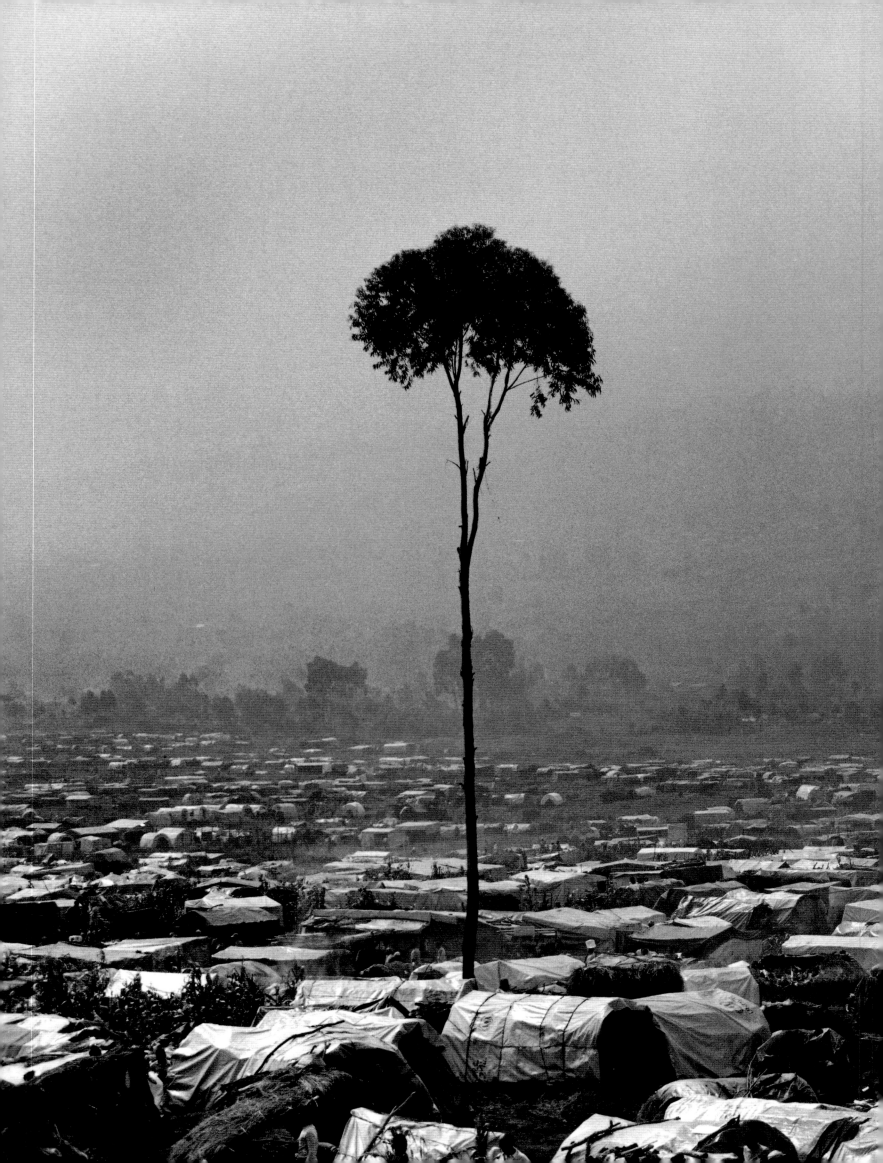

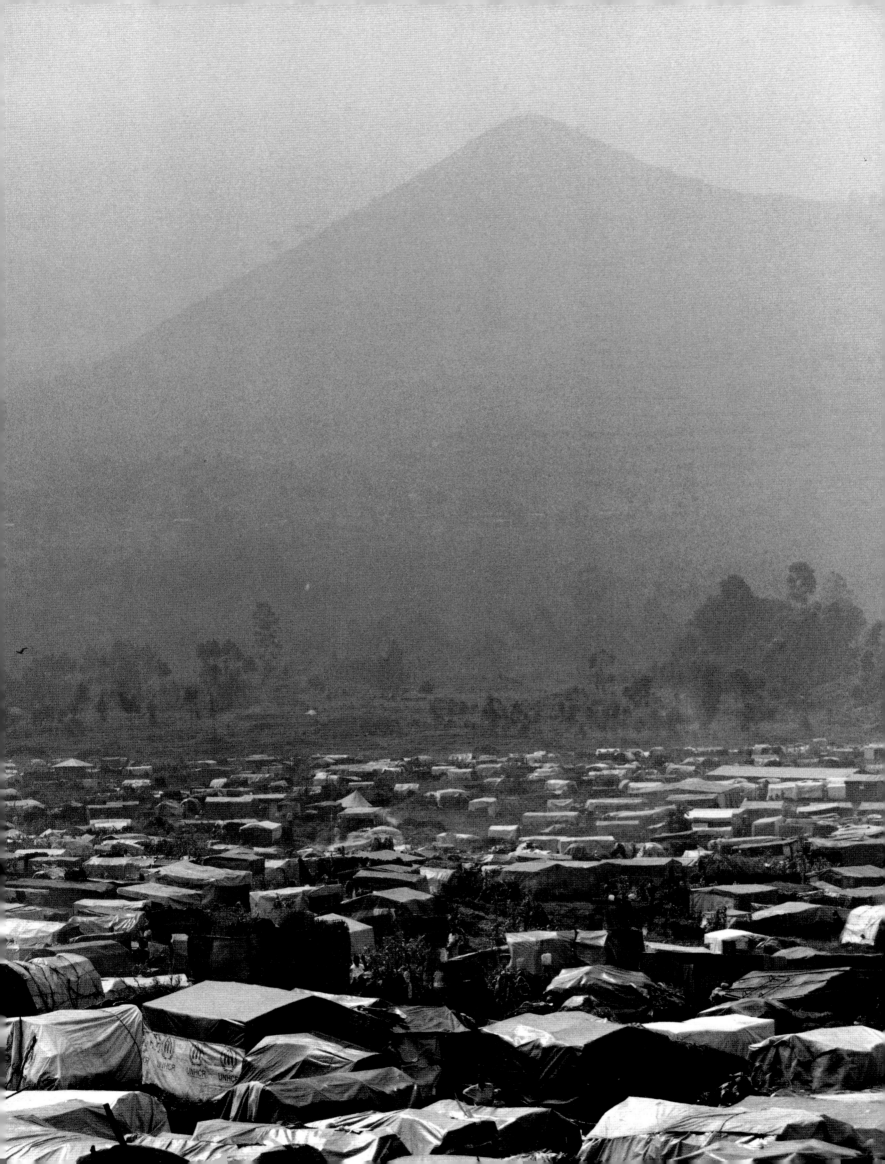

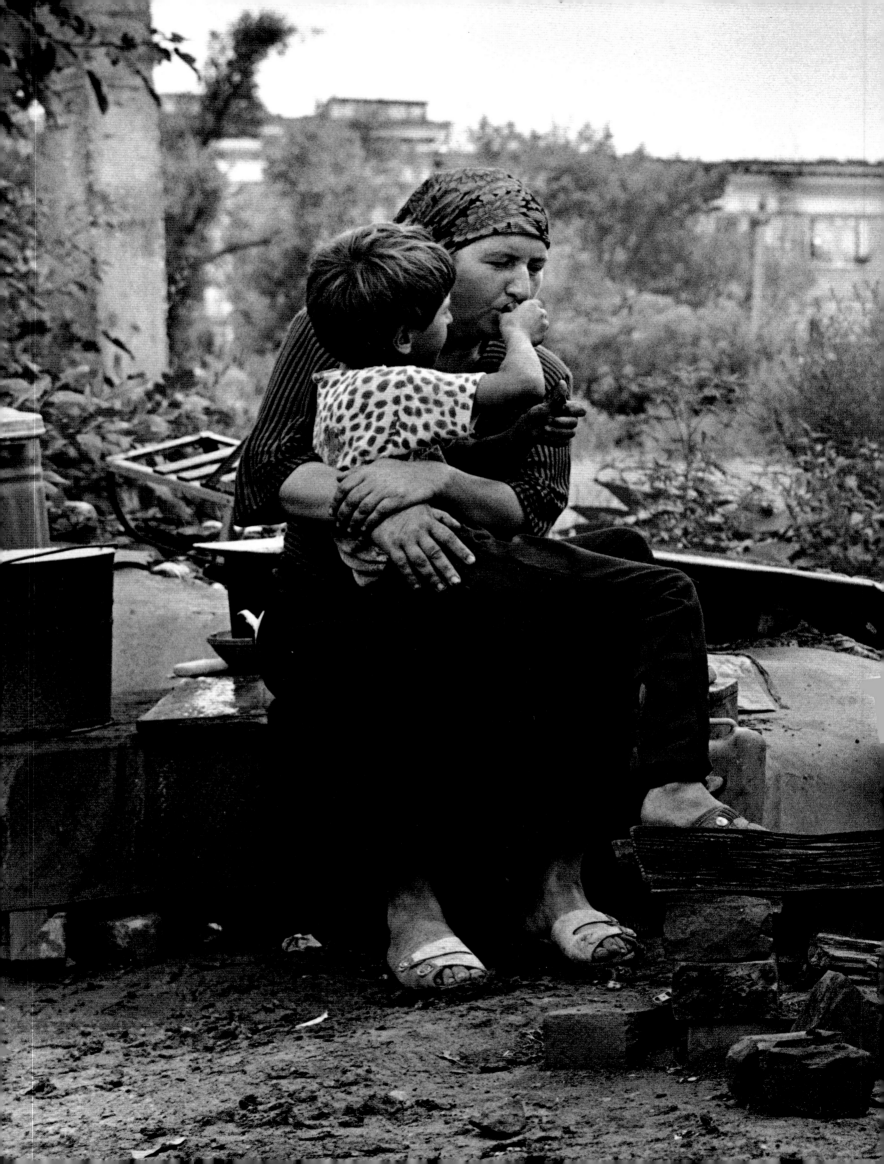

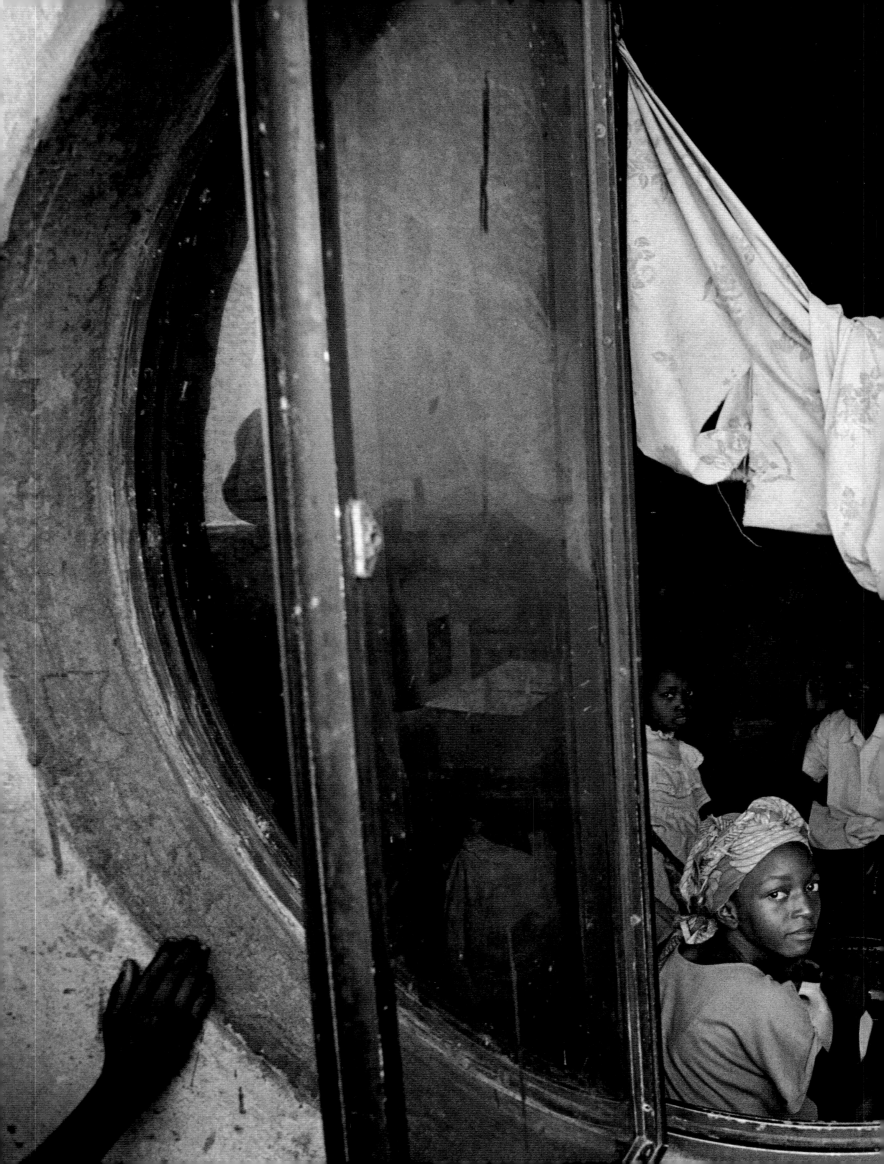

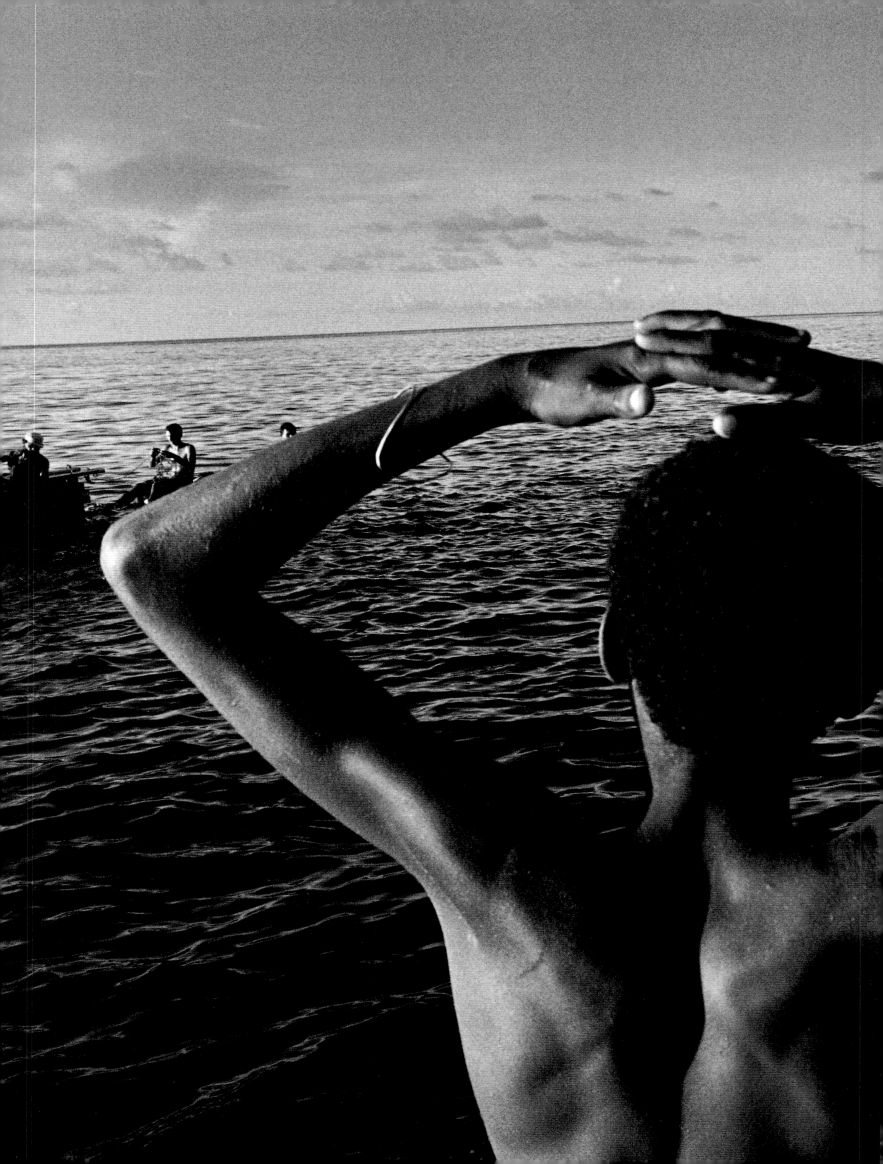

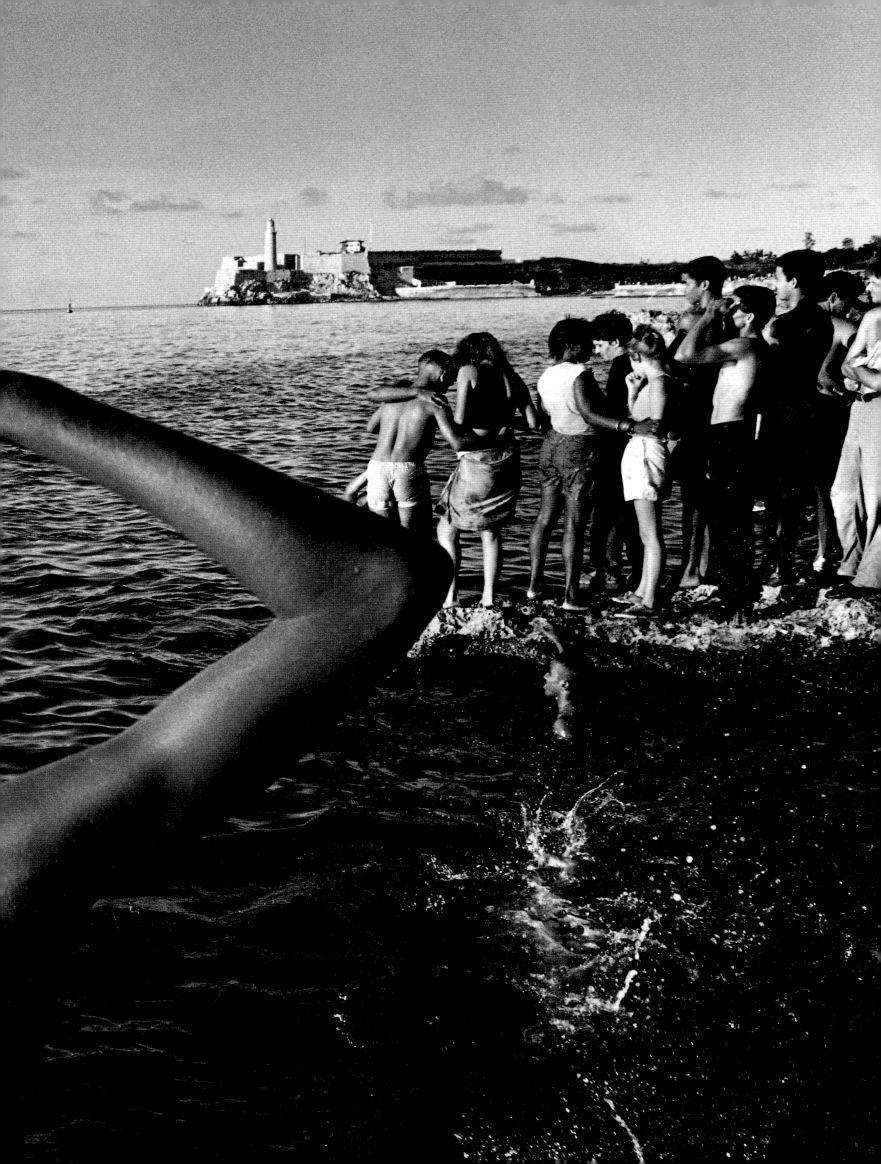

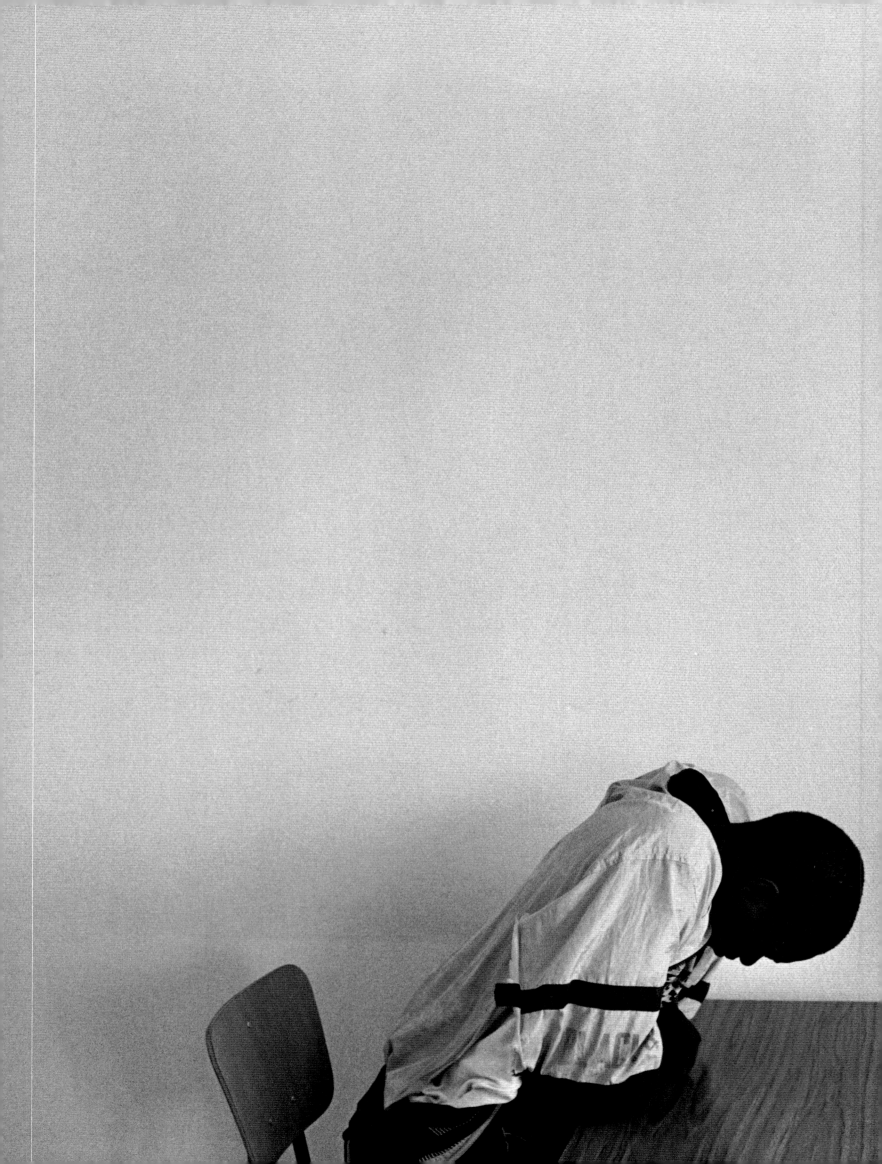

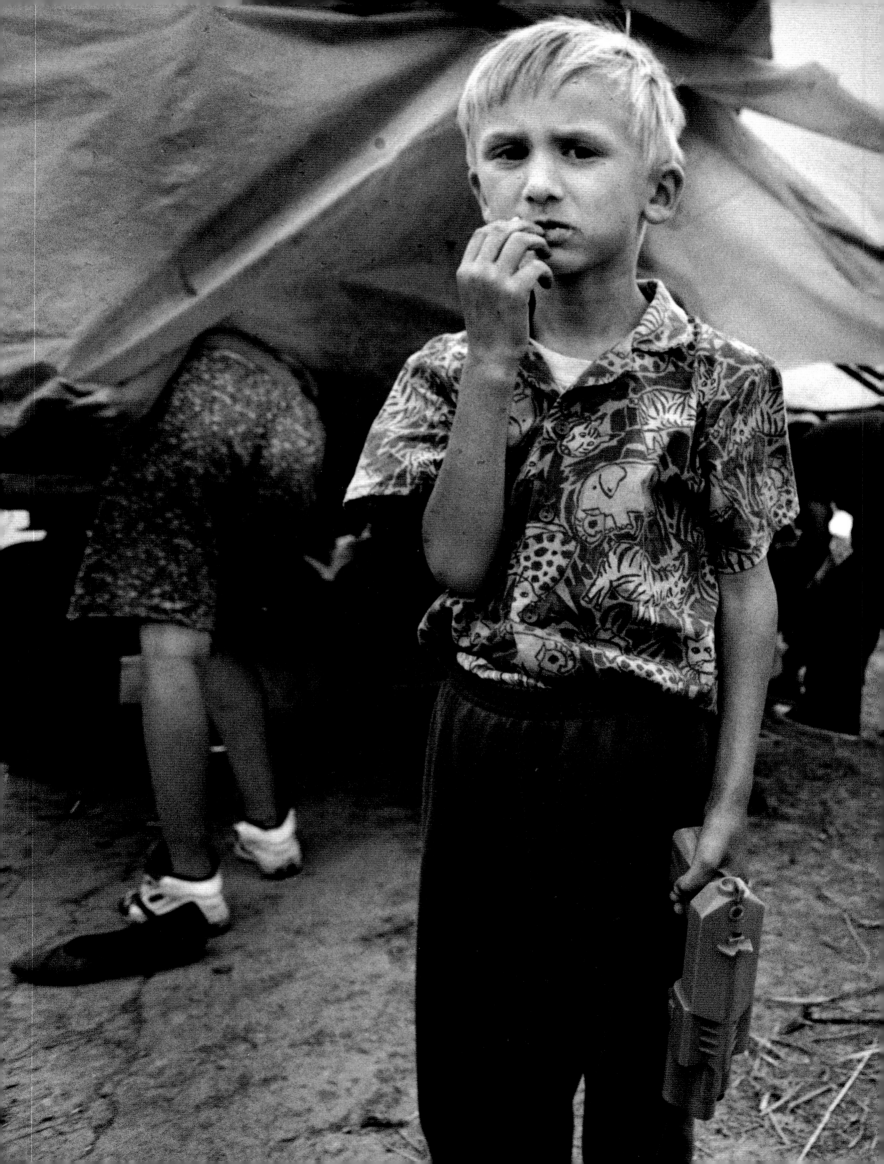

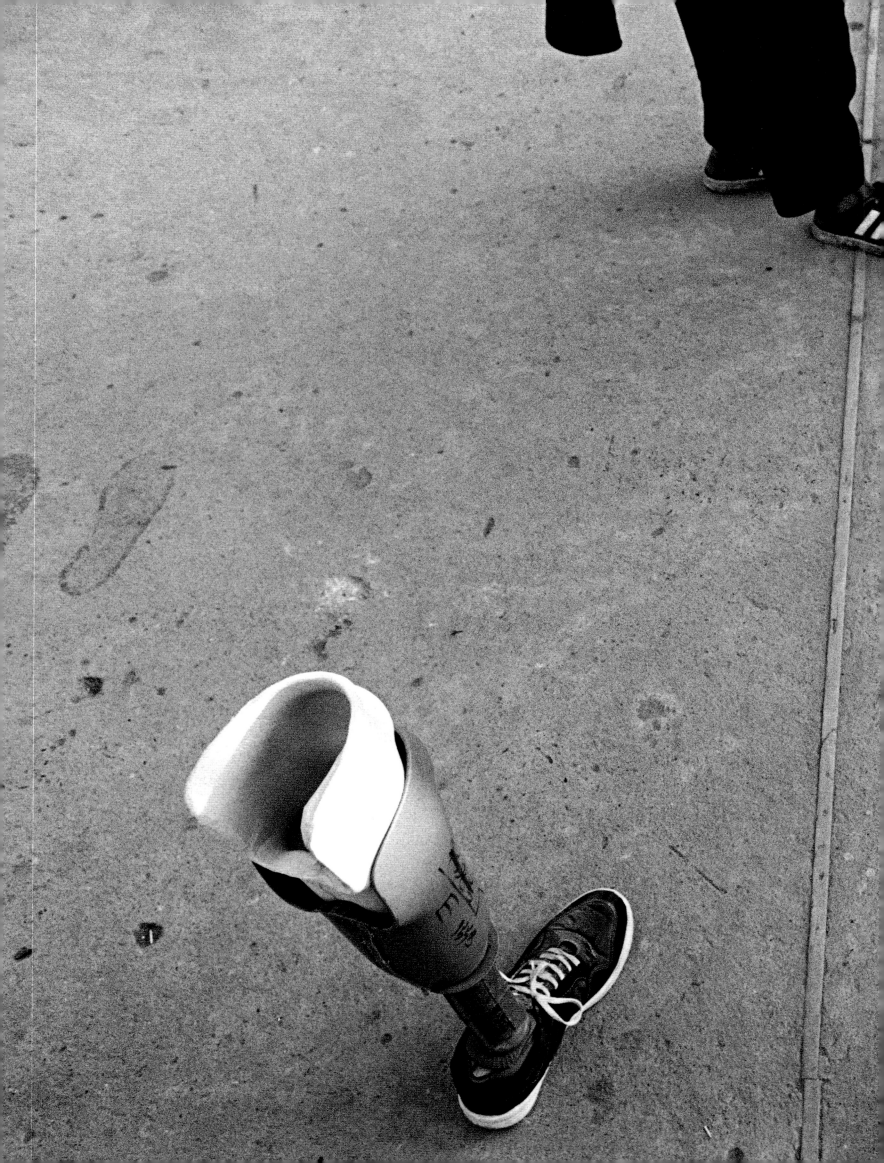

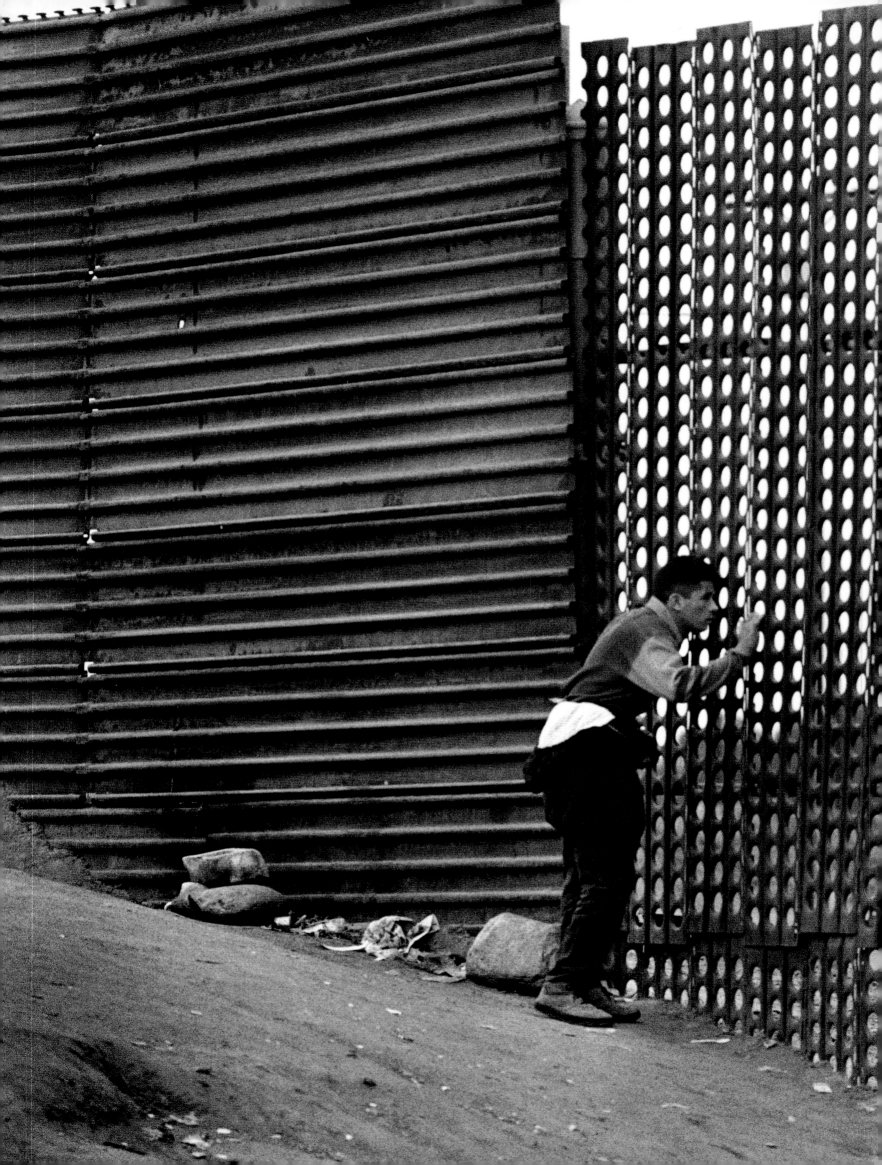

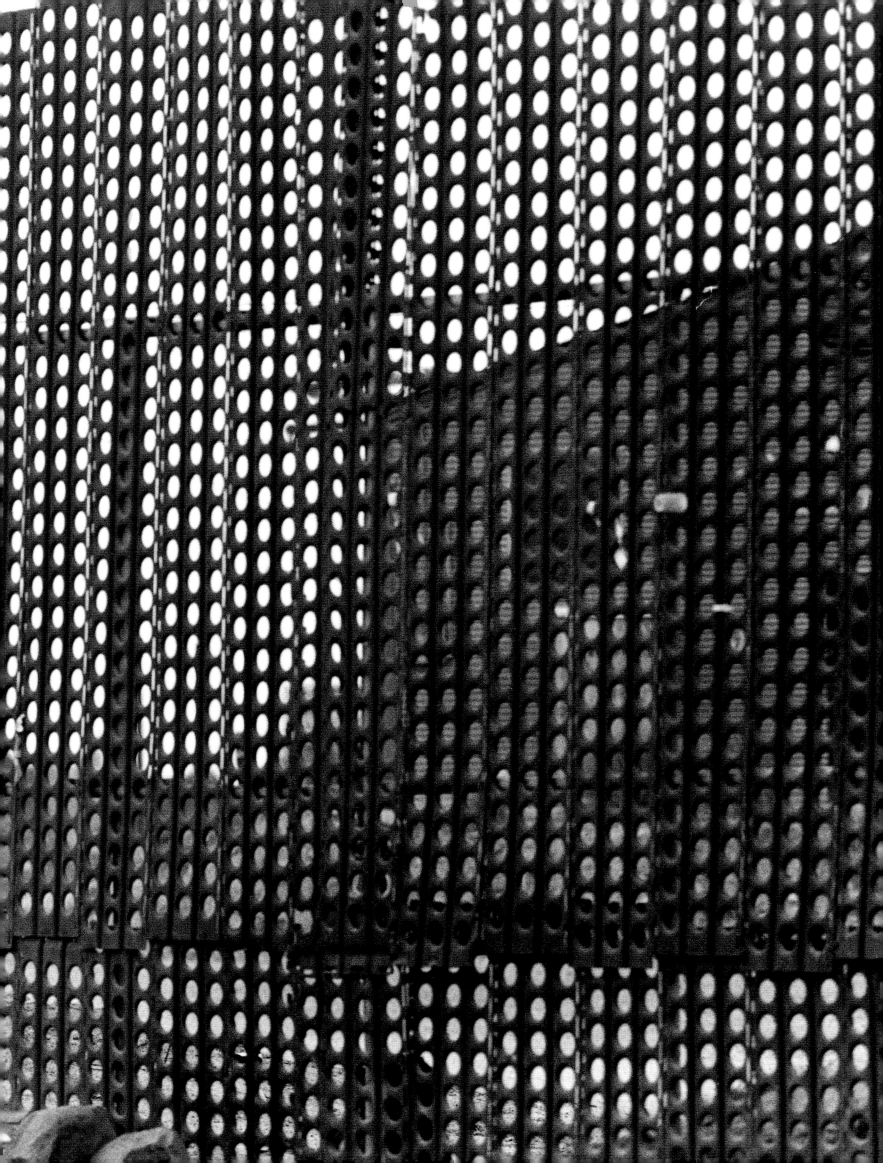

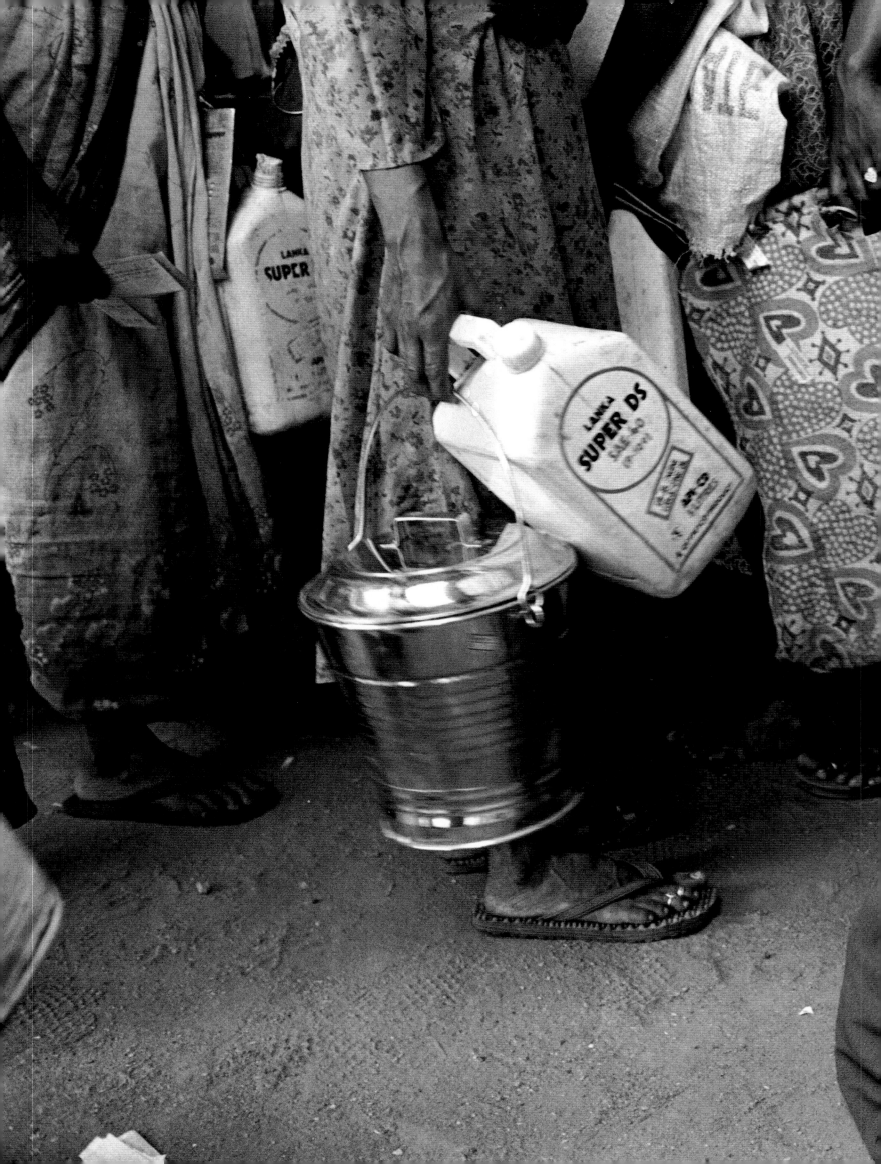

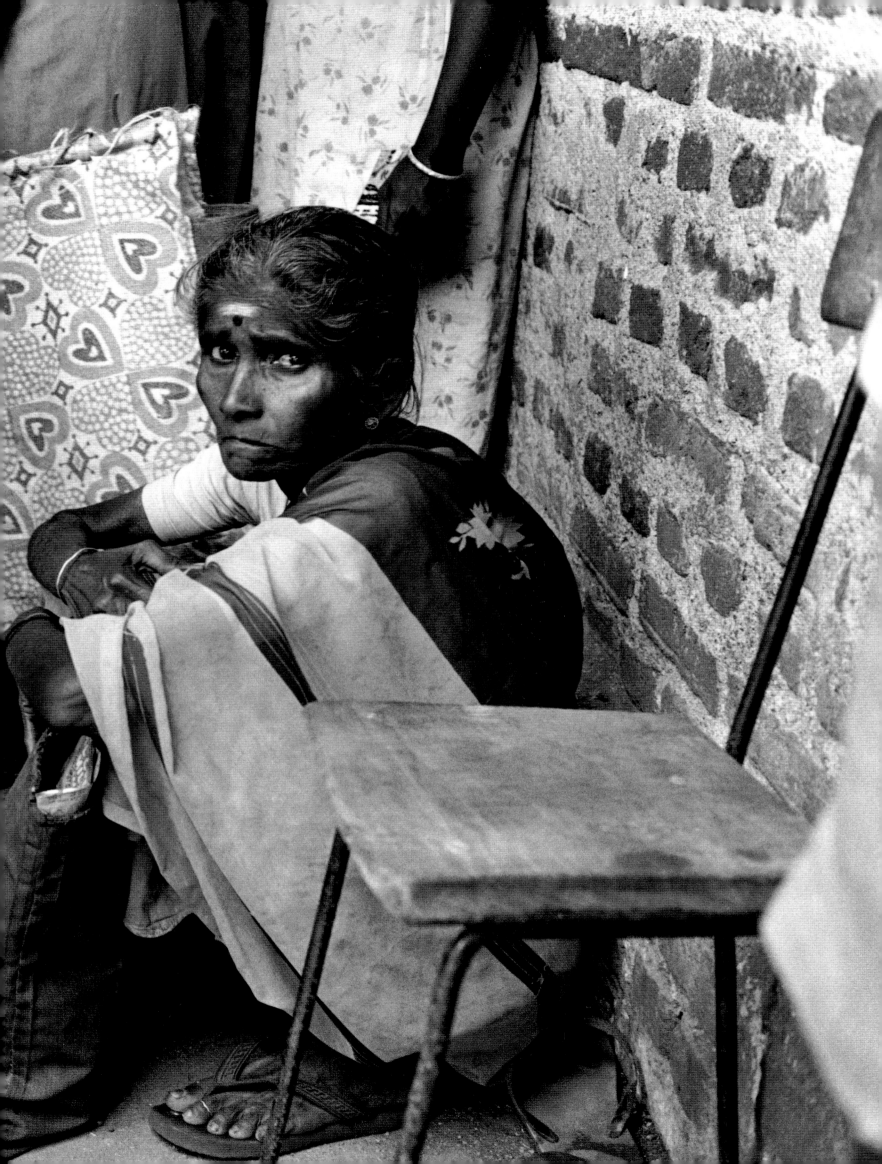

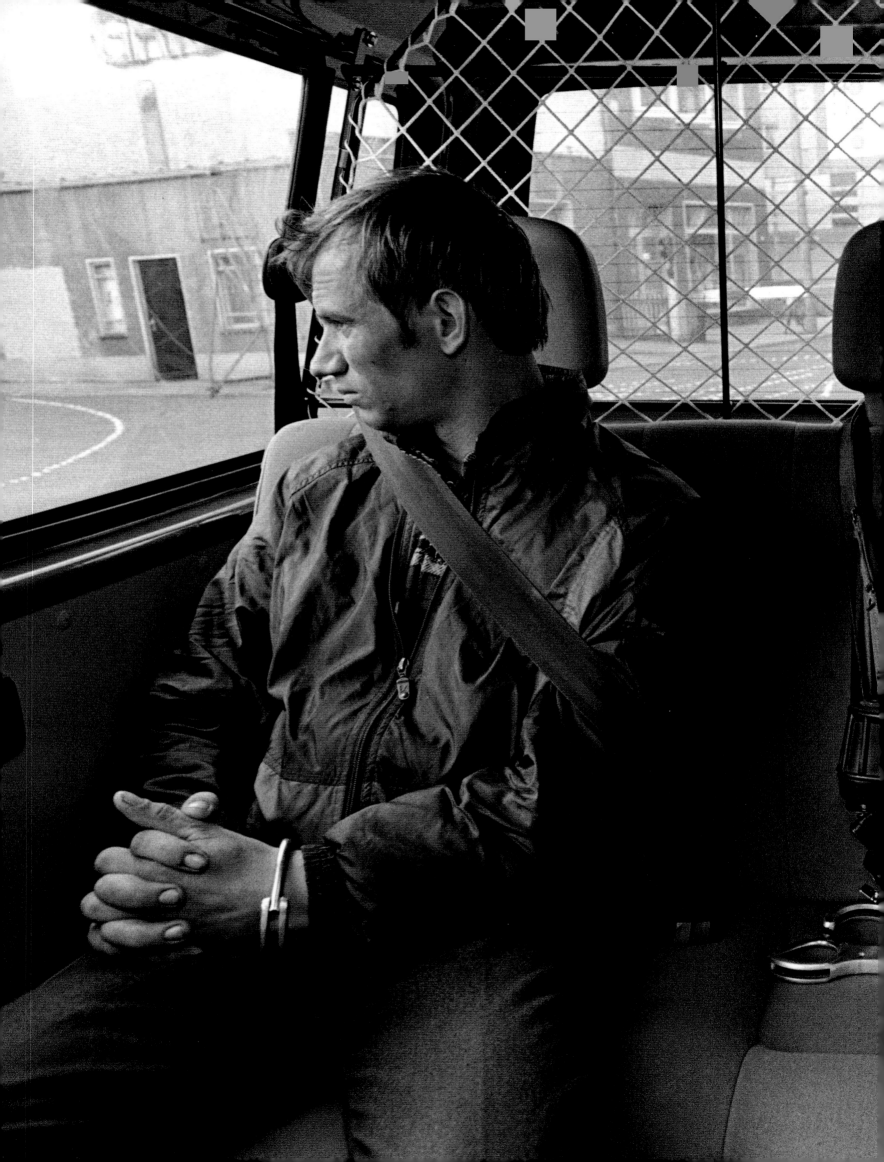

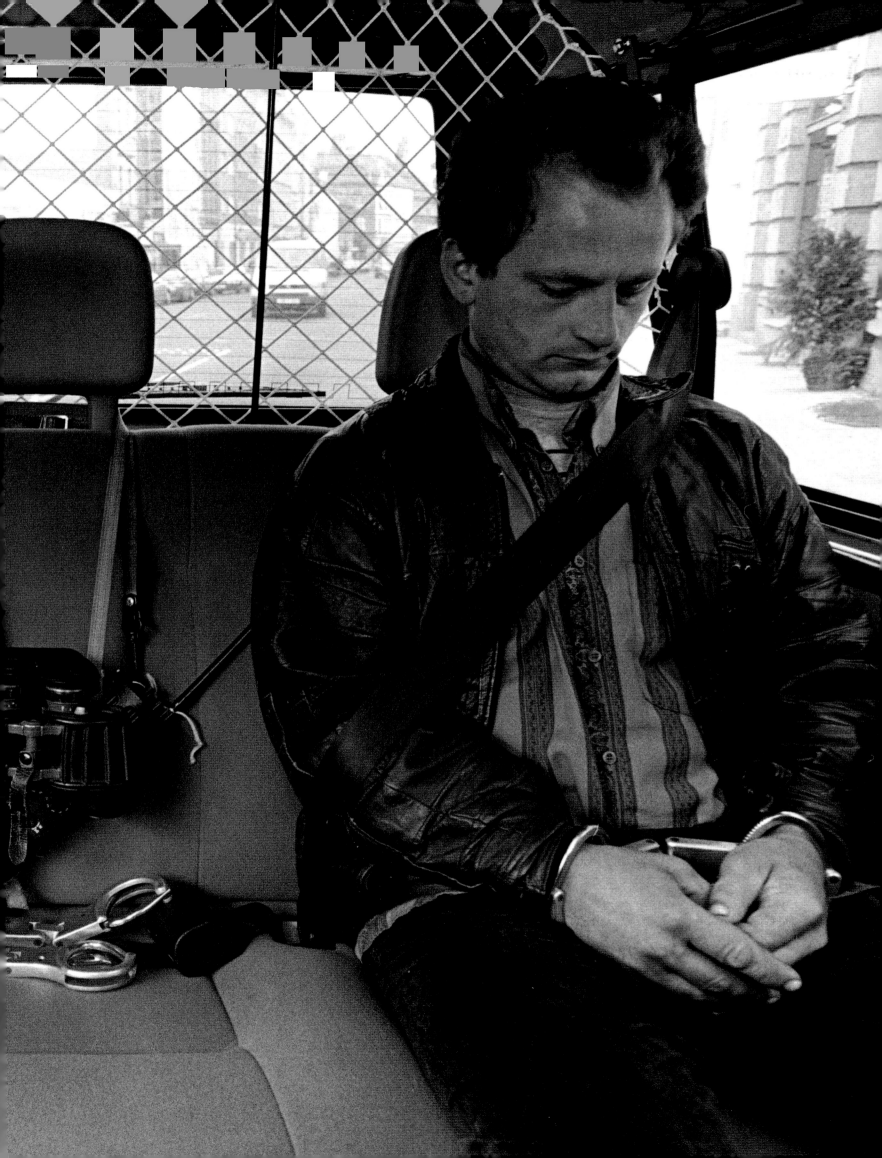

Refugee camp, Goma, Zaire. 1995

Family bombed out of its home. Grozny, Chechnya, 1995

Refugee camp in the unfinished Ministry of Health building,
    Monrovia, Liberia, 1996

Refugees departing from the Malecon, Havana, Cuba, 1994

Illegal immigrant in deportation confinement, Hamburg, Germany, 1996

Refugee camp in the no-man's-land between Bosnia and Croatia,
    Velika Kladusa, 1995

Orthopedic center, Kabul, Afghanistan, 1996

Border fence between Mexico and the US, Tijuana, Mexico, 1996

Man mutilated by rebels, Bo, Sierra Leone, 1996

Refugee camp, Vavuniya, Sri Lanka, 1996

Refugees being returned to Poland by German border police,
    Bademeusel, Germany, 1996

## EXODUS

### 50 MILLION PEOPLE ON THE MOVE
### PHOTOGRAPHS BY SIGNUM

Texts by Judith Kumin, Hans Christoph Buch and Mark Sealy

In cooperation with Caritas Germany, German Red Cross,
German Foundation for UN Refugee Aid, German Agro Action, Pro Asyl,
UNHCR and World Vision

EDITION STEMMLE

# FOREWORD

Judith Kumin, UNHCR Representative in the Federal Republic of Germany

What does it mean to be a refugee? The writer Stefan Zweig called it "a nerve-racking feeling, to stagger around with eyes wide open, knowing that one can be sent out at any moment from wherever one has managed to gain a foothold."

Refugees: They are history's flotsam. Germany's former Chancellor Willy Brandt called this century's refugees "pawns on the chessboard of bloody regional and international conflicts." No one knows exactly how many people have lost their homes in this century alone. The mass movement of persons fleeing persecution, oppression and brutal armed conflict is often seen as a phenomenon of the 1990s. In reality, the long columns of refugees on the move have been a feature of this century. Two World Wars, fascism and communism, decolonisation and the reappearance of nationalism along with an ever-widening gap between rich and poor: these have become synonymous with the misery and suffering of millions.

In the face of the radical social and political upheaval of recent years, it is surprising that the number of persons on the move across international borders is not even larger. It is true that one out of every 120 persons on this planet has been forced from his or her home. But the number who are displaced within their own countries is twice as high as the number who have crossed a border.

Even so, fear of mass migration is rife – not only in Western Europe – and this fear erodes the already limited sympathy for the plight of refugees. At a time when everyone talks about the world being a "global village," many see in this not the hope for a better future for all, but a looming threat to their own well-being. Empathy is overshadowed by concern for one's own family. The understanding of the fundamental principle behind the institution of asylum, the need to offer protection to those who are threatened at home because of their political beliefs, their religion, or their ethnic origin, fades into the background. Ironically, in these last years of what Heinrich Böll called the "century of refugees," the victims and hostages of political and social conflicts are increasingly viewed as a threat. Yet it is not with border controls and restrictive asylum laws that we will be able to tackle the world's deep-rooted problems. Closing our eyes to the misery of others will not bring us a more stable world.

Preventive action could help to avoid situations where men, women and children are forced to flee. Everyone agrees that conflict prevention is the biggest challenge for international politics today. But here, too, there is a wide gap between ambition and reality. Improvised crisis management and the balancing of competing political interests continue to be the rule, not future-oriented action. The result: emergency humanitarian aid takes the place of development aid, conflicts are juggled, rather than resolved.

Sometimes it looks as if the refugee problem will never go away. This does not just have political consequences. The dangers associated with growing indifference, with the evaporation of solidarity with the victims of war, can no longer be overlooked. Even with the best statistic, facts and analysis it is getting harder and harder to arouse sympathy for the plight of refugees.

Pictures are often better suited than words to arouse our interest in what happens to others. What does it really mean to be a refugee? In this book the refugees themselves give us the answer. The work of the SIGNUM photographers is a moving, and not at all sensationalized, portrayal of the daily life of refugees. Their misery is not put on display. Instead, the anonymous phenomenon of refugees and displacement takes on a truly human dimension. We see the faces of refugees, laughing and crying. We see their mourning and their pride, their hope and their despair. We look into the lives of people who had to leave their homes and who must struggle to come to terms with life in exile. The SIGNUM photographers have managed to capture on camera the overwhelming dignity of these men, women and children. What could be a better compliment?

# CONTENTS

**29**
*A FUGITIVE AND A WANDERER SHALT THOU BE ...*
**Hans Christoph Buch**

**33**
*RWANDA   THE LIVING, THE DEAD AND THE MURDERERS*

**51**
*CHECHNYA   NO WAR, NO PEACE*

**69**
*LIBERIA   PEACE IN ARMS*

**87**
*CUBA   FLIGHT ACROSS THE WATER*

**103**
*GERMANY   LAST STATION: DEPORTATION ARREST*

**119**
*THE FORMER YUGOSLAVIA   PEACE, BUT NO FUTURE*

**137**
*AFGHANISTAN   THE NEVER-ENDING WAR*

**155**
*MEXICO   ACROSS THE FENCE*

**167**
*SIERRA LEONE   PEACE IN SIGHT*

**183**
*SRI LANKA   HOME IN A REFUGEE CAMP*

**195**
*POLAND   NO HOPE OF ESCAPE*

**205**
*DETACHED*
**Mark Sealy**

**206**
*THE PHOTOGRAPHERS AND THE AUTHORS*

**207**
*THE HUMANITARIAN AID ORGANIZATIONS*

**Hans Christoph Buch**

Great popular migrations have not been confined to the period between the fall of Rome and the Middle Ages, an era still known today as an age of migration, but date back to a time long before the flight of the people of Israel from Egypt and their Babylonian Captivity. "Thou shalt be a fugitive and a wanderer on earth." With this irrevocable judgment, the wrathful God of the Old Testament condemned the fratricidal Cain to wander the earth forever. And further, "When thou tillest the ground it shall not henceforth yield unto you her strength." Here, the scriptures describe not only a *conditio humana* for all times and places but also mark the transition from the nomadic life to that of tillers of the ground that stands at the threshold of human development – in a sense the second original sin following the banishment of Adam and Eve from the paradise of Eden: Cain was a farmer who killed his shepherd brother Abel, whose sacrificial lamb was more pleasing to God than the fruits of the field offered up to him by Cain. It is a biblical story that can be transposed literally to the fratricide committed by Hutu farmers on Tutsi nomads, thus far the last genocide of our waning century.

As in the case of Cain and Abel, the story begins with the spilling of innocent blood. Today as well, every genocide, every civil war and every massacre unlooses a wave of refugee migration, and at the end of the 20th century there are so many categories of "fugitive wanderers" that our vocabulary is no longer sufficient to name all of the causes and effects. Language capitulates in the face of gruesome reality: Refugees and internal refugees, asylum-seekers and "false asylants," immigrant laborers and economic emigrants, late and forced resettlers, displaced persons and boat people, victims of ethnic cleansing, political and religious persecution, the raped and the tortured. No longer is it possible, as it was in Goethe's time, to put our heads in the sand while "far off somewhere, back in Turkey, the nations are hammering each other,"[1] for the global media network transmits the news of war against the Kurds via cable or satellite live and direct into our living rooms. In a matter of days, the victims of the conflict appear at the borders, requesting political asylum. Under the pressure of economic and

political crises, many people in the industrialized countries find it impossible to cope with this virtual simultaneity. Willingness to accept the misery of strangers – literally and figuratively – is on the decline. Moreover, the joyous utopia of the 1980s, the dream of a multicultural community of life, has been left by the wayside.

We live in *one* world, but our minds are still at home in the 1960s, when Maoist Cultural Revolutionaries put up a Chinese Wall between the first world and the third. We now speak even of a "fourth" or a "fifth world," while the second, formerly socialist world has vanished from our field of perception. This subdivision into first, second and third-category countries moves what has clearly grown closer in a spatial sense far off into the distance. Underlying this tendency is a legitimate need for distance, as no one is capable of taking in and coping with all of the misery of this world at once. But the consciousness barrier too often becomes a threshold of fear, while lack of knowledge turns to lack of desire to know, to aggressive rejection of everything that threatens to undermine our sense of well-being, which calls to mind the pharisaic utterings of the bourgeois Philistine in Goethe's *Faust*:

"What's better, on a Sunday or a holiday,
Than talking war or rumors of it
While far off somewhere, back in Turkey,
The nations are hammering each other?
You stand beside the window, drain your glass,
And watch the bright ships gliding down the stream,
And then at last, at twilight, go home happy
And thank your God for peace and peaceful days."[2]

Only a small minority of people is prepared to risk life and health in order to observe first-hand the everyday circumstances of people in crisis areas and war zones. I am not thinking of tourists, diplomats and managers, who see political and military conflicts only as disruptions of their official routines, but those whose job it is to place themselves in danger: humanitarian helpers, photographers and journalists. These three groups are alike in that they all abandon their comfortable hotel rooms and air-conditioned offices and experience events

---

1  Johann Wolfgang Goethe: *Faust I*. An English translation by Randall Jarrell (New York: Farrar, Straus & Giroux, 1976) p. 44.

2  ibid., p. 44.

close-up in order to develop and communicate to us an accurate picture of a situation. It is at this point that popular criticism of the media enters the scene, the kind that makes the messenger responsible for the message by accusing him of pursuing sensationalism, profit or the gratification of base instincts: a populist refrain to which I do not care to lend my voice.

One need only look at the photographs presented in this volume without prejudice in order to recognize that none of them appeals to voyeuristic tendencies and that neither greed for profit nor sensationalism had anything to do with their origins. The SIGNUM photographers do not wish to shock but to enlighten. They show living people in all their dignity and beauty. Here, the individual is more than a drop in a vast ocean of misery, and war is not depicted as an anonymous twist of fate visited upon a people like some natural disaster – indeed, it has a name and an address. The third world does not appear as a conglomeration of hopeless misery but as a creative chaos in which people with imagination and a talent for improvisation find ways to survive. The slum-dwellers of Monrovia, the residents of refugee camps in Bosnia or Sri Lanka and the homeless people living in the ruins of Grozny or Kabul are not presented as recipients of aid and passive objects but as subjects who, under conditions unimaginable for us, gain mastery over a life that is more than mere survival. Many of them laugh and look happier than those living in the so-called donor countries. And there is nothing frivolous about that statement, for along with the experience of shared suffering, many people in industrialized countries have also lost the capacity for joy, whereas spontaneous *joie de vivre* is most likely to be articulated where it is threatened from outside. We should also note that the military and political conflicts of the 1990s were not and are not wars of a conventional nature, but instead low intensity wars, in which markets and dwellings are laid to waste in lieu of factories and palaces. Massive destruction such as has taken place in Mostar or Monrovia, large-scale bombardments like those that have destroyed Kabul or Grozny are exceptions. There have been and still are numerous niches in which civilian populations, on whose backs the wars are waged, have managed to survive. Women's groups such as the mothers of Russian soldiers, human rights activists and prominent intellec-

tuals like Tadeusz Mazowiecki and Sergei Kovalyov have appealed for an end to the fighting, for peace and reconciliation. And even though their appeals have not brought an end to the killing, the presence of international observers and the permanent involvement of humanitarian organizations make the civil and ethnic wars of the 1990s quite different from those of earlier periods. While human rights violations have not been prevented through their influence, perpetrators have been identified by name and forced to recognize that they will be called to account for their deeds. The UN Human Rights Tribunal for Rwanda and the former Yugoslavia has begun its work. Although no palpable results have as yet been achieved, a first step, at least, has been taken. And the efforts of humanitarian helpers from all over the world have not only softened the impact of war on civilian population and brought treatment to countless victims of land mines but have also helped to rescue homeless people from starvation, to repatriate refugees and to reintegrate those traumatized by violence into their social communities.

On my desk lies a 7.6-mm cartridge I picked up from the ground in Grozny last fall. The brass casing holds a pointed lead projectile capable of killing a human being. The round is still live – Kalashnikov ammunition of the kind strewn about every war zone in the third world. And Michail Timofeyewich Kalashnikov, whose AK-47 has presumably killed more people than the atomic bomb, has celebrated his 77th birthday in a sanitarium near Moscow and will one day die peacefully in bed. Even more destructive than these automatic weapons are grenades and bazooka shells, rockets fired from helicopters and vacuum bombs such as those used experimentally by the Russian army on Chechnyan villages – which leave buildings largely intact and kill "only" their inhabitants. The arsenals appear to be inexhaustible, and any hope that a ban on weapons trafficking will put a stop to warfare is as naive as the idea of worldwide condemnation of war through a voluntary renunciation of violence. Weapons are available in sufficient quantities nearly everywhere, and where this is not so, they can be imported illegally or manufactured, as in the weapons factories of Peshawar. The human potential for violence can perhaps be channeled, but it can never be eradicated. Thus it is possible to speak of

an urge for destruction or death that has accompanied human history since its very beginning and for which the myth of Cain and Abel is but *one* indicator. Yet life in crisis regions and war zones is not quite as depressing at it appears in journalistic retrospect. What correspondents' reports tend to ignore is the imaginativeness and inventiveness with which people undermine the fates of war in order to retrieve a piece of life from the jaws of death, expressing their human dignity in subversive imagination. Mankind is not evil by nature. Streetfighters in Monrovia interrupted their firing to allow reporters and journalists to pass across the front – calling out to their enemies to stop shooting temporarily – and both sides went along. Aside from encounters with mistrustful military officers who suspected the presence of spies everywhere, I have never had the sense of being seen as an unwanted observer or a bothersome eyewitness. Those concerned have answered my questions patiently, even when they found them naive or dumb. We must remember that, for the victims of armed conflict, the opportunity to pass on knowledge about what is happening to them is just as essential for survival as material aid. Nothing has a more paralyzing effect than the feeling of being victimized by events about which the world will never learn.

Is this view of things not somewhat too naive? Does it gloss over too many of the questionable aspects of the situation? After all, didn't reporting of the Gulf War, the German army operation in Somalia, genocide in Rwanda and the massacres in Bosnia show us how cynically the press, most notably television, manipulates public opinion? Certainly, but on the other hand it was this very omnipresence of the press that exposed such manipulations and brought the truth to light – in Vietnam no less than in the Gulf War. In Bosnia, Chechnya and Somalia, courageous reporters refuted premature reports of success and revealed the falsity of government propaganda. If manipulation of the minds of newspaper readers and television viewers goes on nonetheless, then not by means of blunt corruption of the truth, which are hardly possible any more in the era of the Internet, satellite telephones and faxes – today's infrared satellite cameras can easily detect the existence of chemical weapons factories, prisoner-of-war camps and mass graves – but through more subtle methods. The decision to present a military

or political conflict in all its complexity or to condense it into two brief lines of print or a few seconds of coverage is all too often left to chance or to the questionable competence of a particular editor. It is also true that our media ordinarily do not focus upon the third world until blood is spilled. Little effort is expended in the search for causes.

The discovery of historical truth presupposes an understanding of political realities. To this end, the photographs compiled in this volume offer much more than mere pictorial material. A close examination of the pictures reveals, for example, that the border fence between Mexico and the US is not a Berlin Wall, that deportation confinement for asylum-seekers cannot be equated with life in a concentration camp. Gratuitous analogies and spurious comparisons offer little help here. Every historical injustice and every political crime must be judged, and condemned if appropriate, in its own right. The present volume cannot and does not intend to do the work of judging for the reader, but it provides indispensable assistance for those prepared to make the effort.

November 1959
In the course of the so-called "Hutu Revolt," the centuries-old feudal system is swept away along with the monarchy of the Tutsi minority. Tens of thousands are massacred, and many Tutsis flee the country, primarily to Burundi and Uganda.

July 1962
Rwanda gains independence from its Belgian colonial rulers. Some 120 000 people, most of them Tutsis, have already fled their homelands in the wake of the Hutu takeover. By the late eighties, approximately 480 000 Rwandans – about 7 per cent of the country's population – have left the country.

October 1990
Following the failure of negotiations, the Tutsi resistance movement, the Rwanda Patriotic Front (RPF), launches an attack against Rwanda from Ugandan soil. The 16-year rule of the Hutu unity party comes to an end. Tensions appear to abate as the transitional government officially recognizes the right of refugees to return in 1993. A peace treaty is concluded with the RPF. Despite these positive developments, the civil war continues with growing brutality, as extremists on both sides reject the agreements.

April 1994
The death of the presidents of Rwanda and Burundi in an airline crash triggers a further intensification of hostilities. Indescribably horrifying massacres of Tutsis and moderate Hutus follow, carried out by Hutu militiamen and a number of civilians. According to conservative estimates, some 500 000 people are murdered. Within just two days, 250 000 Rwandans, primarily Hutus, flee to Tanzania. A mass exodus begins.

July 1994
In one of the largest and most rapid refugee evacuations in history, half a million Rwandans move into eastern Zaire. Most of those in flight are Hutus fearing retribution. Conditions in the refugee camps are desolate; aid organizations can do little. A large-scale aid undertaking supported by military forces brings some relief. The RPF announces the end of the war and assumes the reigns of government.

February 1995
A conference of central African countries and major providers of aid resolves to encourage the return of Rwandan refugees to their homeland through trust-building measures. A number of circumstances hamper implementation, however.

April 1995
Massacre at the Kibeho refugee camp on April 22nd: between 5000 and 8000 people are shot to death by government troops. The flow of returnees to Rwanda ends abruptly. Up to this time, as many as 800 Rwandans per day have begun the journey home since February 1995.

October 1996
Another hotspot develops in eastern Zaire: People of the Banyamulenge group, Tutsis of Rwandan descent, join with other groups and parties to form a resistance movement in opposition to the Mobuto regime in Zaire. The coalition, known as the Alliance of Democratic Forces for the Liberation of the Congo-Zaire, is led by Laurent Kabila. As the rebels advance, attacks are carried out on civilian population. Hundreds of defenseless civilians are murdered; women and young girls are raped and hordes of looting Banyamulenge and Zairian troops move through the countryside. According to reports from Amnesty International, the massacres were made possible by deliveries of weapons and military equipment from western Europe, South Africa, China and the US. Within a very brief period of time, 750 000 refugees have fled Zaire and Tanzania and returned to Rwanda.

May 1997
Having taken the other major cities in the country, the rebel alliance now prepares to enter its capital, Kinshasa. Under mounting international pressure, Mobuto relinquishes power and flees the country. Laurent Kabila names himself president, and his troops march into Kinshasa. The United Nations begins returning refugees from Zaire to Rwanda by rail and air.

Distributing aid supplies in the refugee camp at Benako, Tanzania, 1995
Hutus suspected of murder at the overfilled central prison, Kigali, Rwanda, 1995
Victims of a massacre in which hundreds were killed, carried out by Hutus in April 1994, Ntarama, Rwanda, 1995
Hutus suspected of murder at the overfilled central prison, Kigali, Rwanda, 1995
Hutus suspected of murder at the overfilled central prison, Kigali, Rwanda, 1995
Victims of a massacre in which 4000 were killed, carried out by Hutus in April 1994, Mission Station Nyarabuye, Rwanda, 1995
Moving the bodies of massacre victims, Nyakaliro, Rwanda, 1995
Refugee camp with Rwandan refugees, Goma, Zaire, 1995
Refugee camp with Rwandan refugees, Goma, Zaire, 1995
Rwandan woman in the clinic of the refugee camp at Benako, Tanzania, 1995
Abandoned refugee camp, Rwanda, 1995

# RWANDA

## THE LIVING, THE DEAD AND THE MURDERERS

**33**

**Photographed by Andreas Herzau in August 1995**

The coexistence of the Hutu and Tutsi ethnic groups in Rwanda and Burundi has been plagued
by conflicts for centuries. Tensions were escalated in 1959 when a Hutu government
took power, ending a period of Tutsi rule. Massacres and mass refugee movements ensued.
Hundreds of thousands have died since the outbreak of war between
the Tutsi exile movement, the Rwanda Patriotic Front, and the Rwandan army. Since 1994,
the refugee population in the neighboring countries of Zaire, Burundi,
Tanzania and Uganda has swollen to more than a million people. Despite the return
of many refugees, there is no end of the catastrophe in sight.

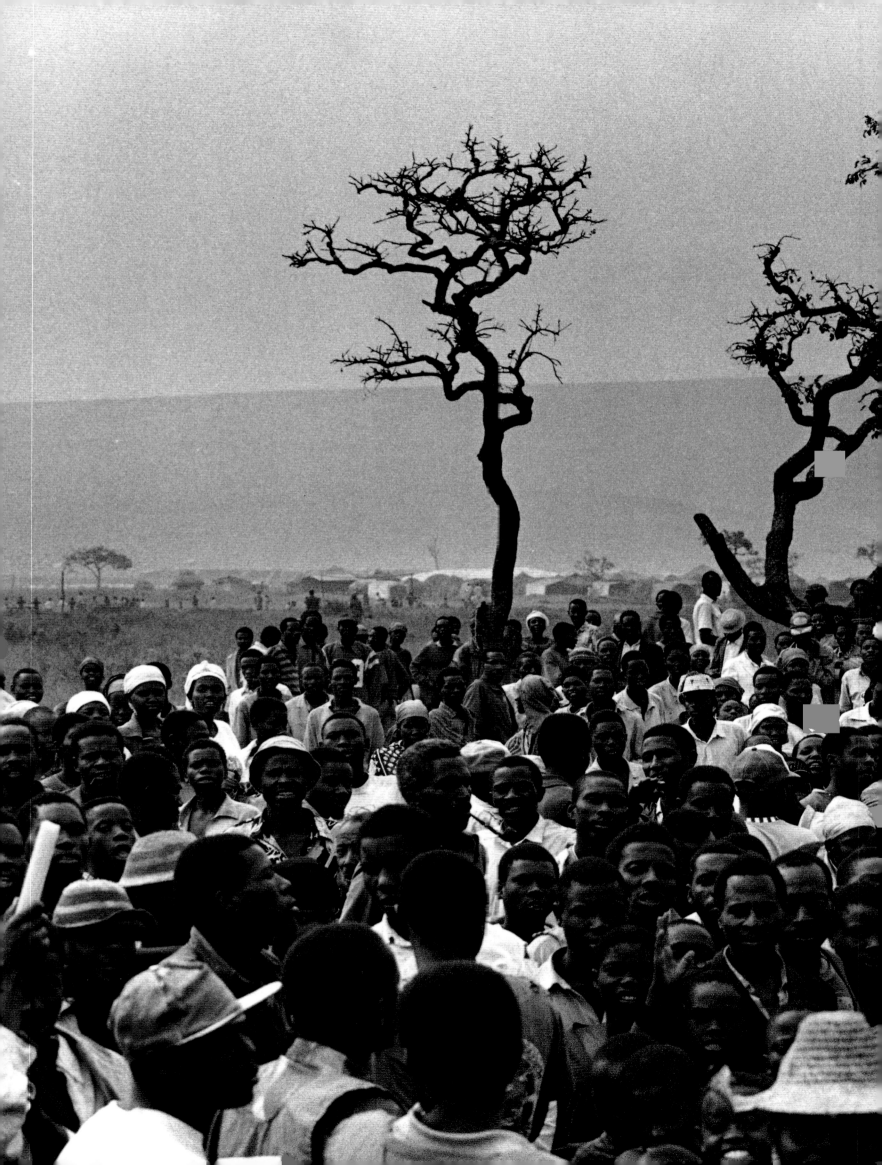

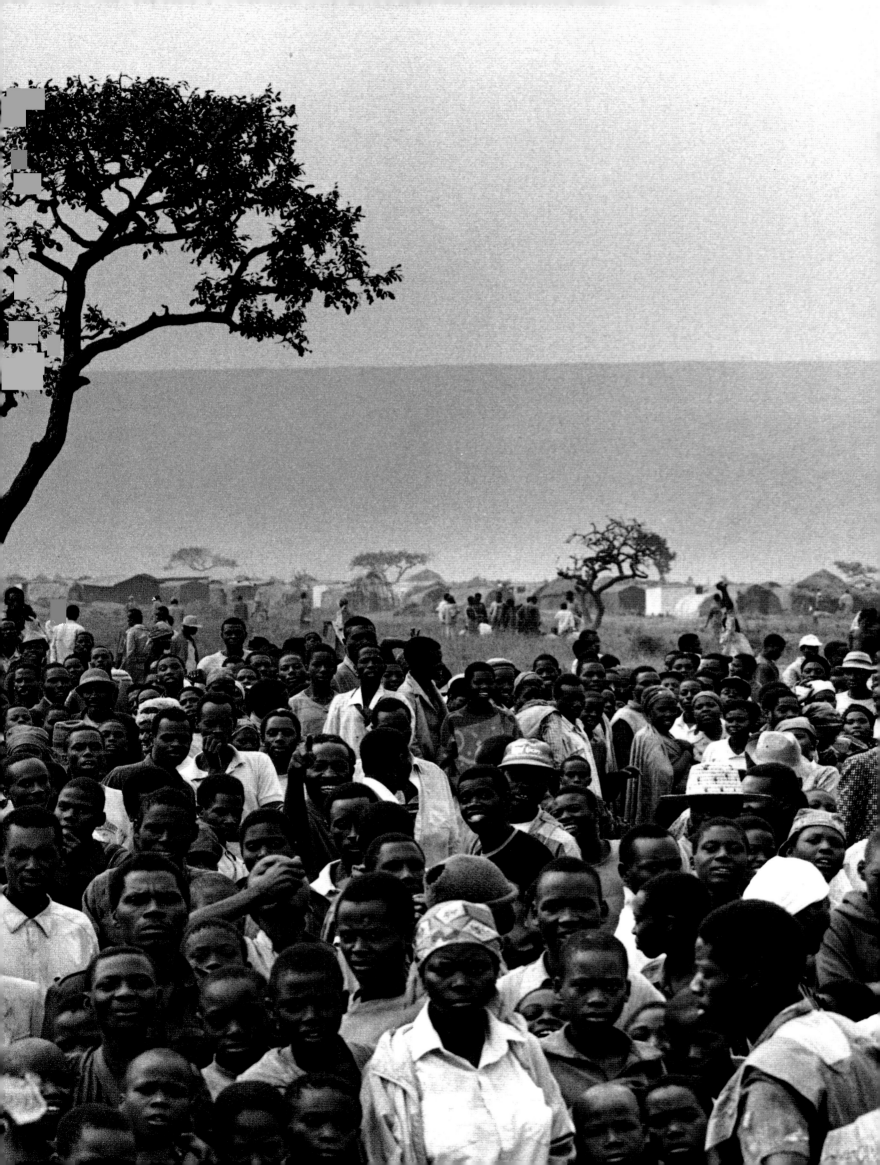

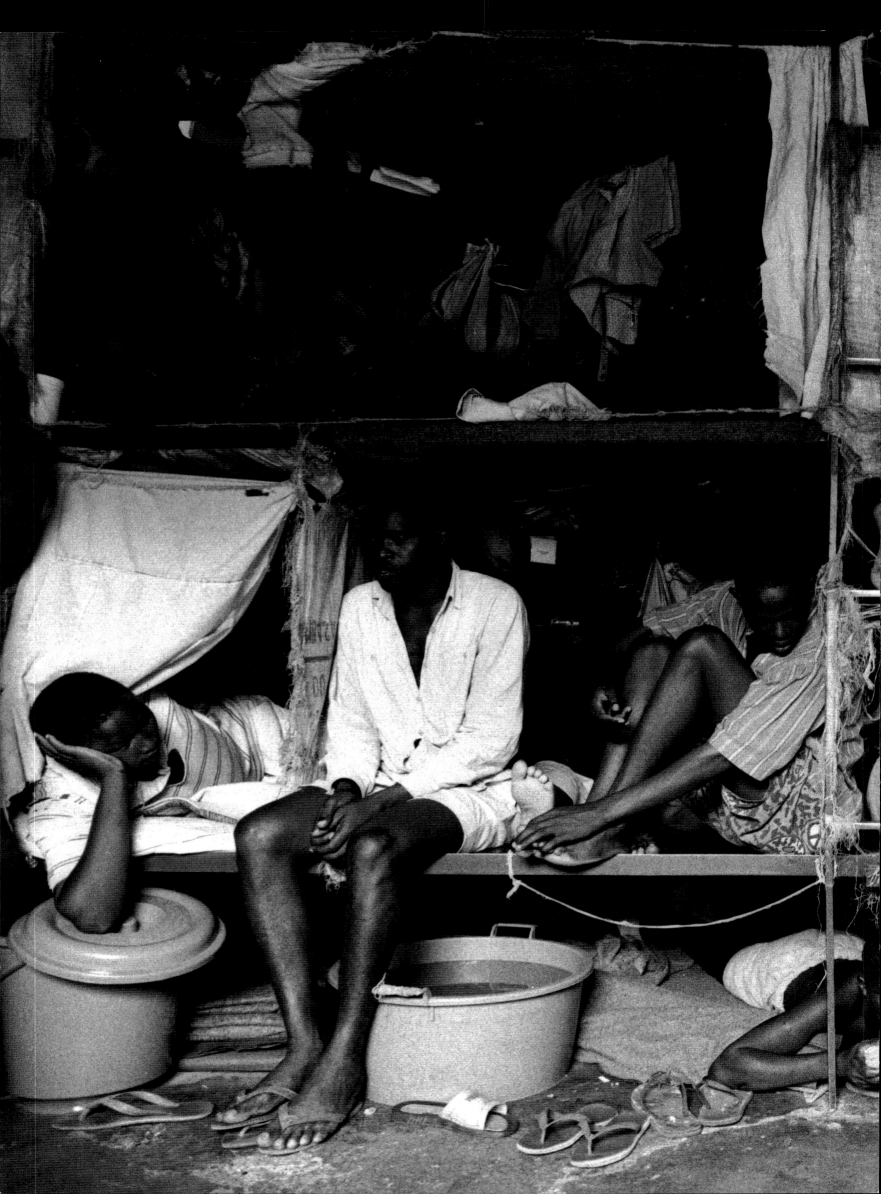

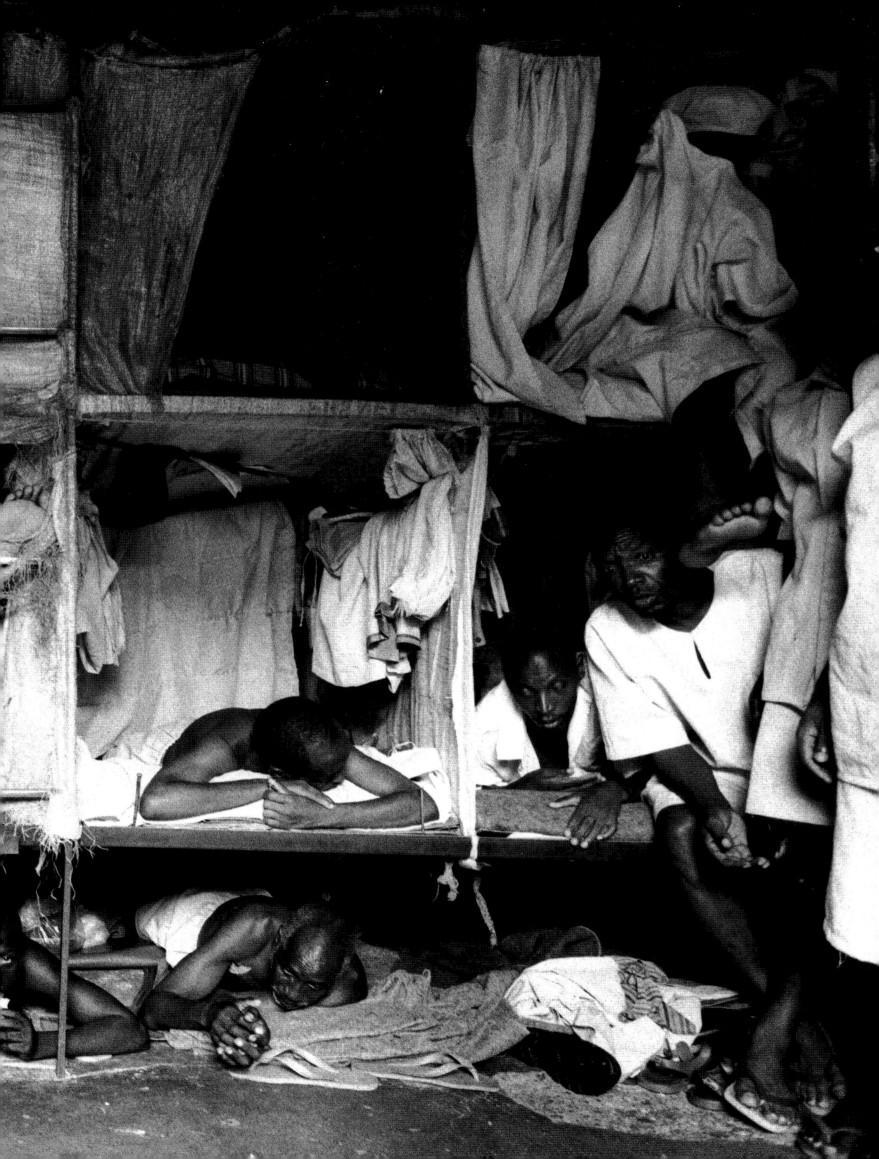

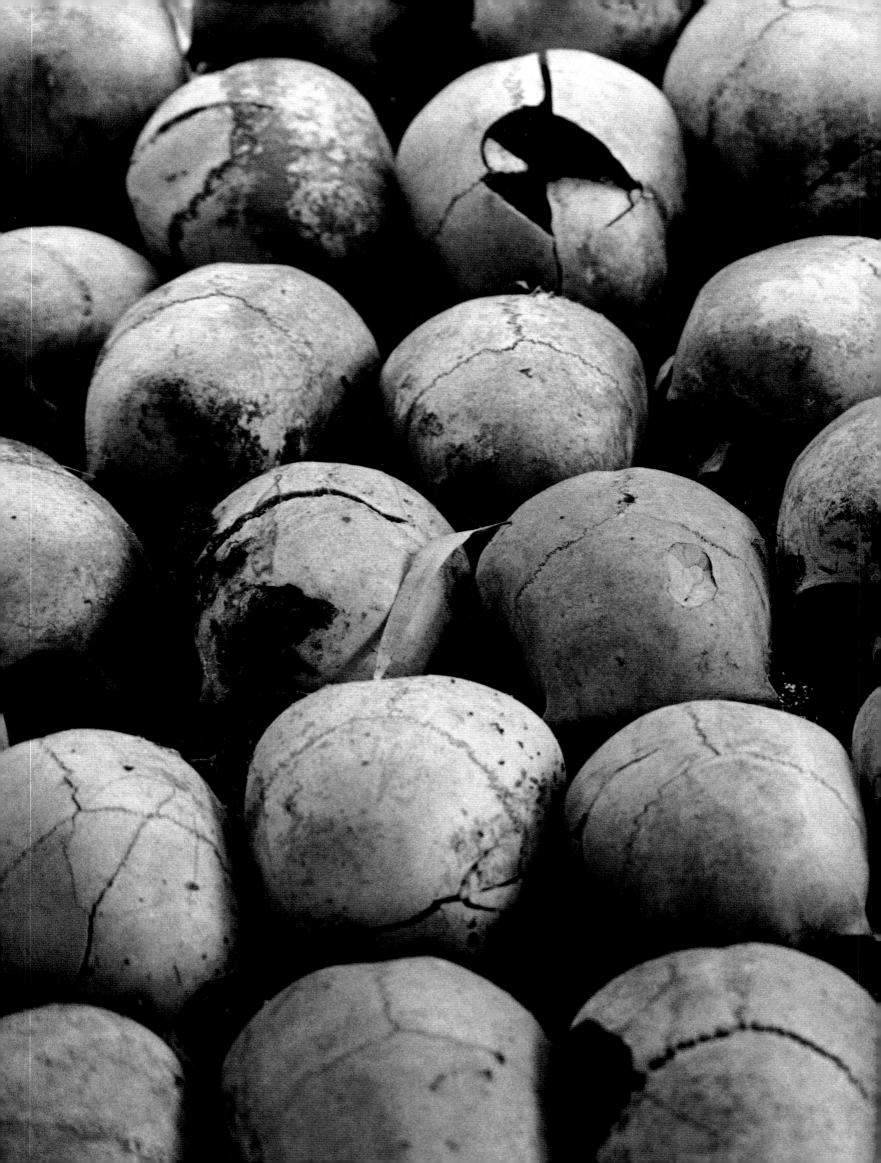

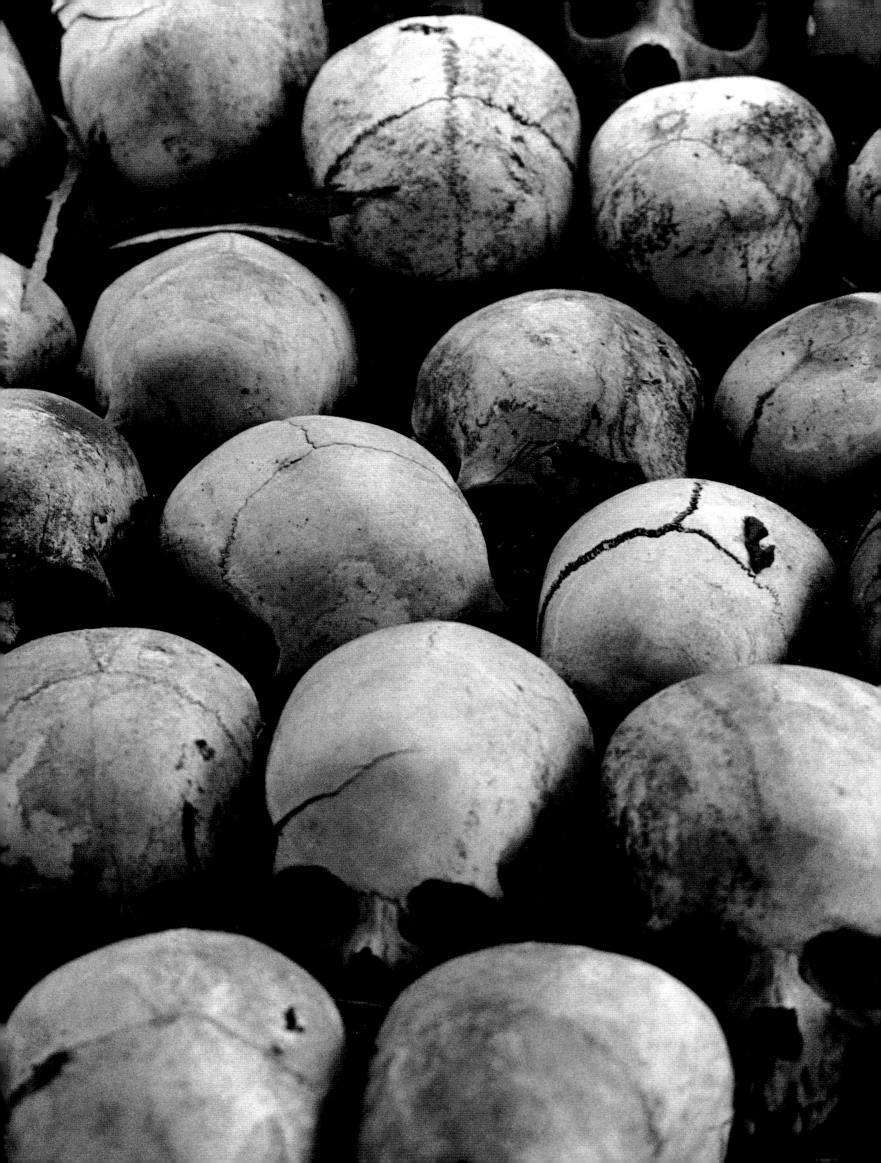

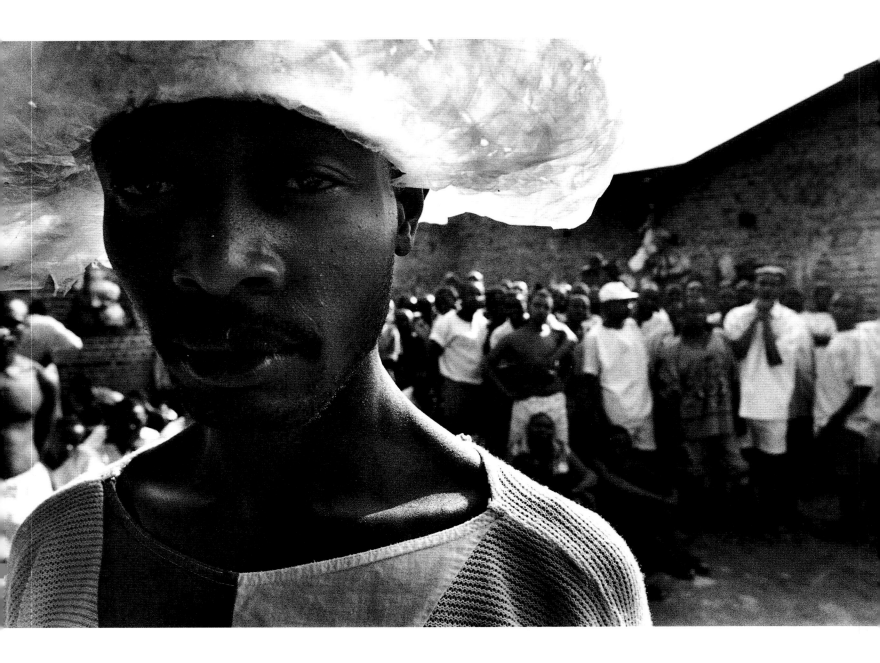

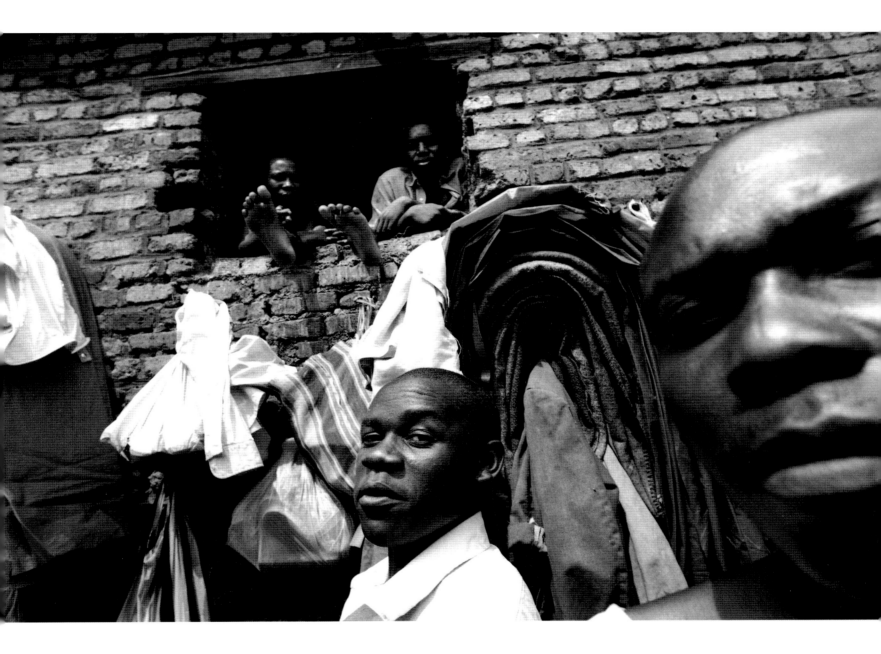

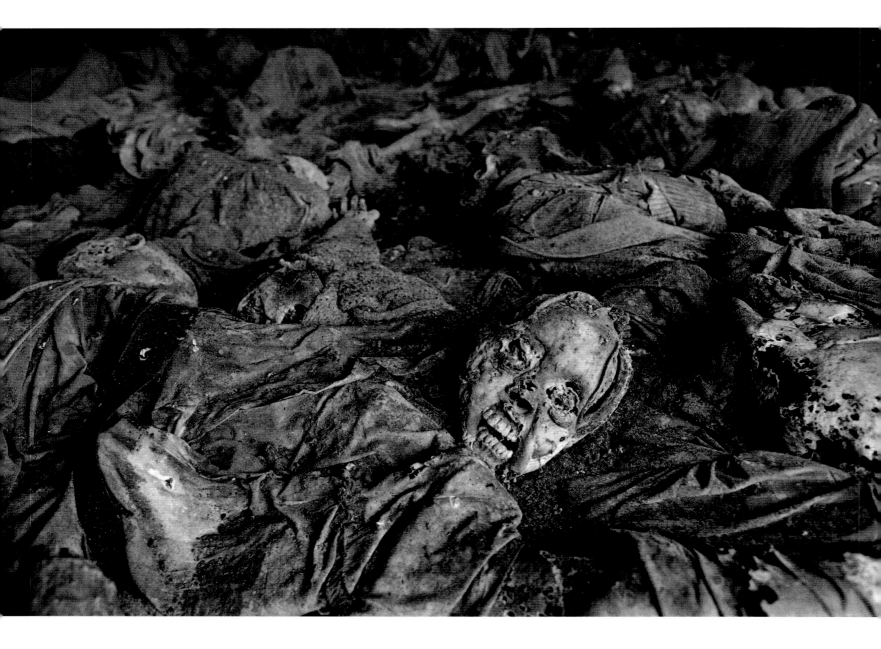

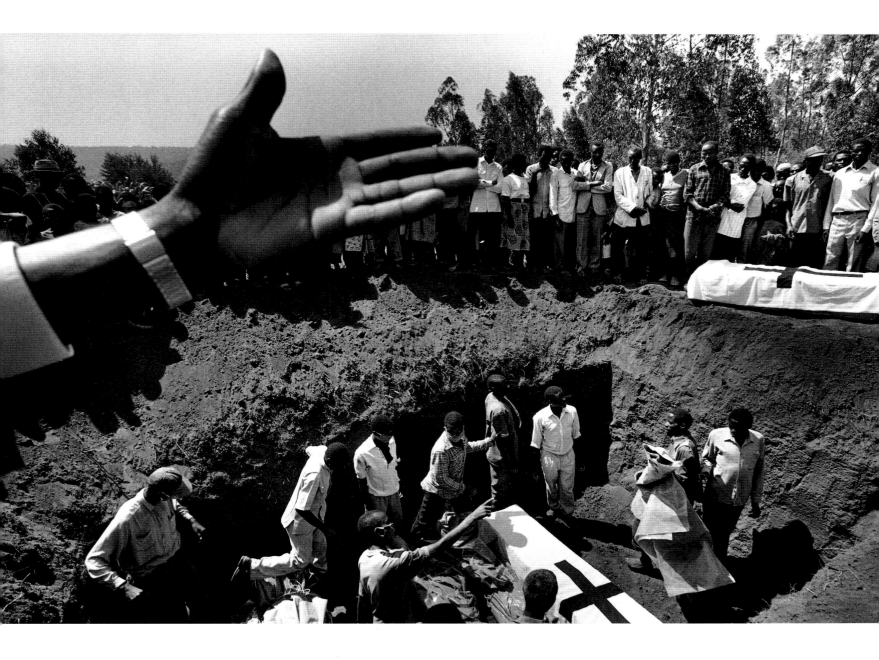

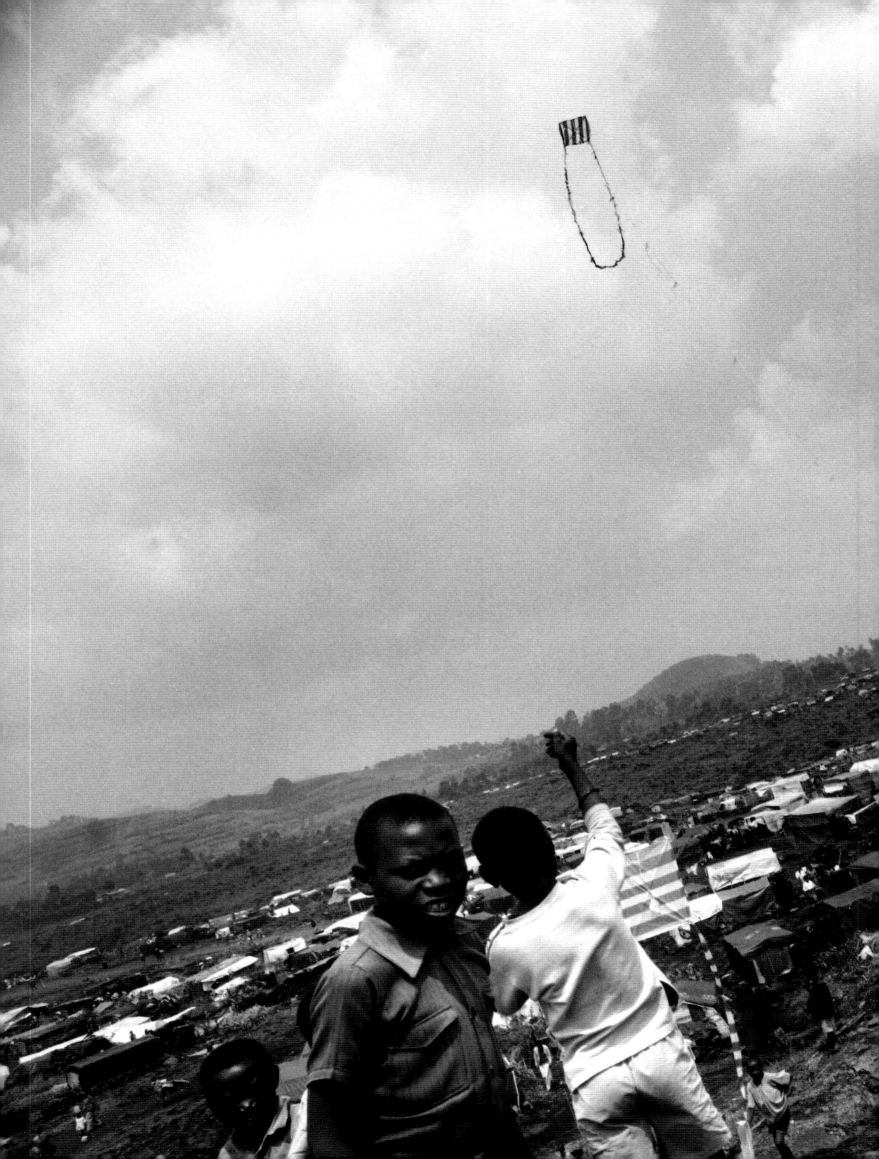

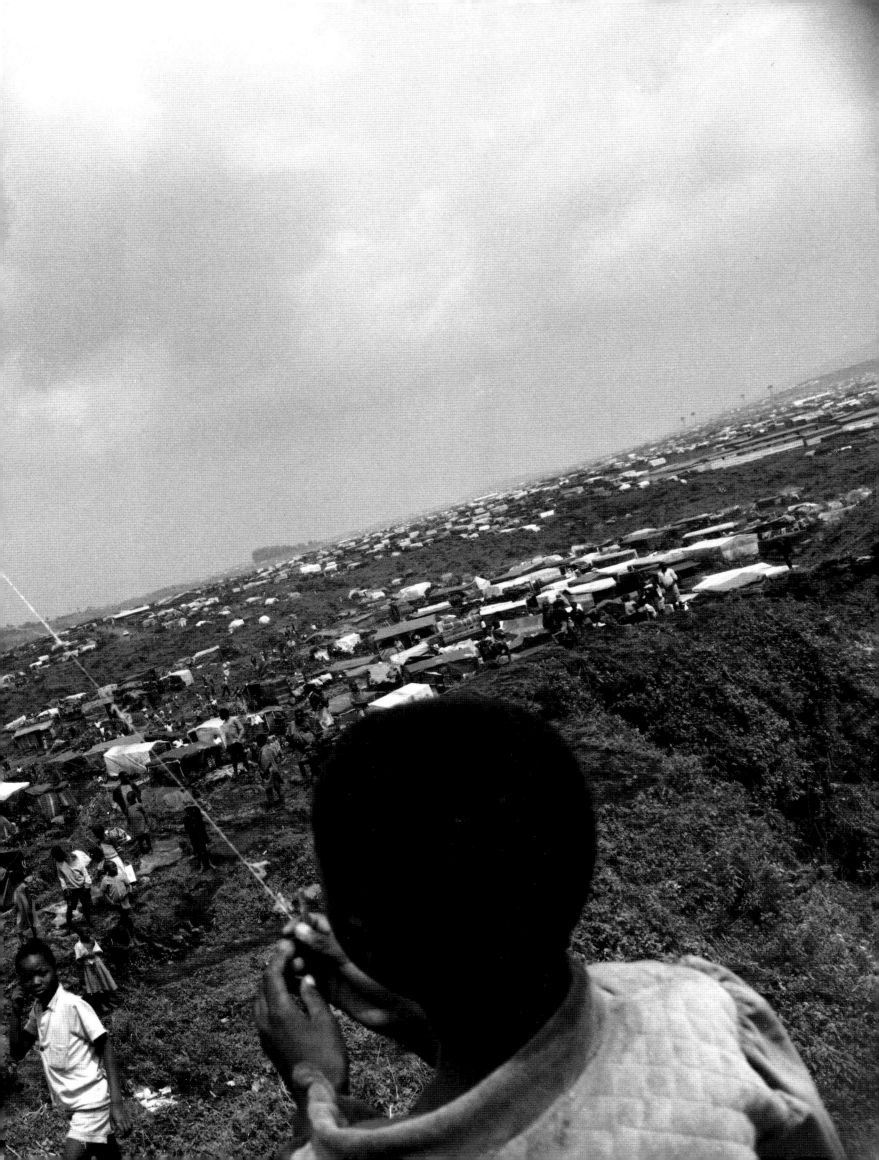

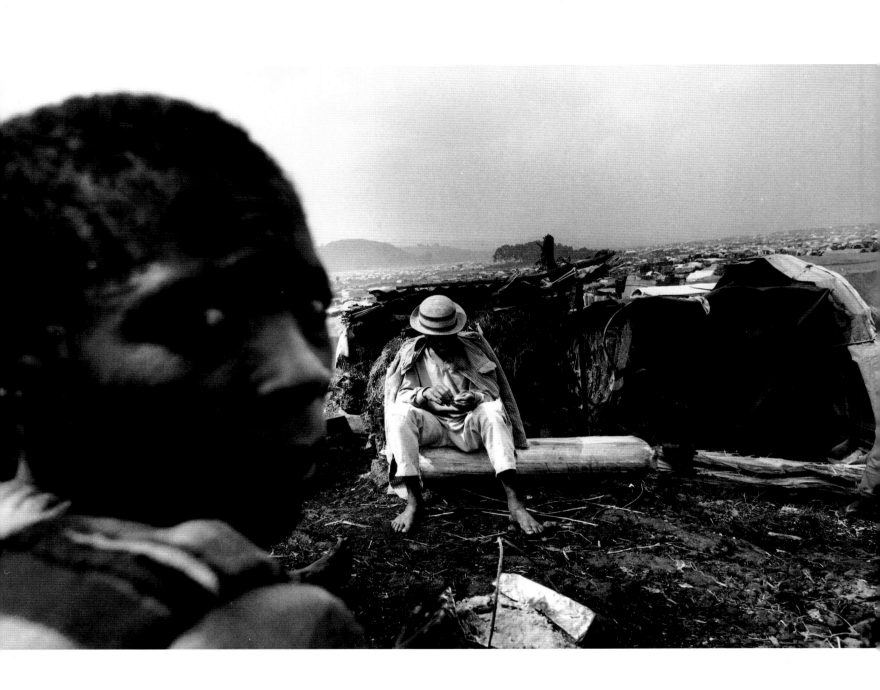

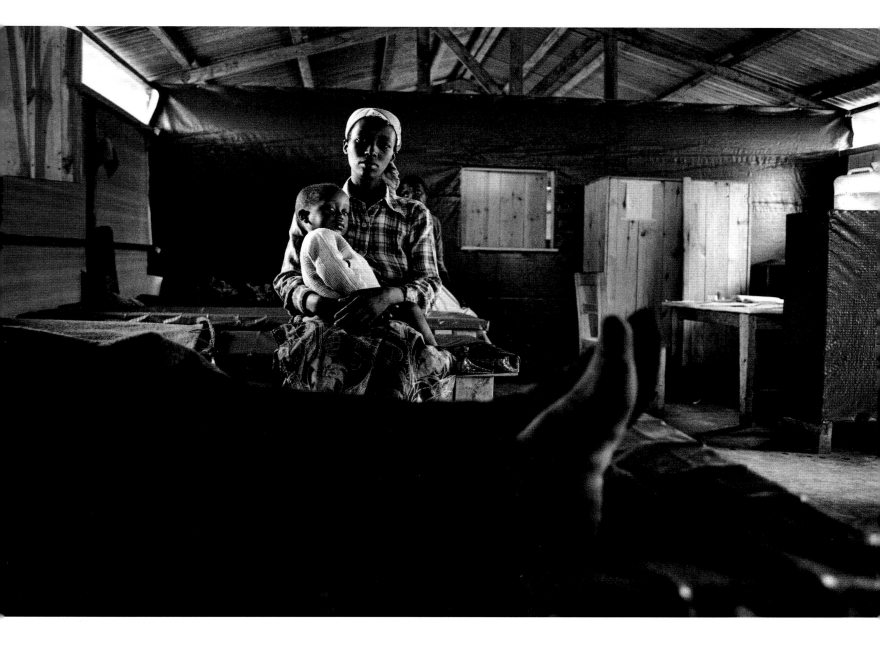

Early 19ᵗʰ century
Caucasian peoples resist Russian territorial advances. The fight against Russian expansionism begins. Numerous ethnic groups are eradicated. Chechnyans refuse to recognize the rule of the Czar.

1922 – 1943
The Chechnyan people rise up in a series of revolts against Russian oppression and collectivization.

February 1944
Under the pretense that Chechnyans have collaborated with the Nazis, nearly the entire Chechnyan population is deported to Kazakhstan. More than 100 000 people succumb to freezing temperatures and epidemics. Chechnyan villages are leveled and their names erased from the map.

1956
Without government approval, Chechnyan survivors return to their homeland and begin rebuilding their villages. Although Moscow agrees in 1957 to the restoration of the Republic of Chechnya, Russian rule is maintained.

November 1990
In the course of the *Perestroika* movement a "Chechnyan National Congress" convenes and issues a declaration of national sovereignty. Congress chairman is Dzhokhar Dudayev.

October 1991
In a hastily arranged election, Dudayev wins the majority of votes cast and moves quickly to declare the Republic's independence. The former government flees. The new Russian President Boris Yeltsin and the Russian parliament disagree on the proper course of action. Chechnya's independence is not recognized by Russia.

1992 – 1994
Moscow applies pressure to the Republic through economic blockades and threats of occupation. Economic and social problems lead to unrest and opposition to Dudayev. Moscow supports opposition efforts to depose Dudayev.

December 1994
Troops from the Russian Confederation march into Chechnya. The following years witness the bloodiest war the Caucasus has ever known. Cities are leveled, massacres of civilians force nearly half of the population to flee their homes, and no humanitarian aid reaches the area for many months. More than 50 000 people have been killed.

Late 1996
The Russian general Alexander Lebed achieves a cease-fire and an agreement to hold elections in Chechnya in early 1997. The last Russian soldiers leave Chechnya during the first months of 1997.

Wartime life, Grozny, Chechnya, 1995
Victim of a land mine in a clinic, Grozny, Chechnya, 1995
Wartime life, Grozny, Chechnya, 1995
Russian occupation troops on the outskirts of Grozny, Chechnya, 1995
Hairdresser's shop, Grozny, Chechnya, 1995
Chechnyan woman in a refugee accommodation,
Khasanjurt, Dagastan, 1995
Pediatric clinic in a refugee camp, Khasanjurt, Dagastan, 1995
Praying for the victims of war, Grozny, Chechnya, 1995
Returning to Grozny, Khasanjurt, Dagastan, 1995
Distributing aid supplies in Grozny, Chechnya, 1995
Market in Grozny center, Chechnya, 1995
Life in war-torn Grozny, Chechnya, 1995

# CHECHNYA

## NO WAR, NO PEACE

**Photographed by Russell Liebman in July 1995**

The campaign of Russian troops against Chechnya's independence movement had a particularly brutal impact on the civilian population. More than 50 000 people were killed in massacres between 1994 and 1996. Cities and villages were leveled in retribution for Chechnyan resistance. Nearly half a million people were forced to flee their homeland. No humanitarian aid could be brought into the region for many months.

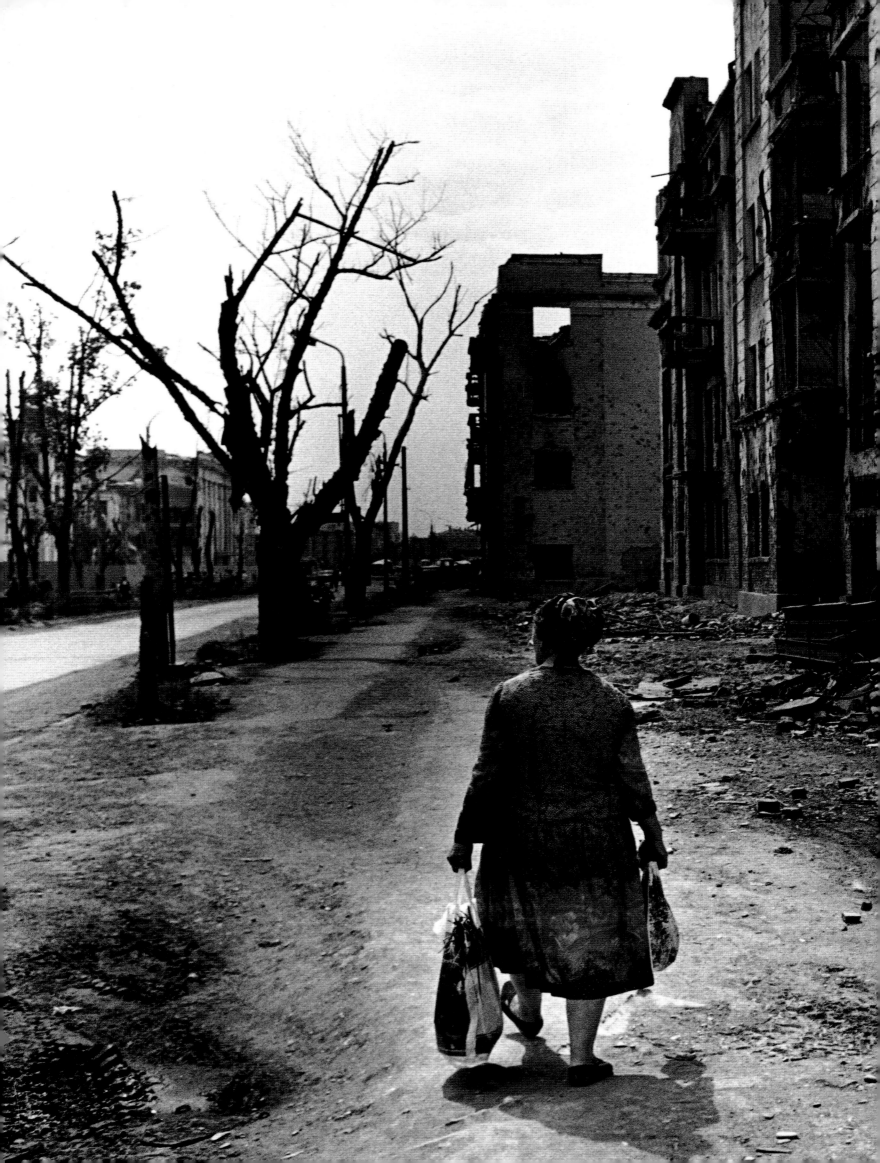

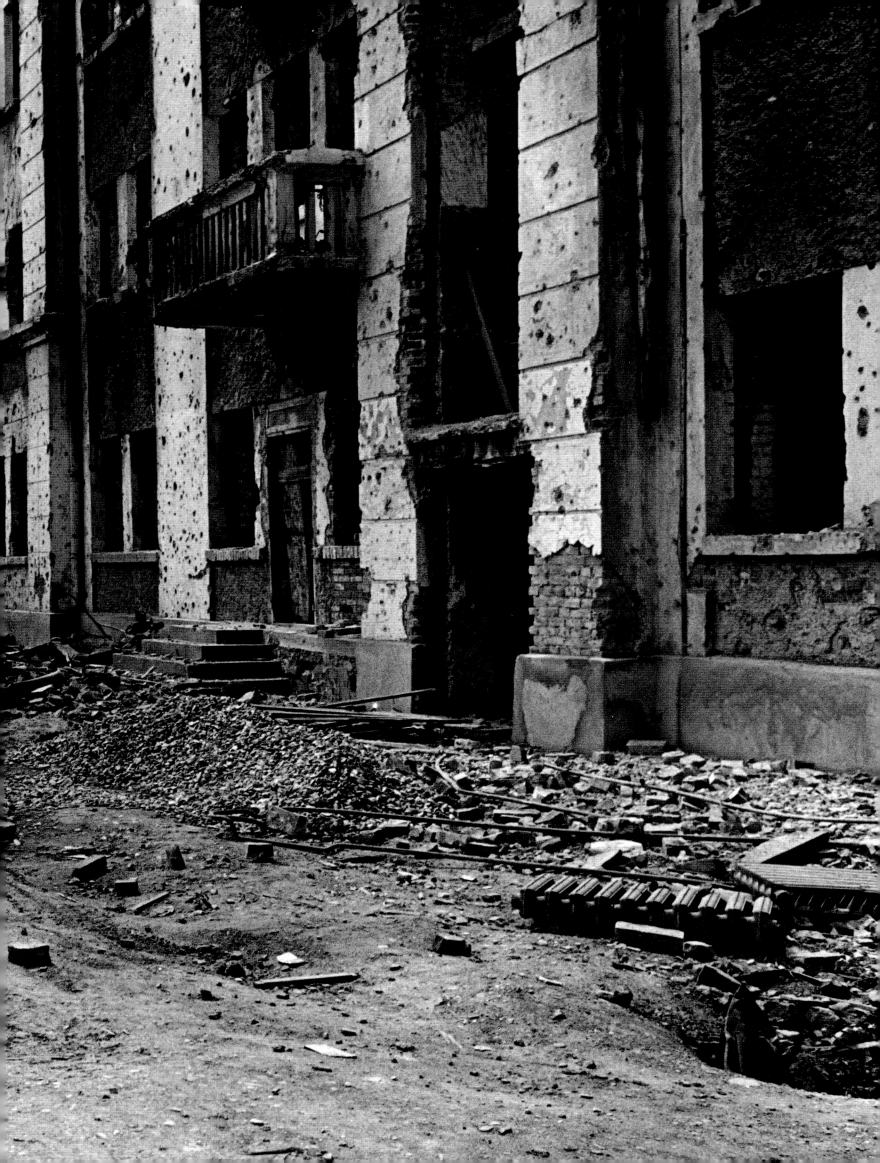

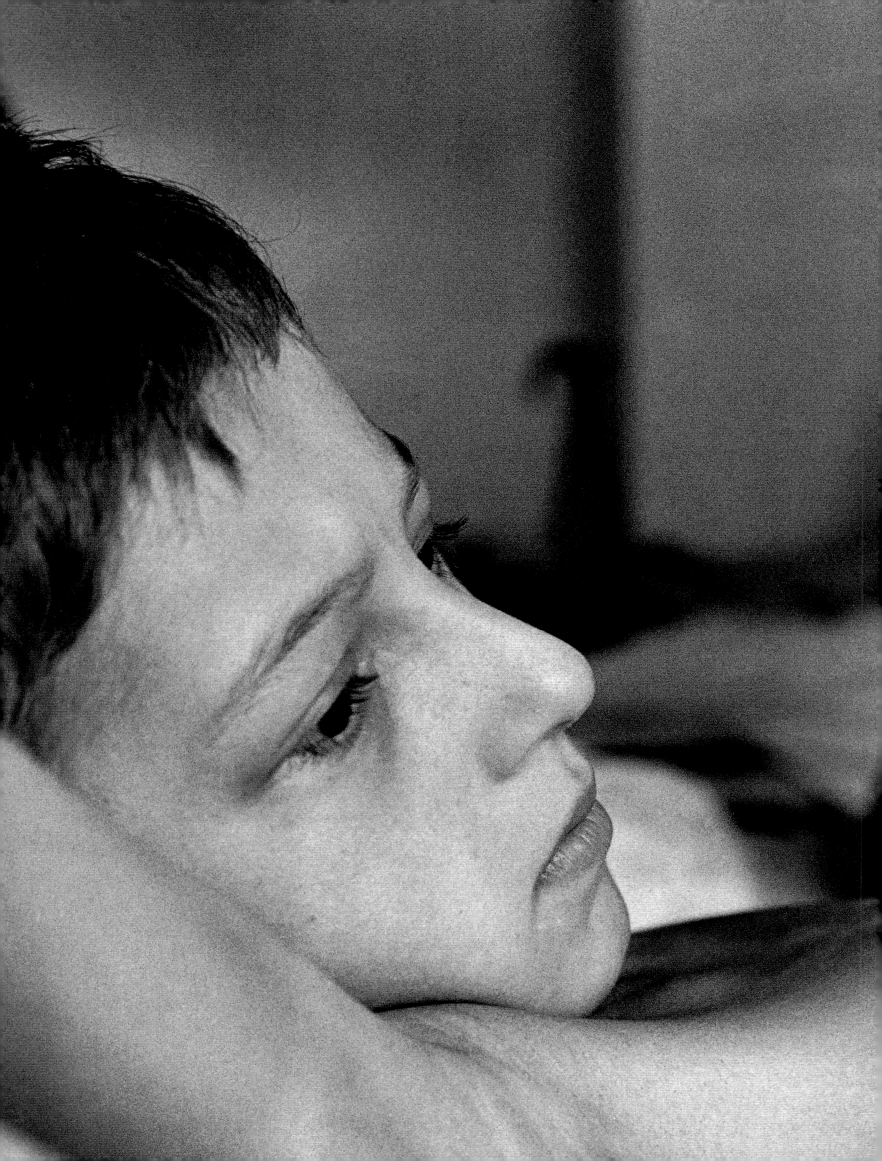

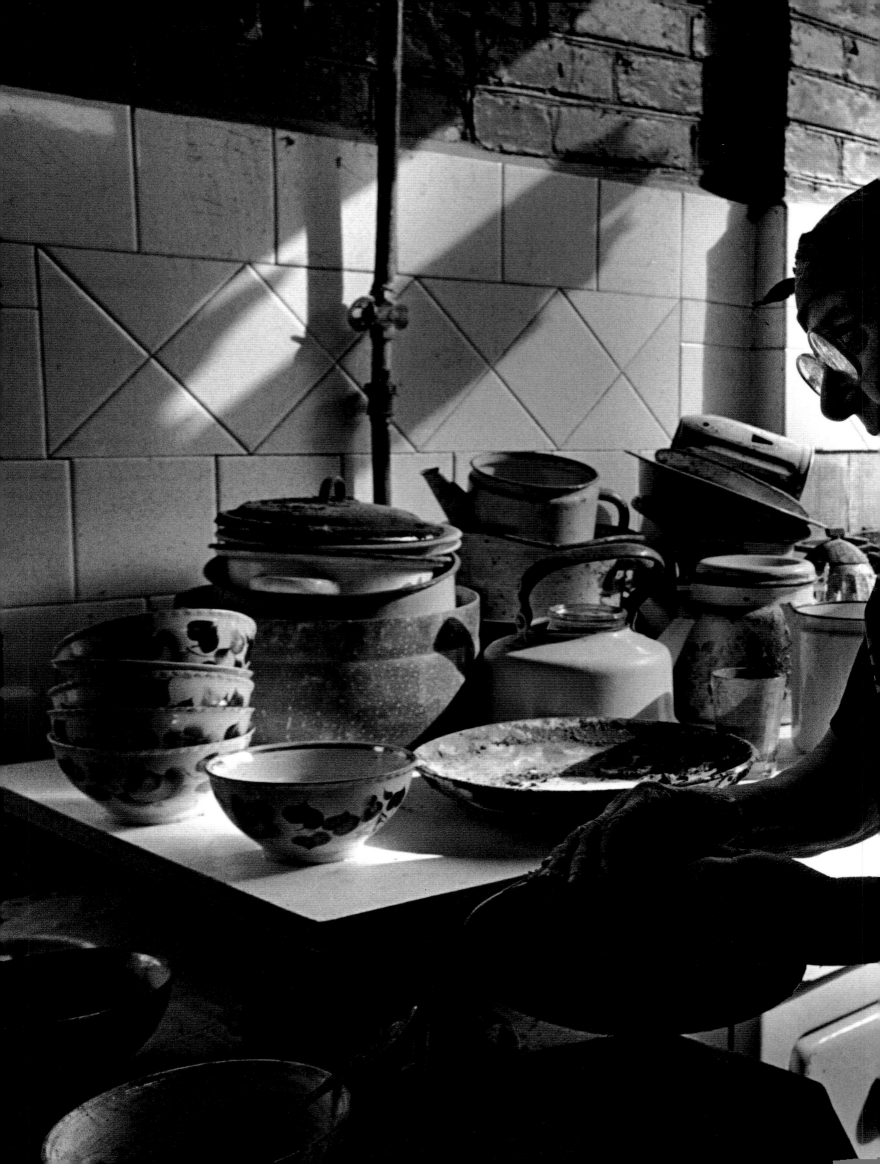

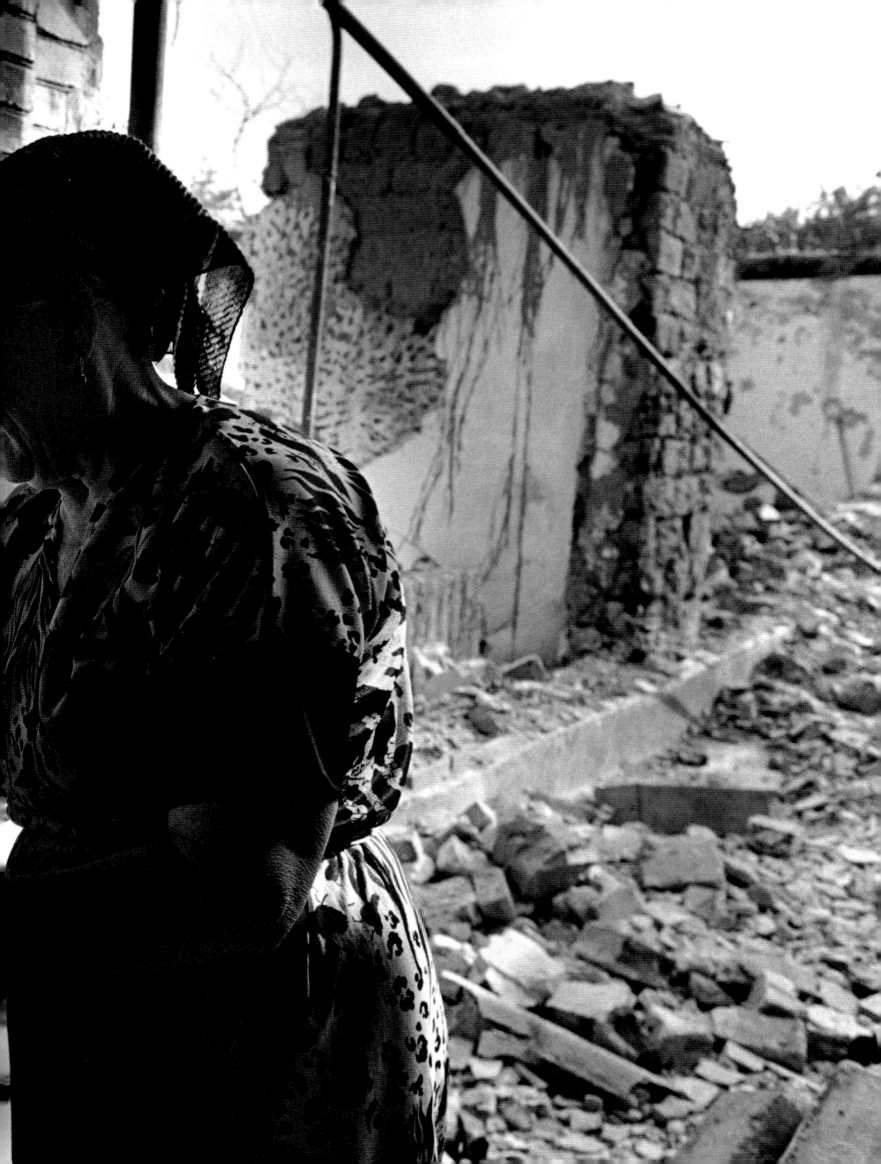

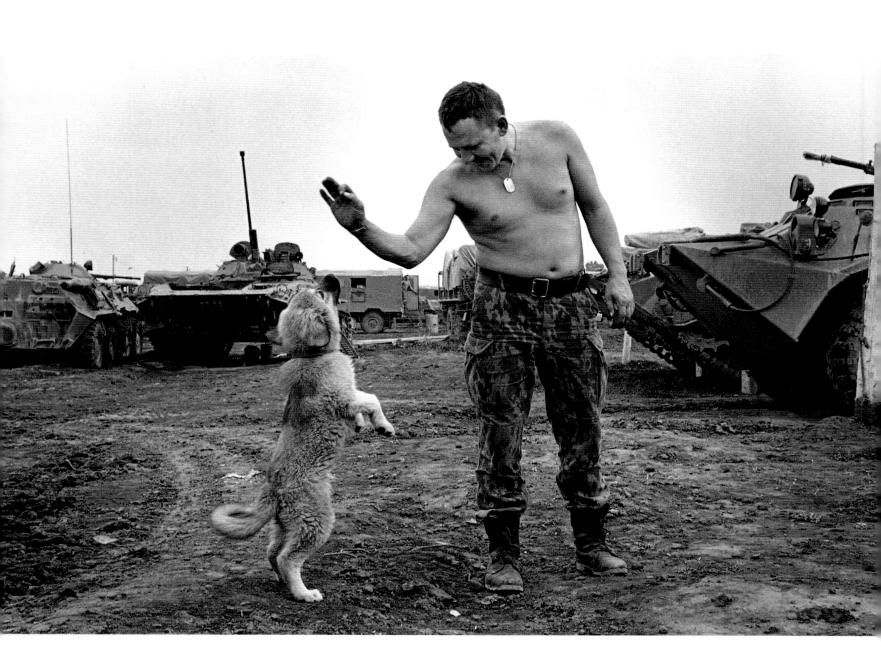

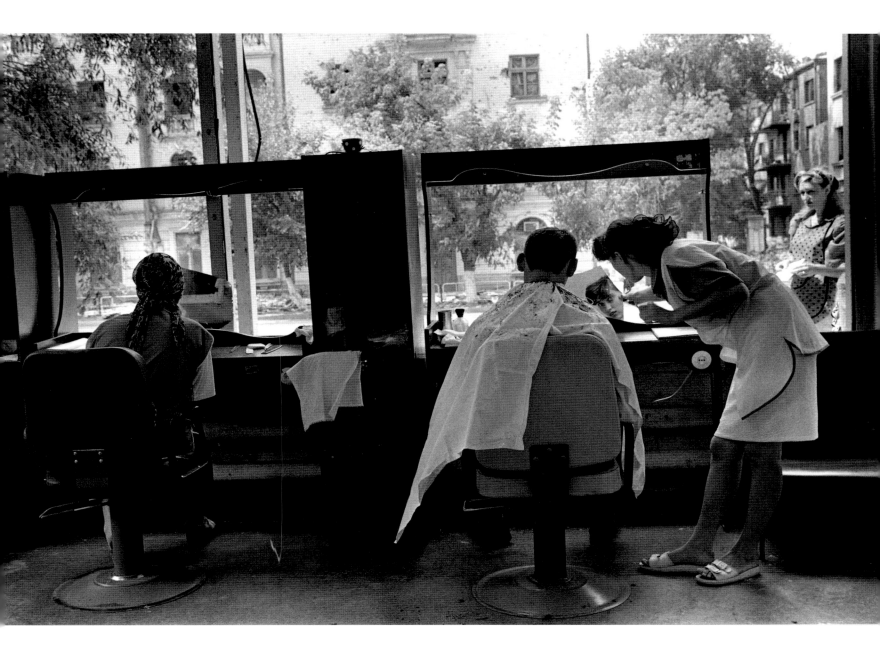

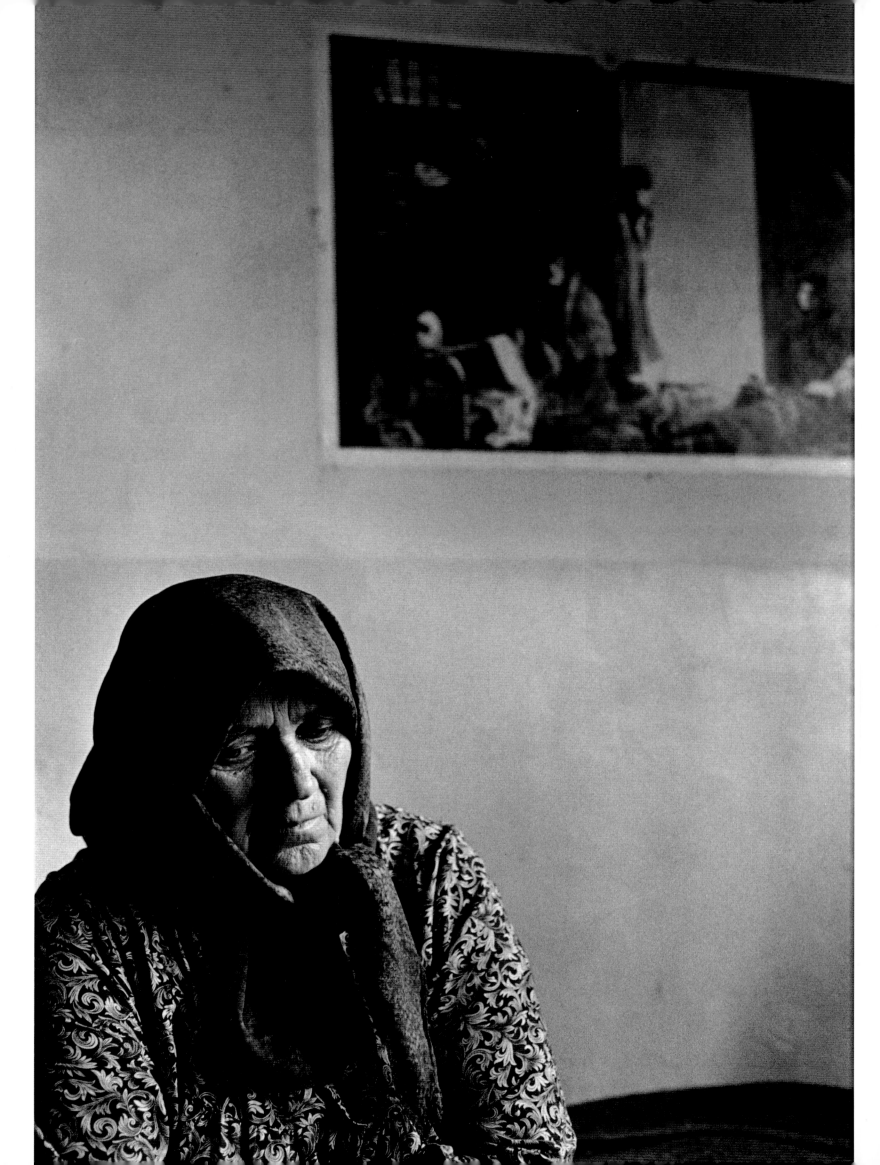

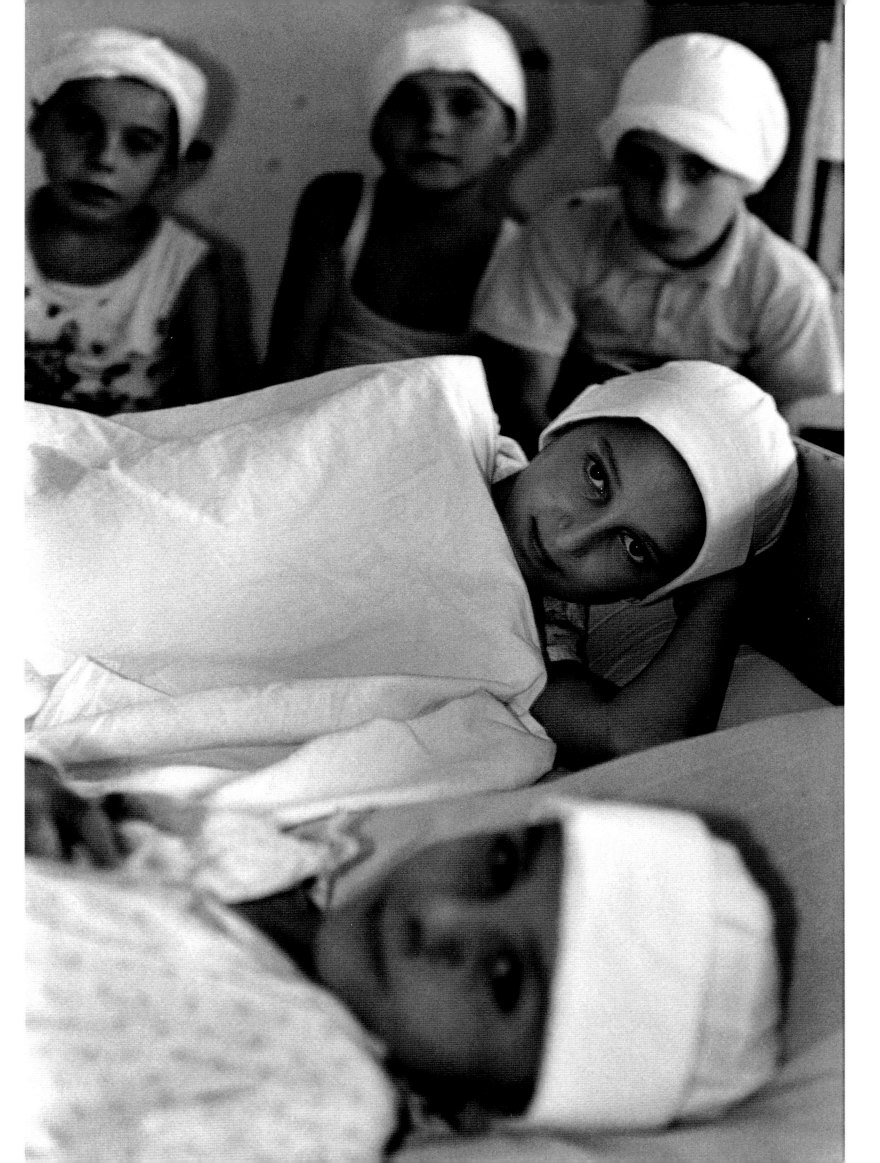

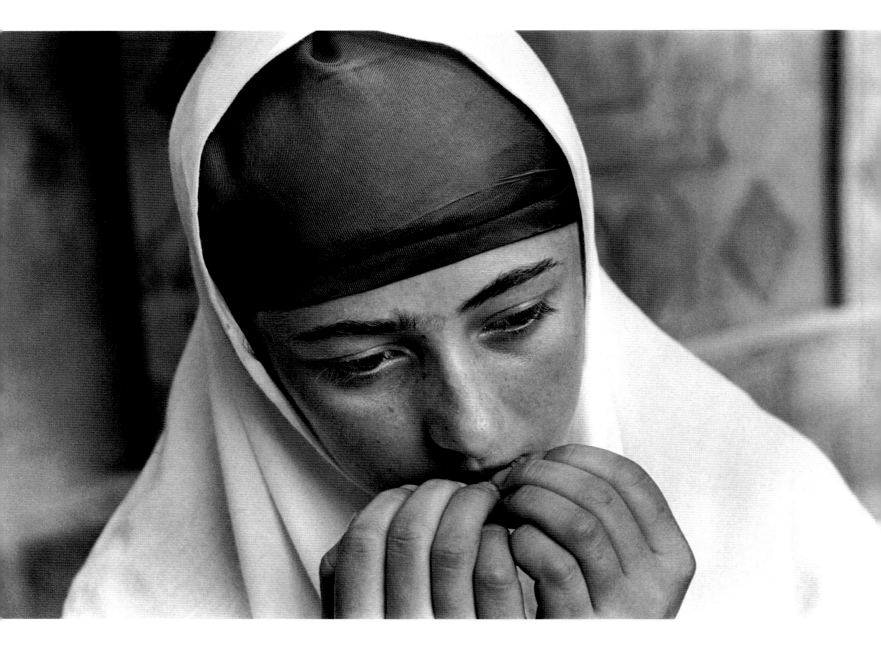

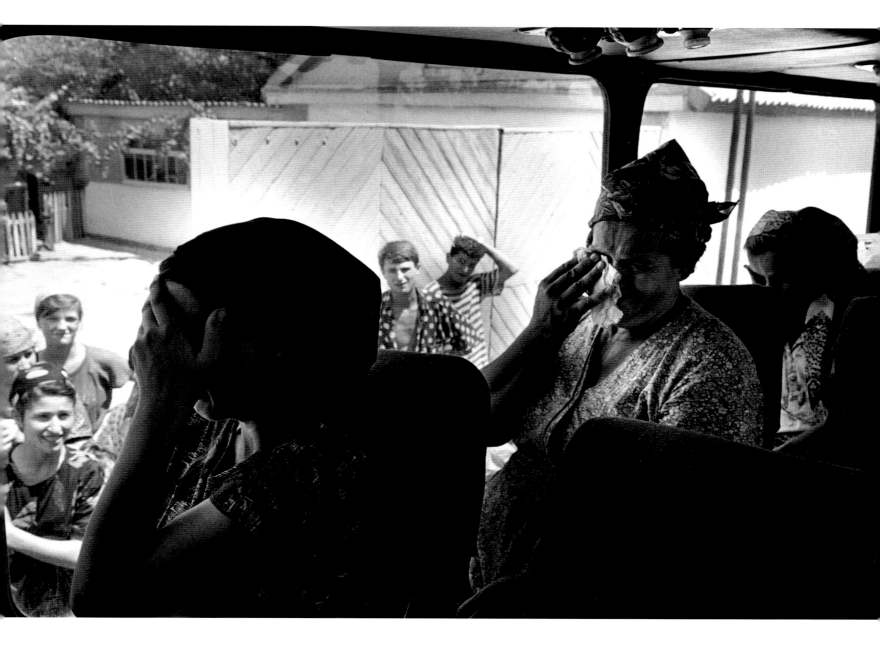

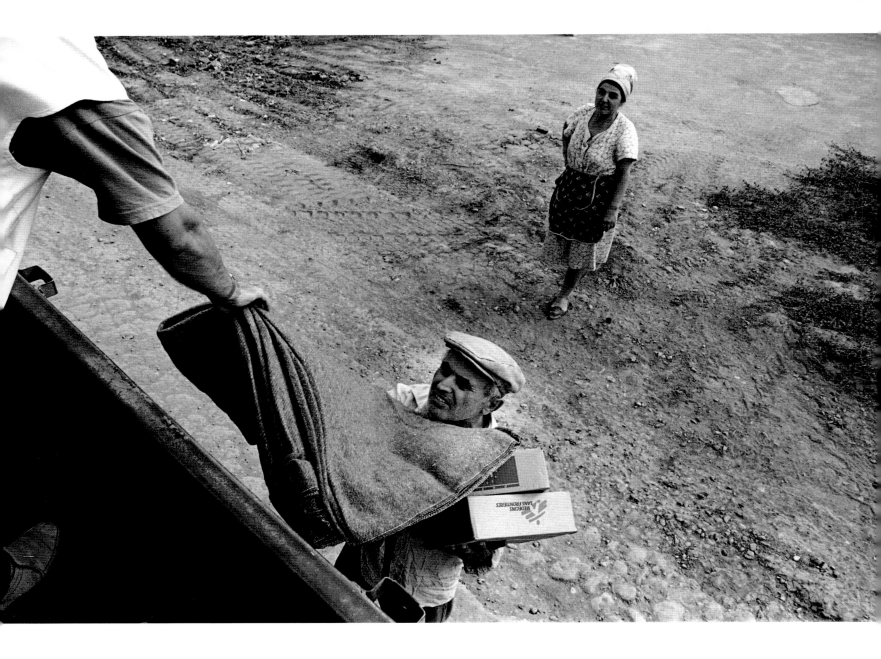

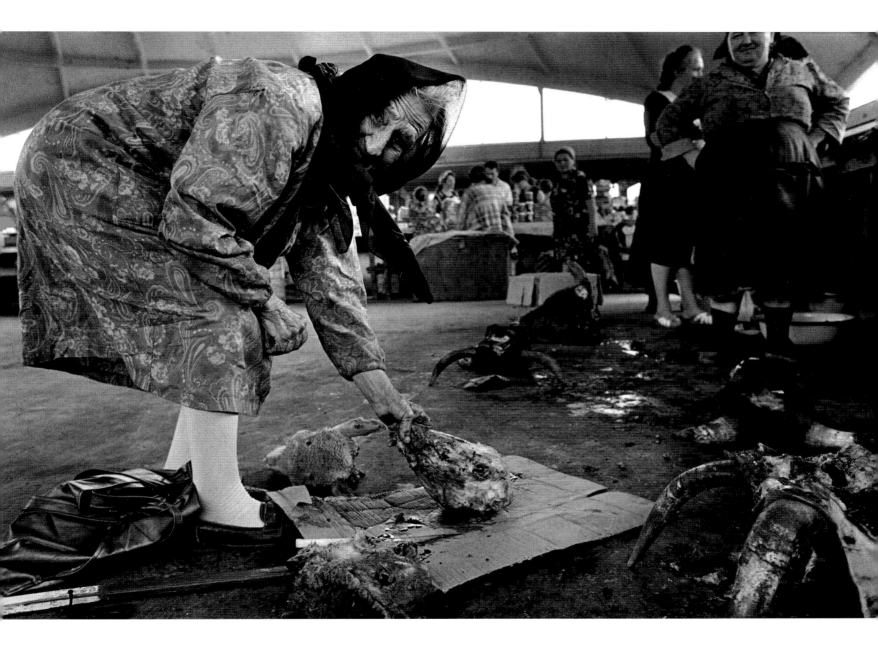

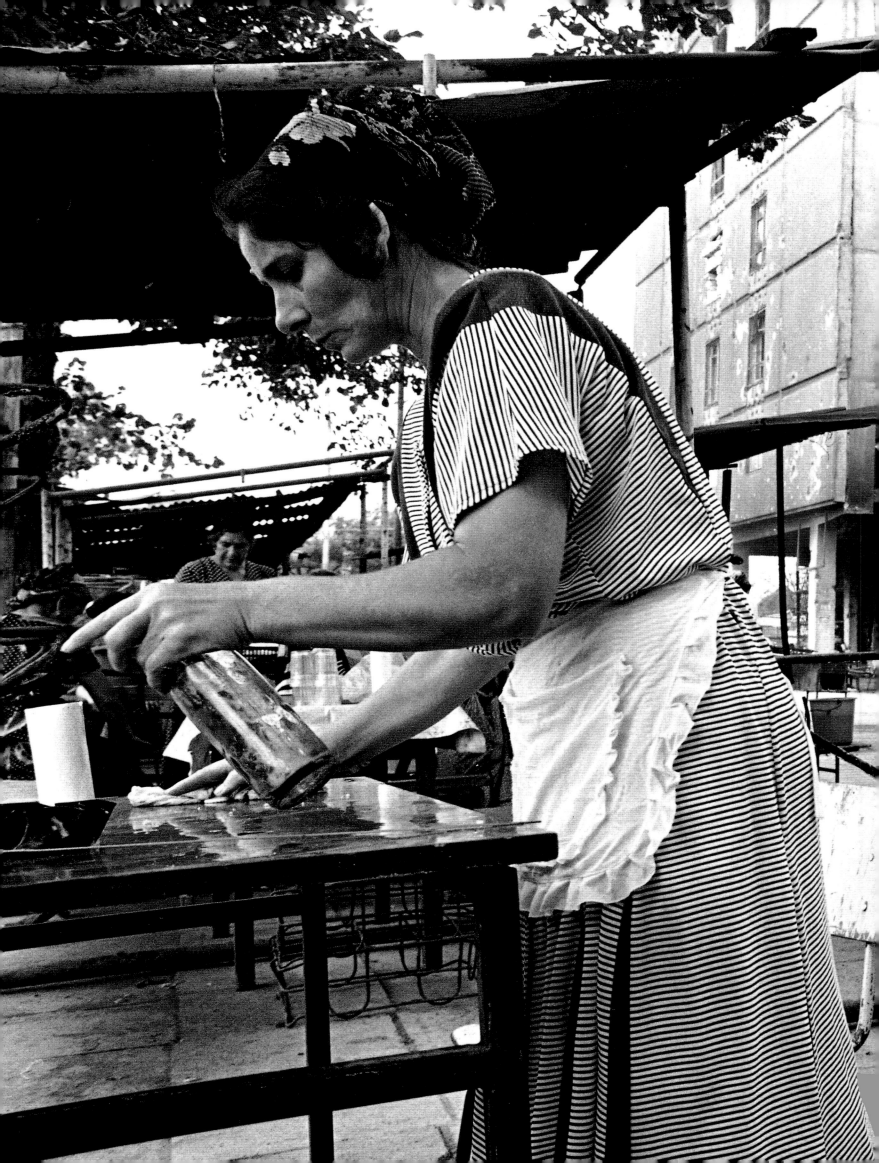

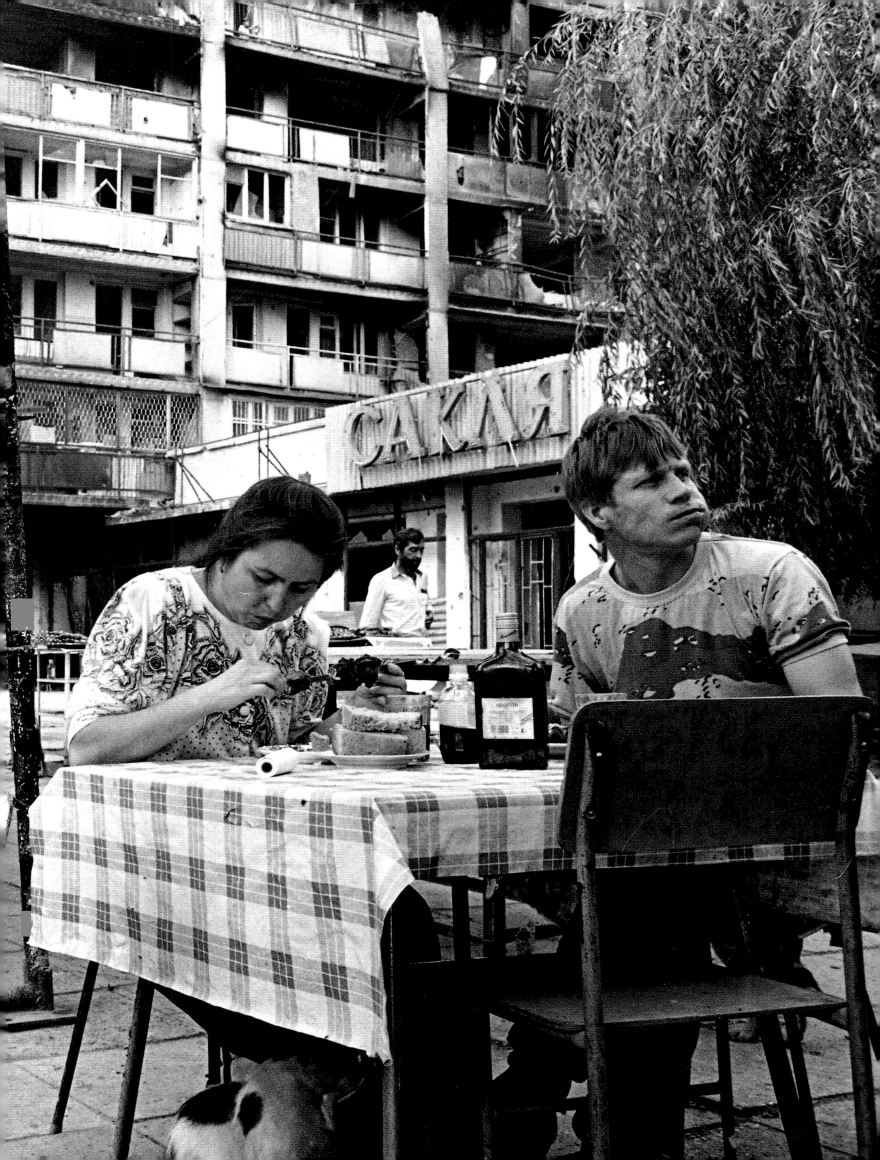

April 1980

A coup led by the military officer Samuel Doe brings the centuries-old rule of Liberia's founders, descendants of former slaves from America, to an end. The new government maintains the authoritarian course set by its predecessors, however. At the same time, the new regime fosters tensions among the various ethnic groups in the country in order to gain strength from divisions among them.

December 1989

Charles Taylor, a former member of the Doe regime, organizes an uprising in the eastern section of the country with the support of the National Patriotic Front (NPLP), of which he is the founder. The consequence of the ensuing armed conflicts is the flight of thousands of Liberians into neighboring countries. By March, 60 000 people have already fled to the Ivory Coast and another 84 000 to Guinea.

July 1990

Thanks to popular support, the rebels succeed in bringing the capital city of Monrovia under their control and deposing the dictator Doe. Attempts to form a new government fail, however, due to dissension among members of the NPLF. Under this situation of virtual anarchy, government troops carry out a massacre in Monrovia, killing some 600 people. Great numbers of Liberians seek refuge in foreign embassies. Tensions are not eased until the arrival of a peace-keeping force formed by west African countries.

March 1991

The civil war spreads into Sierra Leone as troops loyal to Taylor move into that country, contributing to the establishment of a rebel movement. The rebels carry out frequent attacks on government troops and villages in an effort to gain control over the substantial reserves of gold, diamonds and ores. The spread of violence forces nearly 70 000 Liberians to flee back to their homeland or into Guinea. Another 120 000 citizens of Sierra Leone flee to Liberia as well.

August 1995

The seven warring parties sign a peace treaty in Nigeria, agreeing on the formation of an interim government with representation by three rebel leaders and three civilians. More than 150 000 people have died in massacres. Eighty per cent of the population have been displaced within the country or have sought refuge abroad.

April 1996

Heavy fighting breaks out in Monrovia involving units controlled by the rebel leader Roosevelt Johnson. Johnson occupies a military installation, taking thousands of hostages, whom he uses as human shields. Armed gangs rule the streets, shooting at anyone who gets in their way. The city water supply system breaks down completely. Looters raid local hospitals.

August 1996

Warring factions agree to an unconditional cease-fire and the disarming of militia units in accordance with a peace plan worked out by the economic community of west African countries. The cease-fire is maintained in the city only, as fighting continues in the rural areas.

View of Monrovia from the unfinished National Bank of Liberia building, now being used to house refugees, Monrovia, Liberia, 1996
Refugee camp in the former Ministry of Labor, Monrovia, Liberia, 1996
Downtown Monrovia, Liberia, 1996
Unfinished National Bank of Liberia building, now being used to house refugees, Monrovia, Liberia, 1996
Peace demonstration in Monrovia, Liberia, 1996
Victim of war in downtown Monrovia, Liberia, 1996
Blind man in a refugee camp, Monrovia, Liberia, 1996
Cholera station in Monrovia, Liberia, 1996
Center for undernourished children in Monrovia, Liberia, 1996
Moving the bodies of victims of war in downtown Monrovia, Liberia, 1996
Refugee family in the unfinished National Bank of Liberia building, Monrovia, Liberia, 1996

# LIBERIA

## PEACE IN ARMS

69

**Photographed by Andreas Herzau in August 1996**

A number of rebel groups have contended for power since the collapse of the Doe regime in 1990.
The once fertile country, rich in mineral resources, is laid totally to waste in the course
of the fighting. More than 150 000 people have been killed in massacres. Eighty per cent of the population
have become homeless, forced to flee to neighboring countries or seek refuge in the cities.
Thanks to the peace treaty signed by the warring factions in 1996, humanitarian aid has become possible.

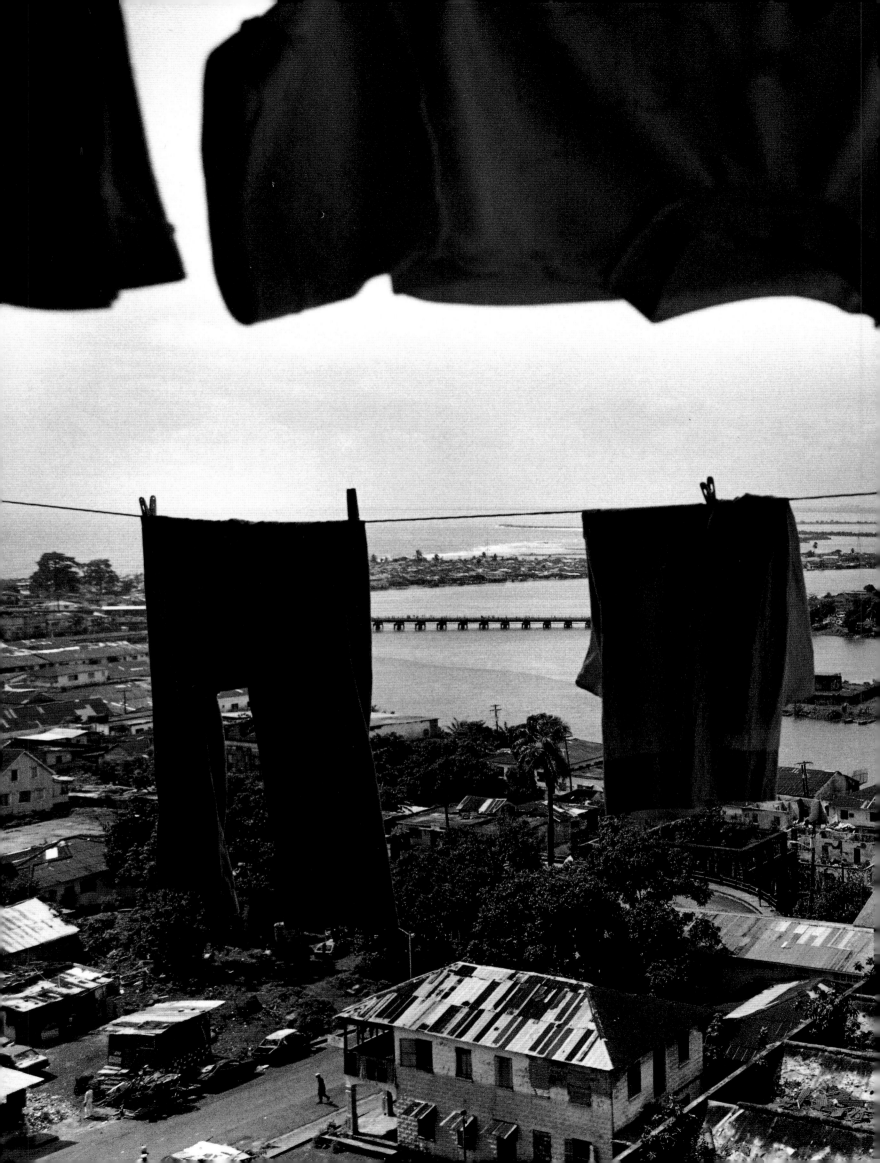

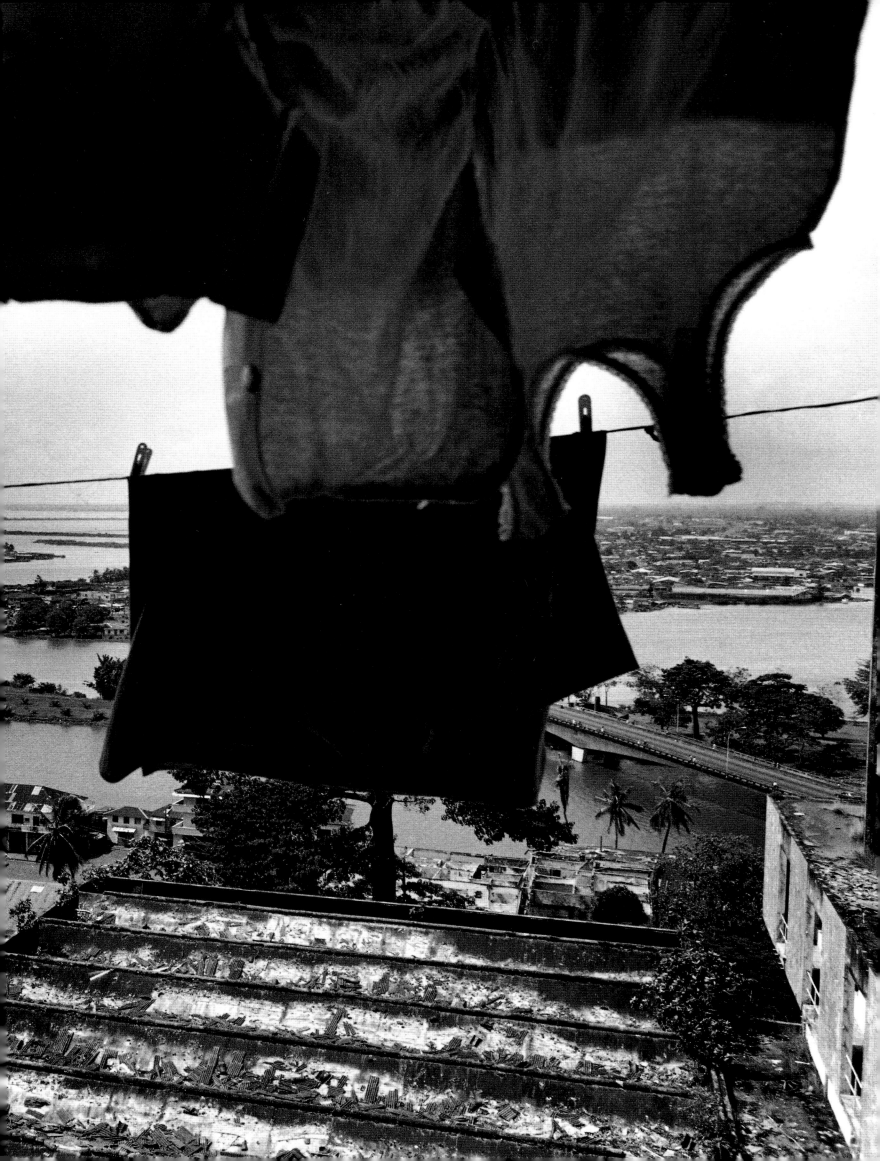

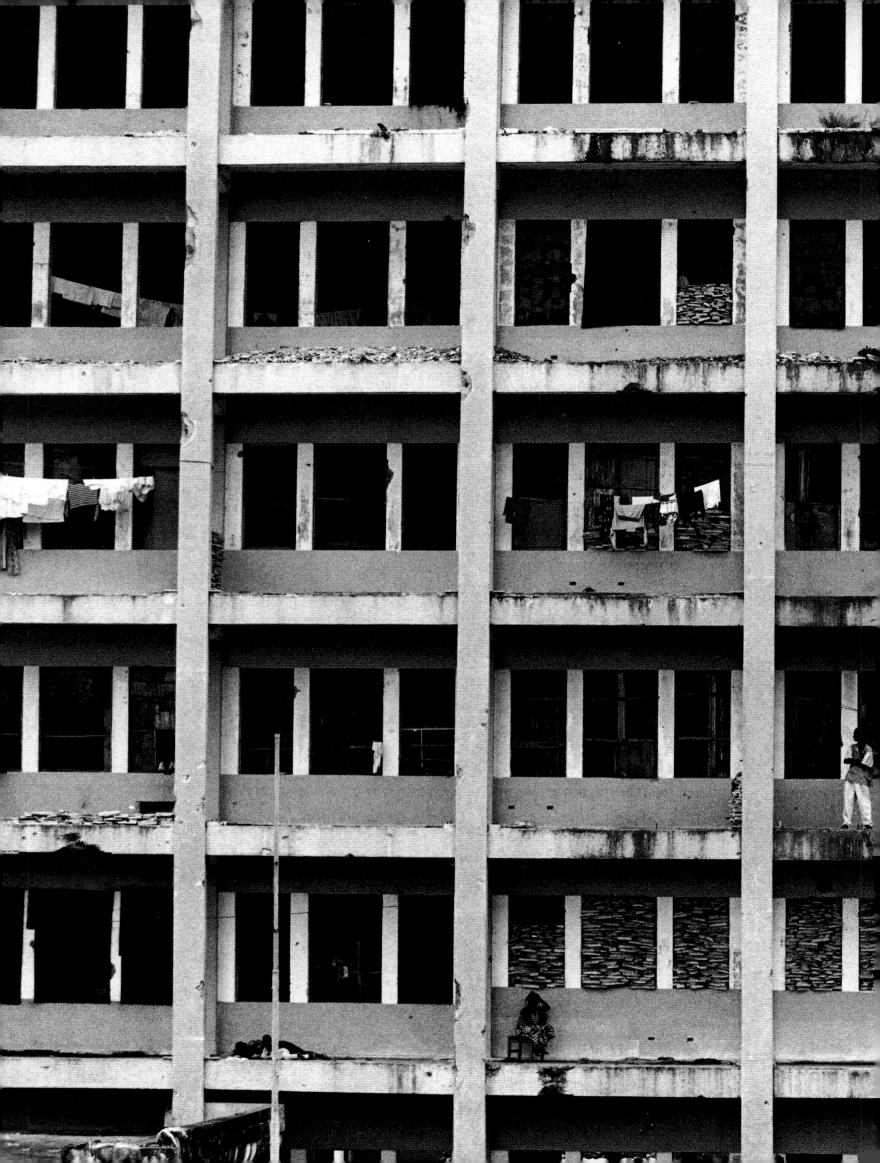

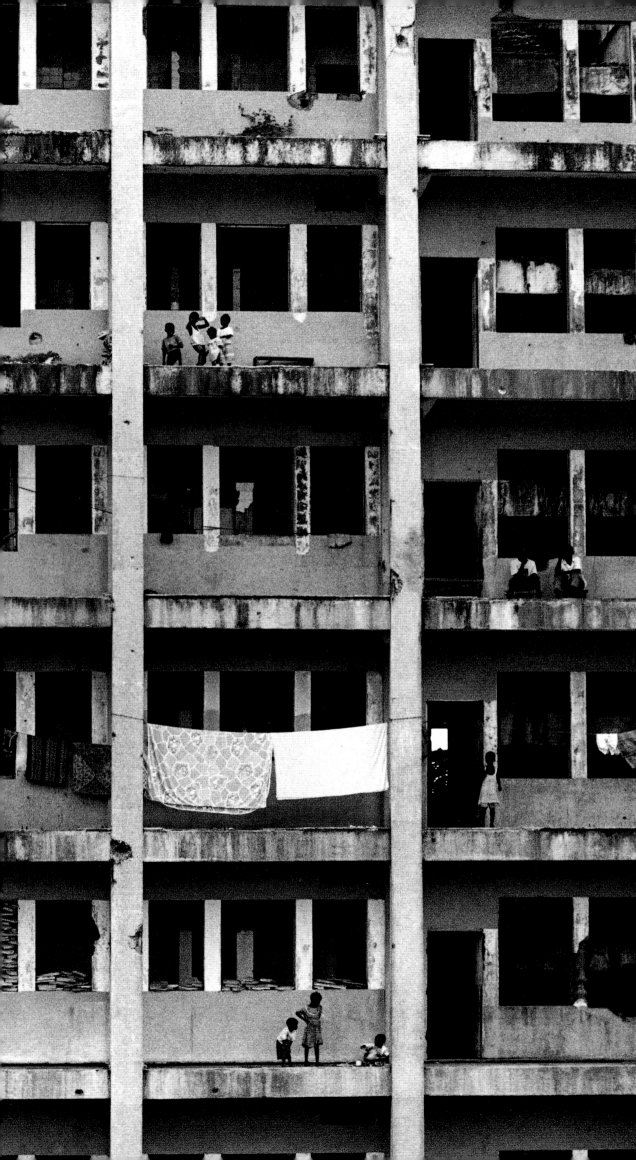

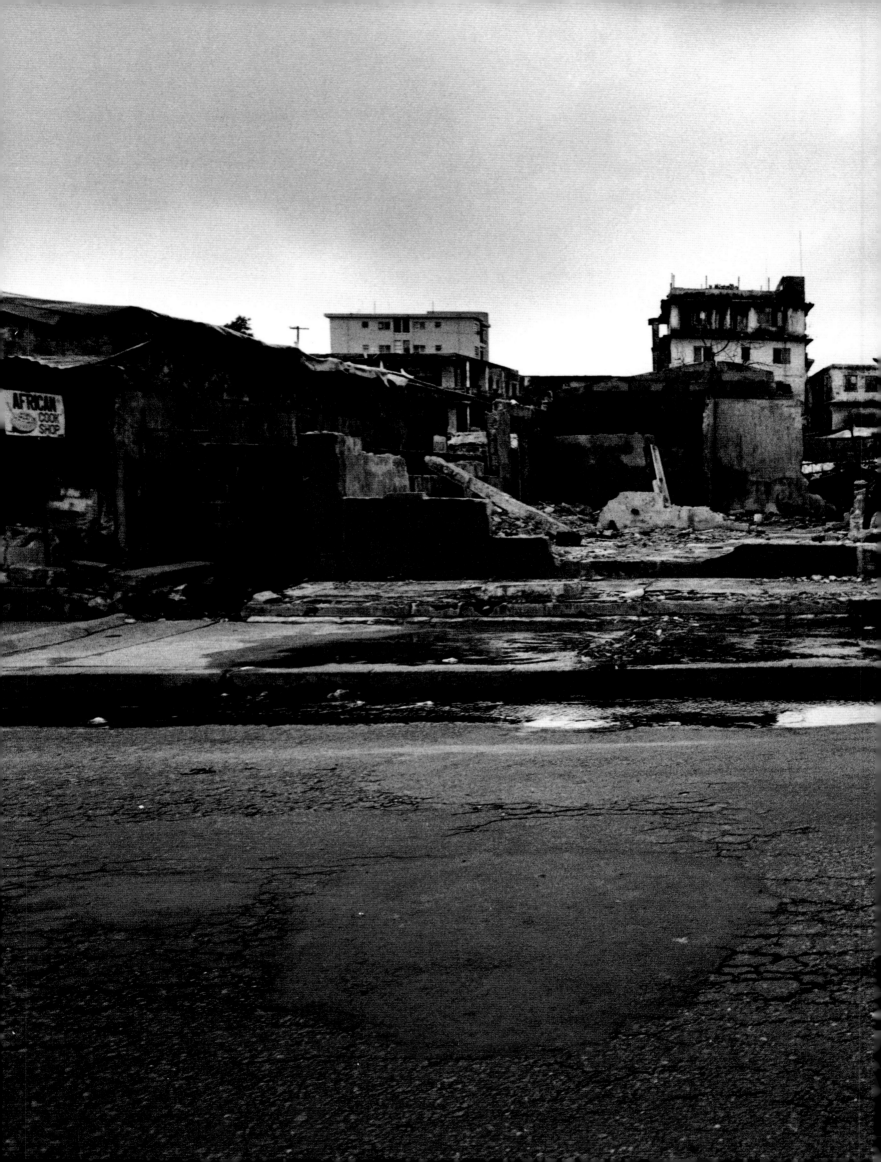

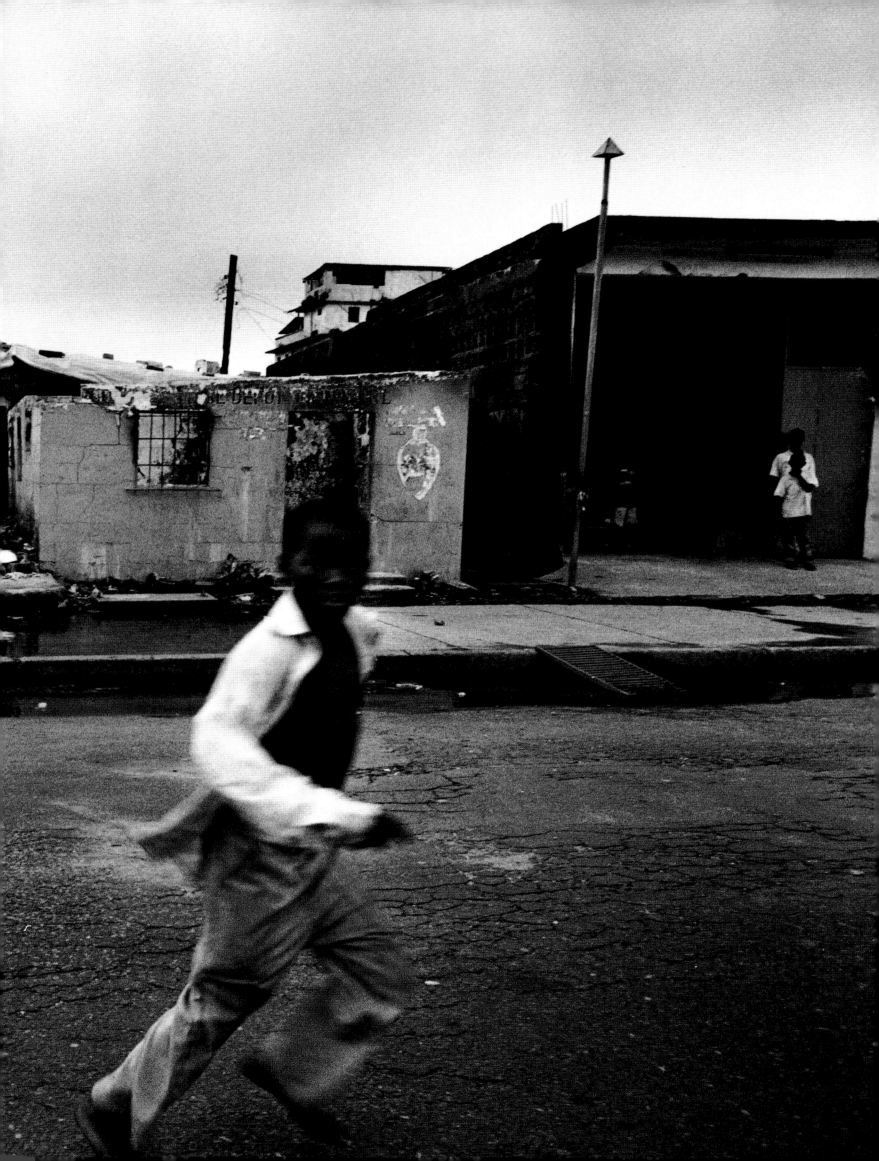

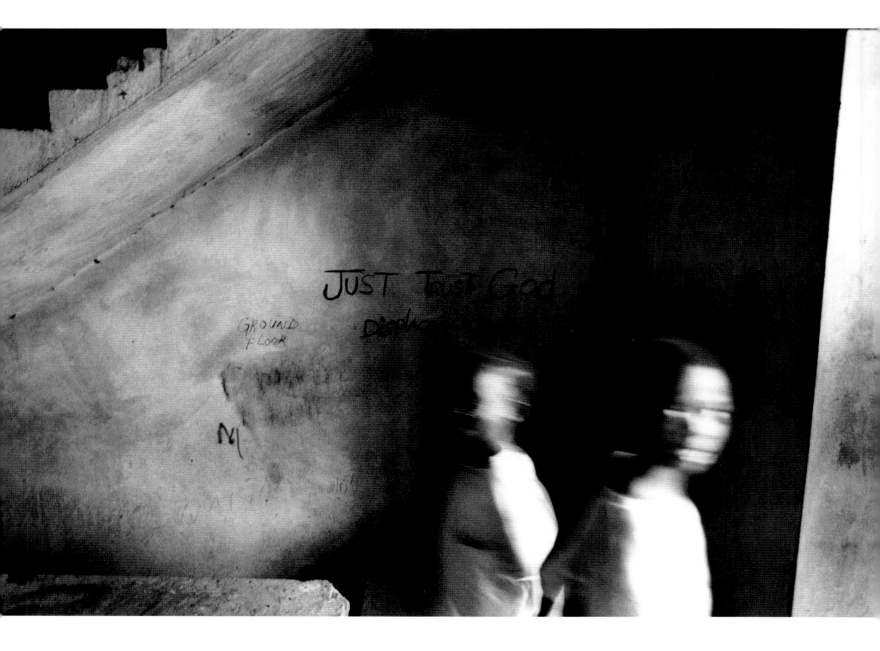

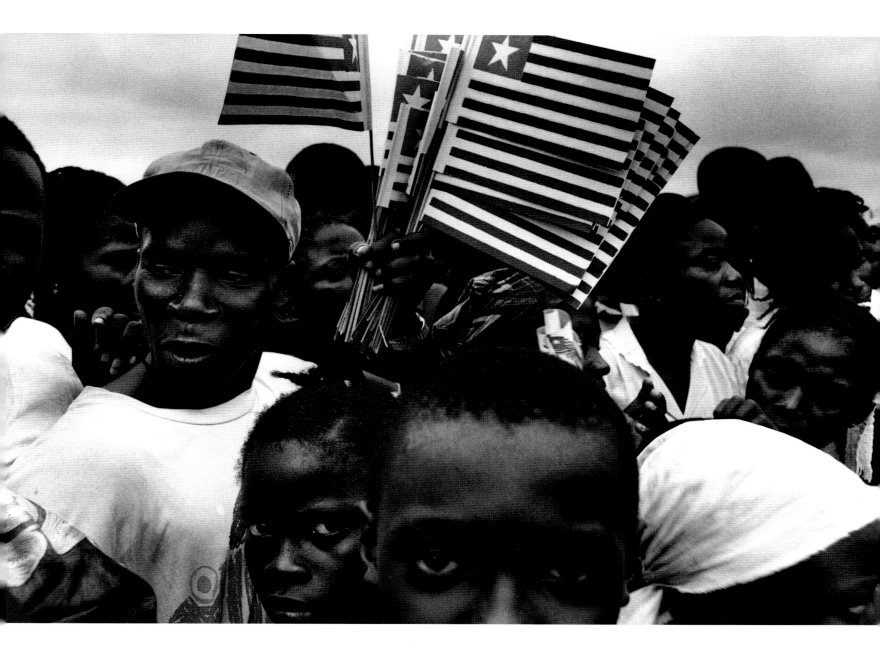

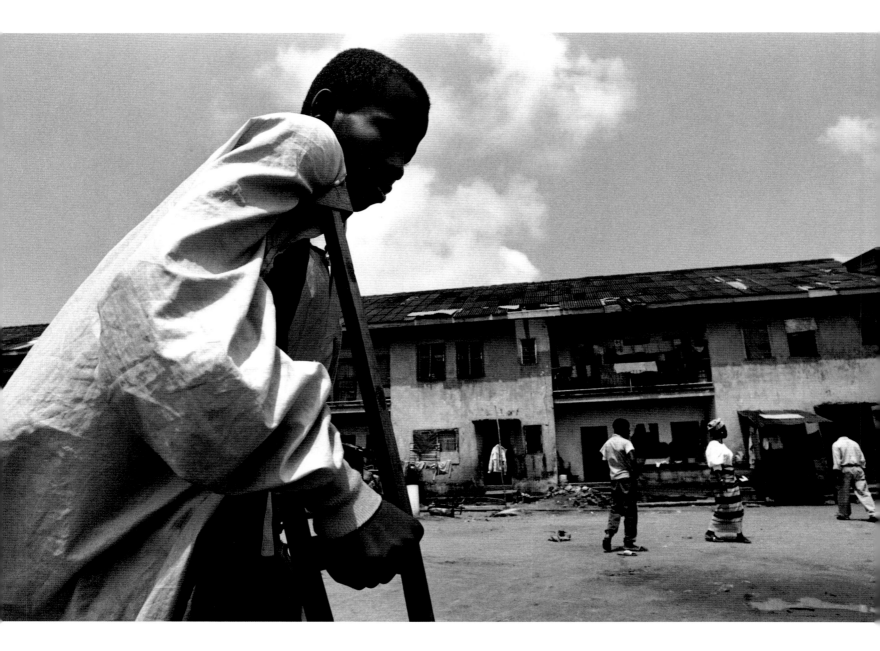

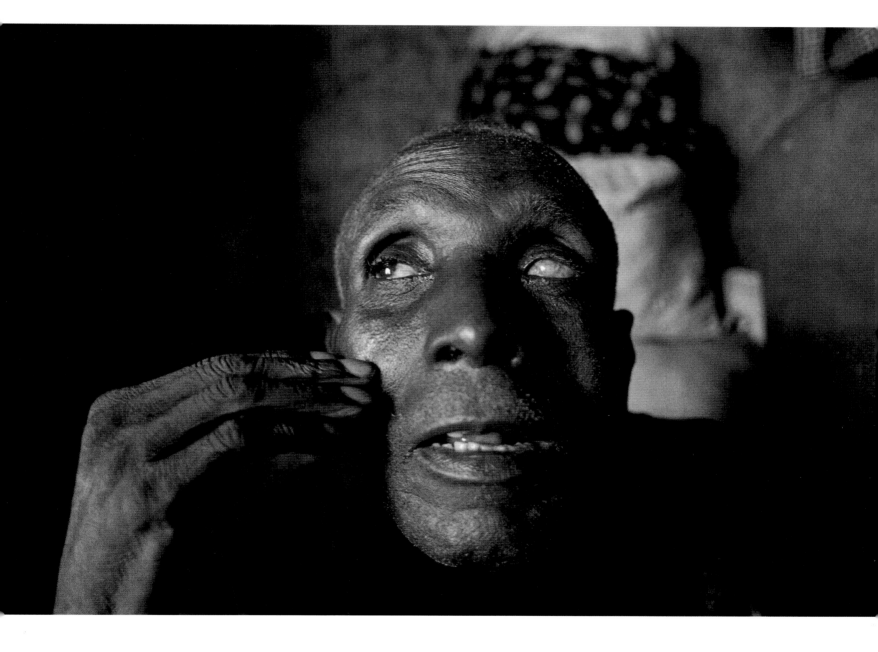

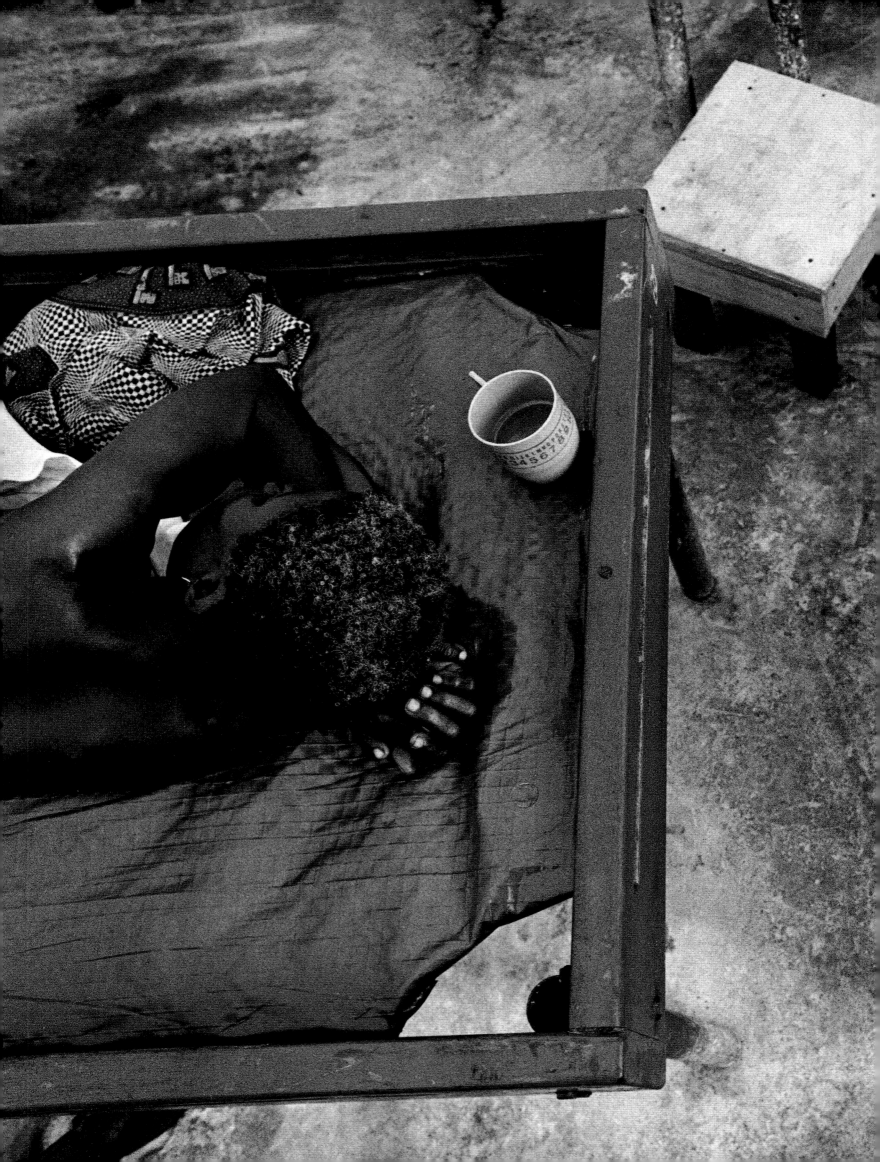

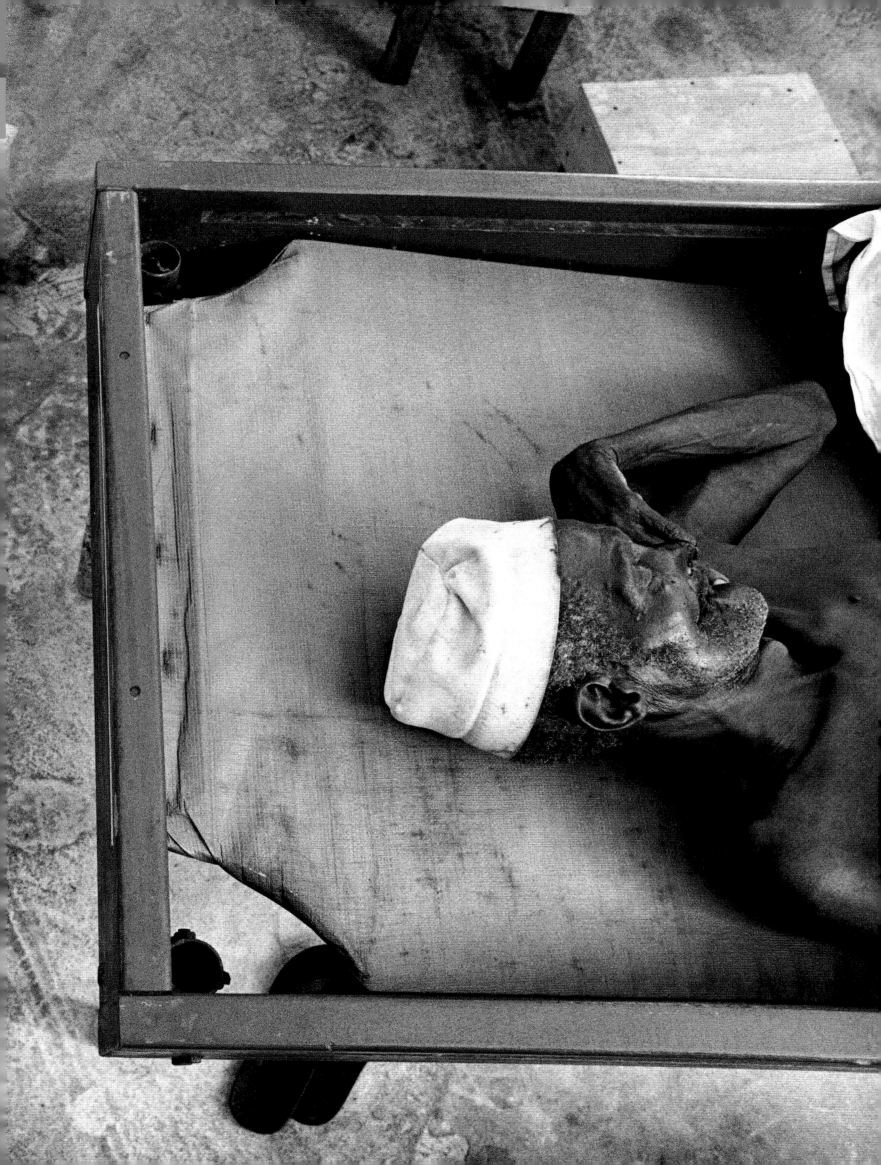

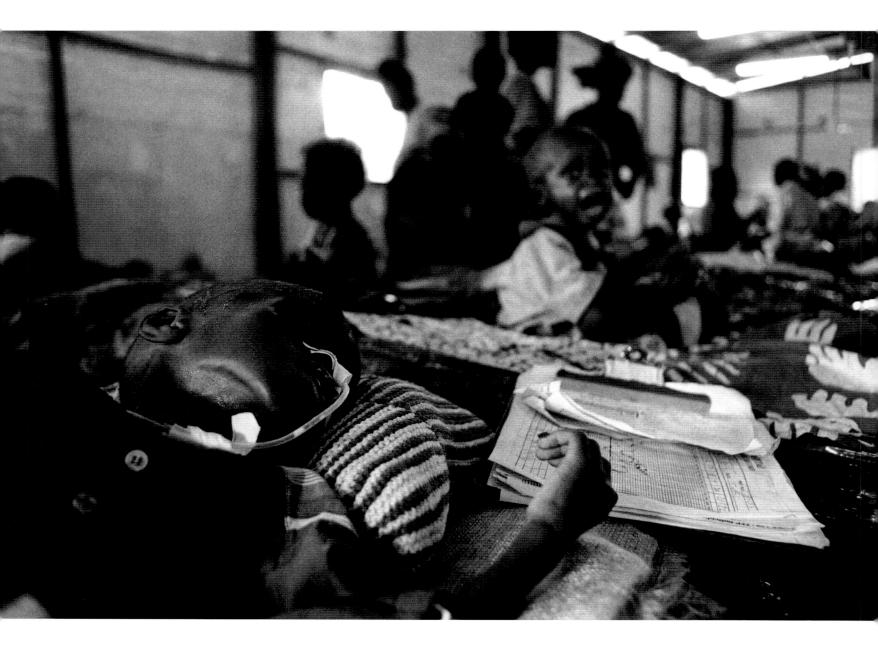

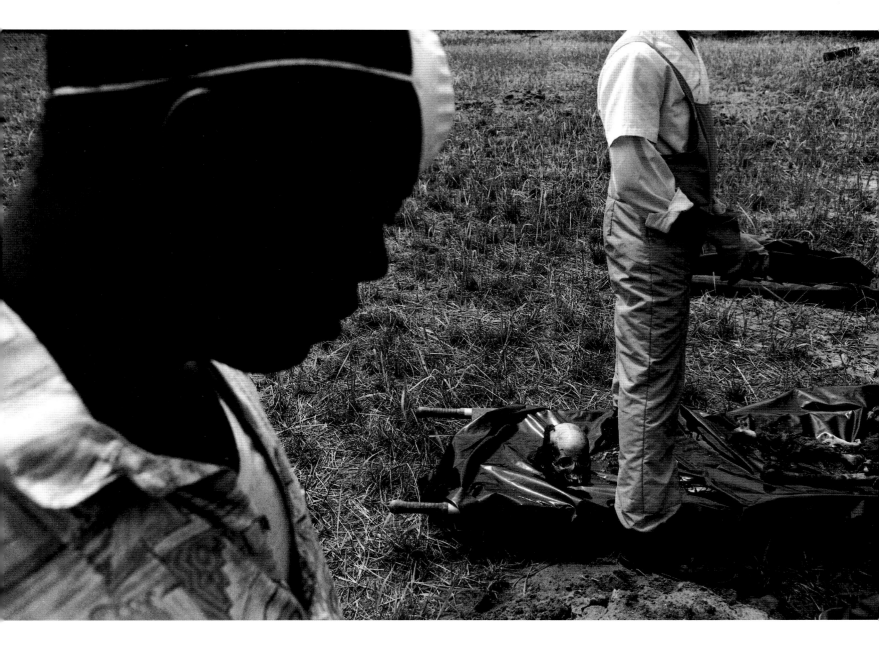

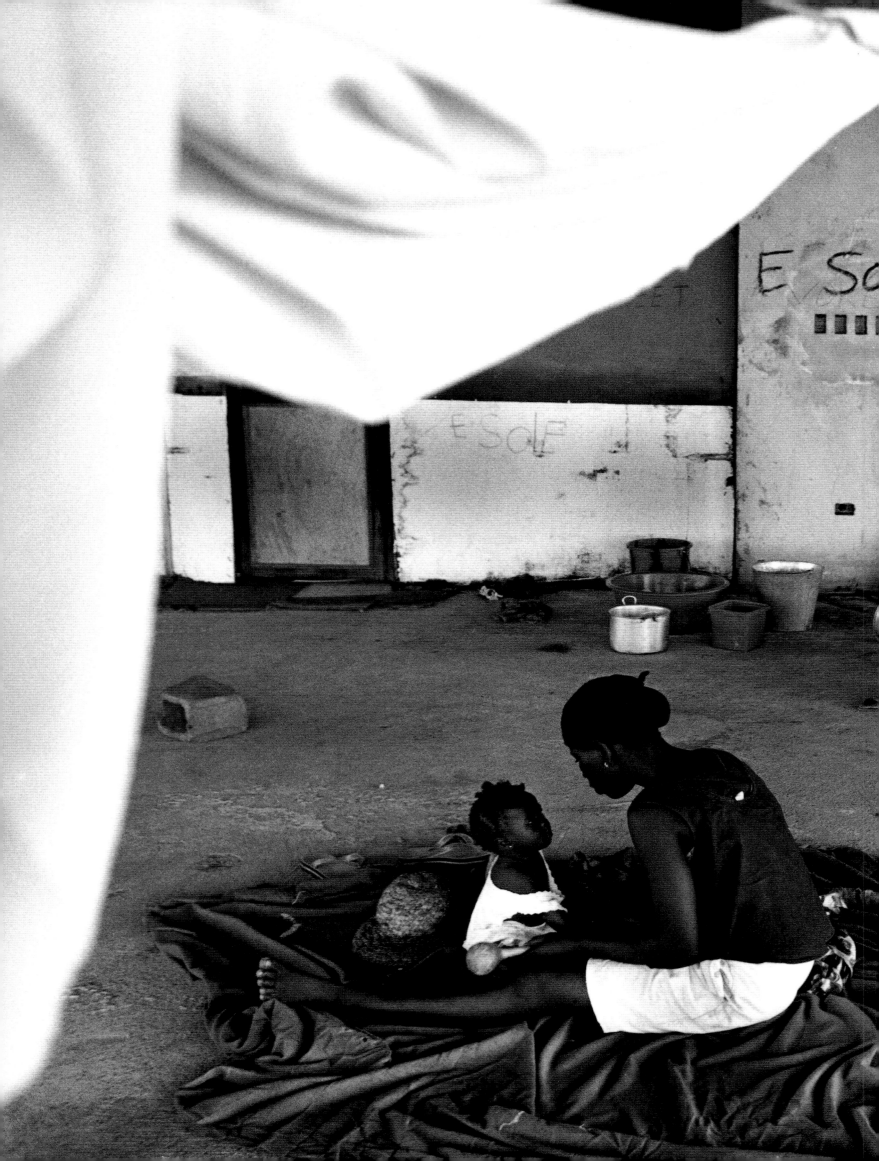

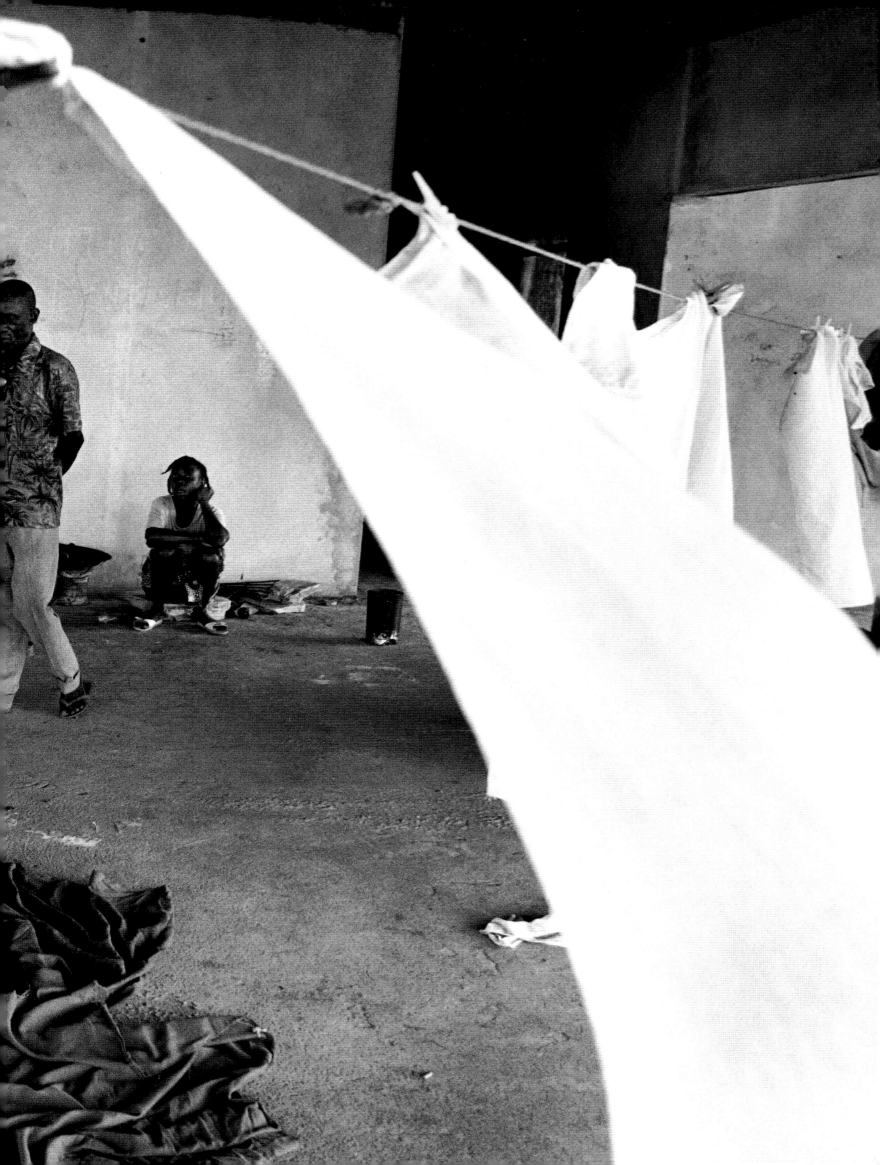

September 1990
Cuba loses its most important sources of financial aid in the wake of the demise of Communist governments in eastern Europe. The government attempts to prevent total economic collapse by rationing consumer goods, including food, cutting electricity consumption by 50 per cent and expanding its export industry at the expense of production for the domestic market.

October 1992
US President George Bush intensifies the trade embargo against Cuba, which has been in force for more than 30 years. Cuba's economic situation worsens with increasing speed. The UN Food and Agriculture Organization (FAO) estimates that significant portions of the Cuban population are suffering from malnutrition.

December 1993
Despite the passage of economic reform measures, the Cuban government maintains its fundamental socialist course. Permitted are market-economy freedoms including small private enterprises in trade, handcrafts and the restaurant business, the leasing of state-owned agricultural operations to private cooperatives and the possession of foreign currency. Nevertheless, acute shortages in food production arise. A two-class society develops, in which those with dollars are able to purchase whatever they need on the black market, while the remainder of the population wallows in misery.

August 1994
At the height of the supply crisis, social unrest accelerates in Havana. Embassies are occupied by Cuban citizens. Fidel Castro orders a temporary opening of Cuba's borders, triggering a mass exodus to the US. More than 30 000 Cubans leave their homeland by sea. The US modifies its immigration policy for Cubans and sends refugees to internment at the US naval base at Guantanamo. At the same time, the US government intensifies its sanctions against Cuba despite UN condemnation of these measures.

October 1994
Free farmers' markets are permitted again in Cuba. Price remain very high, however. Two kilograms of meat or four kilograms of flour and one liter of oil cost an average monthly wage for a Cuban worker. The supply situation remains poor as well, as the energy shortage paralyzes both production and distribution industries.

February 1996
Two private US aircraft are shot down by Cuban rockets, resulting in even greater isolation of Cuba from the international community. President Clinton approves new sanctions intended to block foreign investment in the island country. As a result of a fifty-per-cent reduction in the sugar harvest since 1989, tourism – in addition to private aid – becomes Cuba's primary source of foreign currency, bringing in the equivalent of a billion German marks in 1996 alone. However, the rising tide of tourists fosters a significant rise in prostitution on the island. The embargo also accelerates the collapse of Cuba's free health-care system.

Crossing the Caribbean from Cuba to Miami on a makeshift raft, Havana, Cuba, 1994
Household animals in downtown Havana, Cuba, 1994
Demonstration in support of Fidel Castro, Havana, Cuba, 1994
In downtown Havana, Cuba, 1994
Prostitutes, Havana, Cuba, 1994
Building a boat for the crossing from Cuba to Miami, Havana, Cuba, 1994
Police check in the port of Havana, Cuba, 1994
Female brewery workers, Havana, Cuba, 1994
Mass for the boat-people, Havana, Cuba, 1994
At the beach near Havana, Cuba, 1994

# *F L I G H T   A C R O S S   T H E   W A T E R*

**Photographed by Michael Meyborg in August 1994**

The crisis in Cuba's economy has intensified in the wake of the collapse of the Soviet Union
and under the pressure of the US economic embargo. There is a shortage of food,
and many Cubans are affected by the poor supply situation. As a result, more than 30 000 people
took the chance offered by the temporary opening of Cuba's borders in August 1994 and
set out in boats and rafts for the Florida coast. Most of the refugees were detained by the US Coast Guard
and transferred to refugee camps or sent back to their homeland.

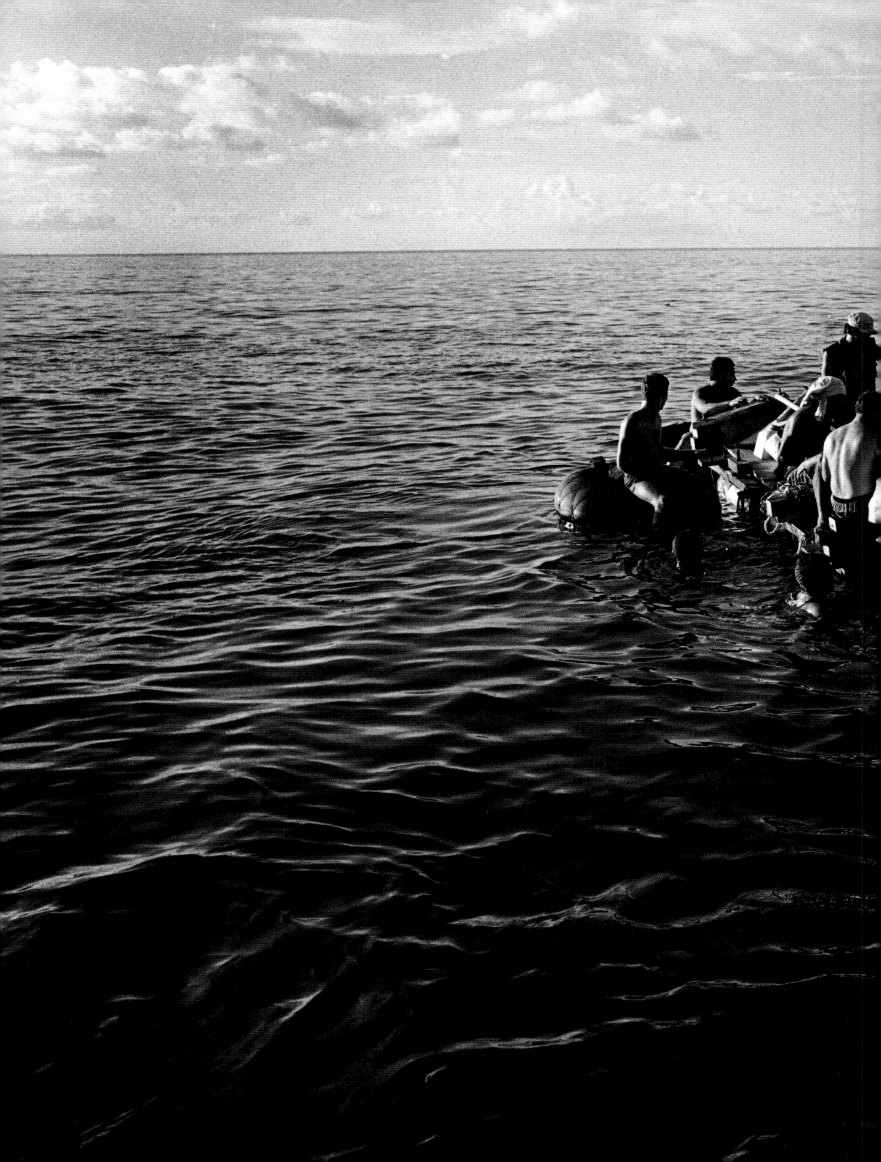

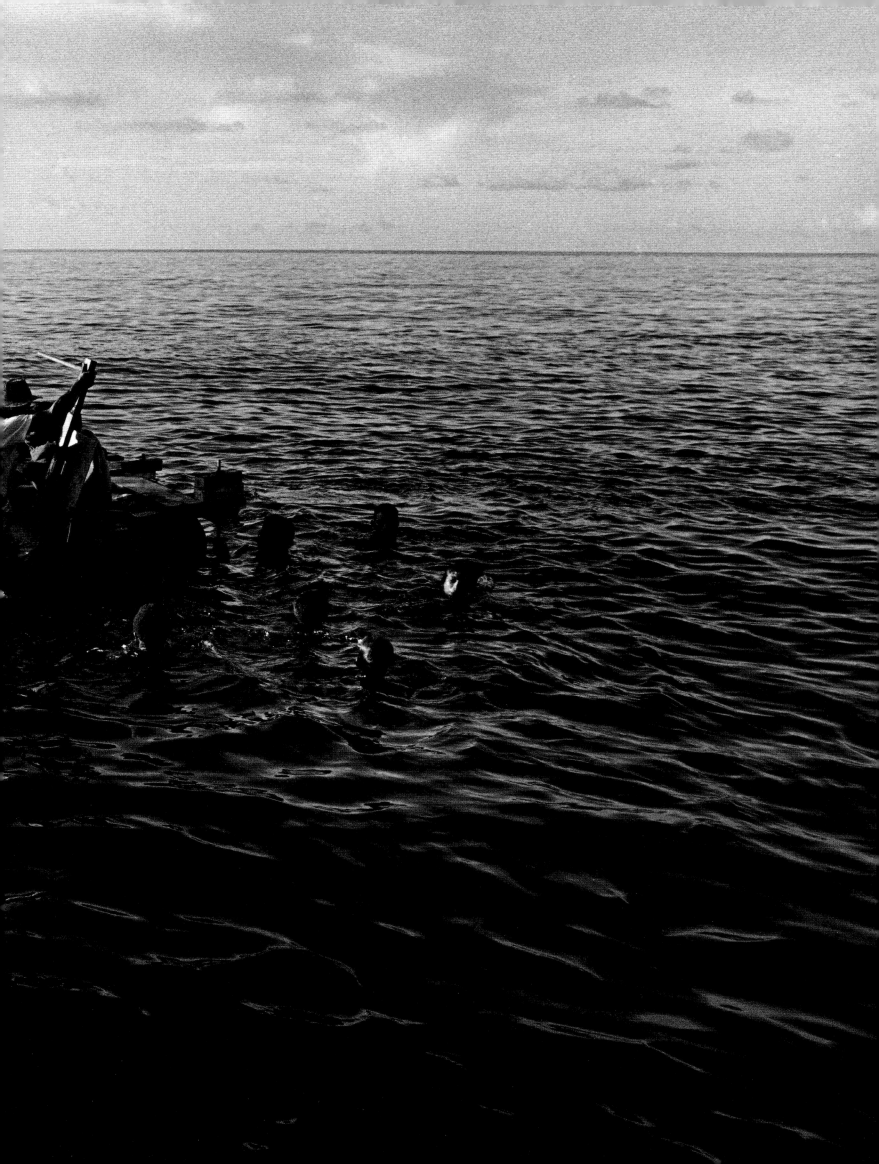

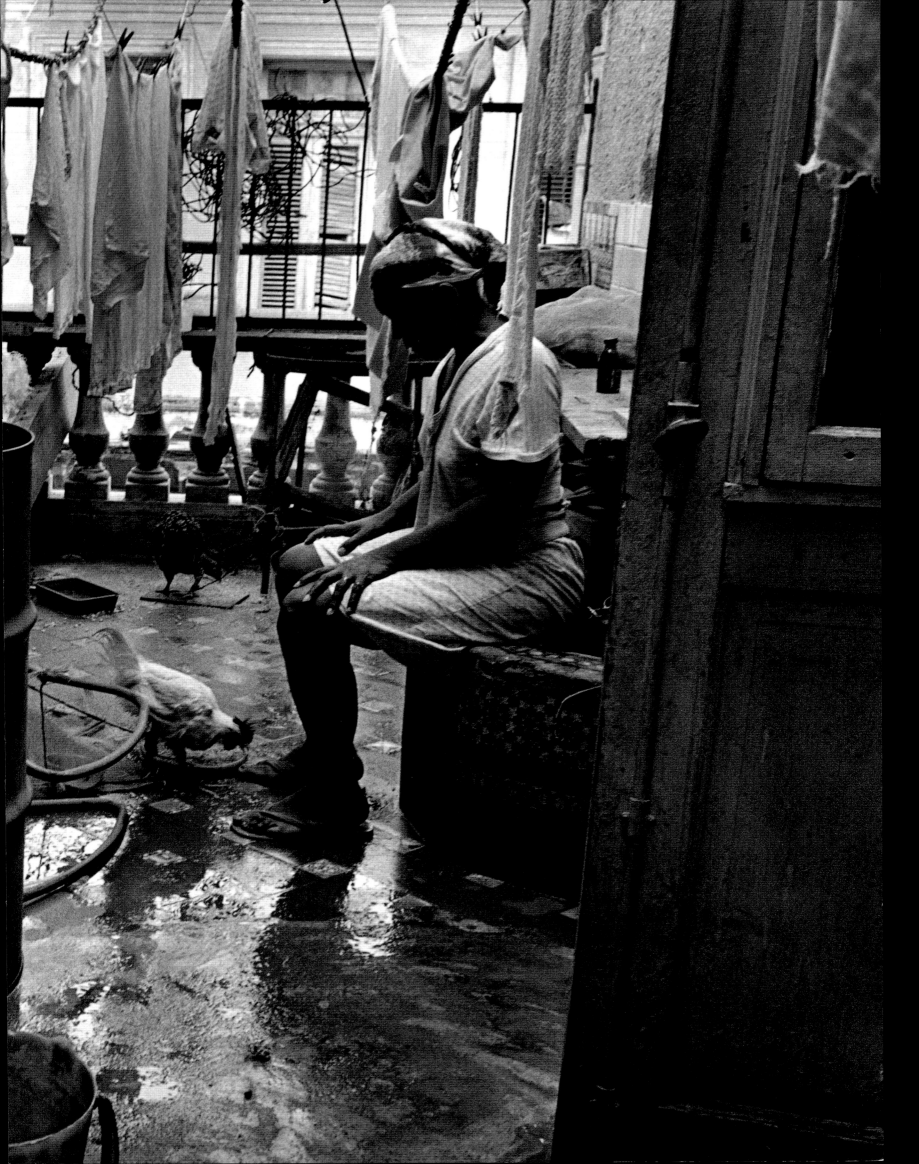

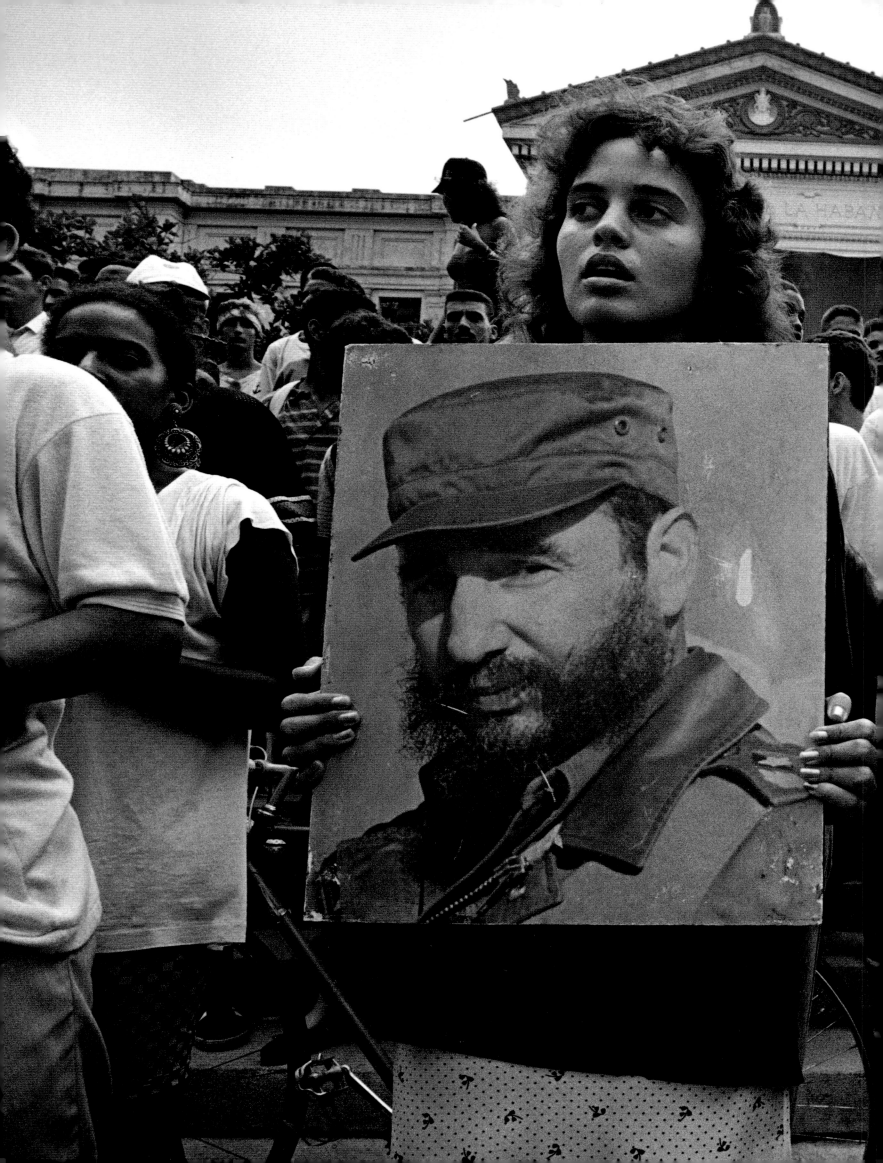

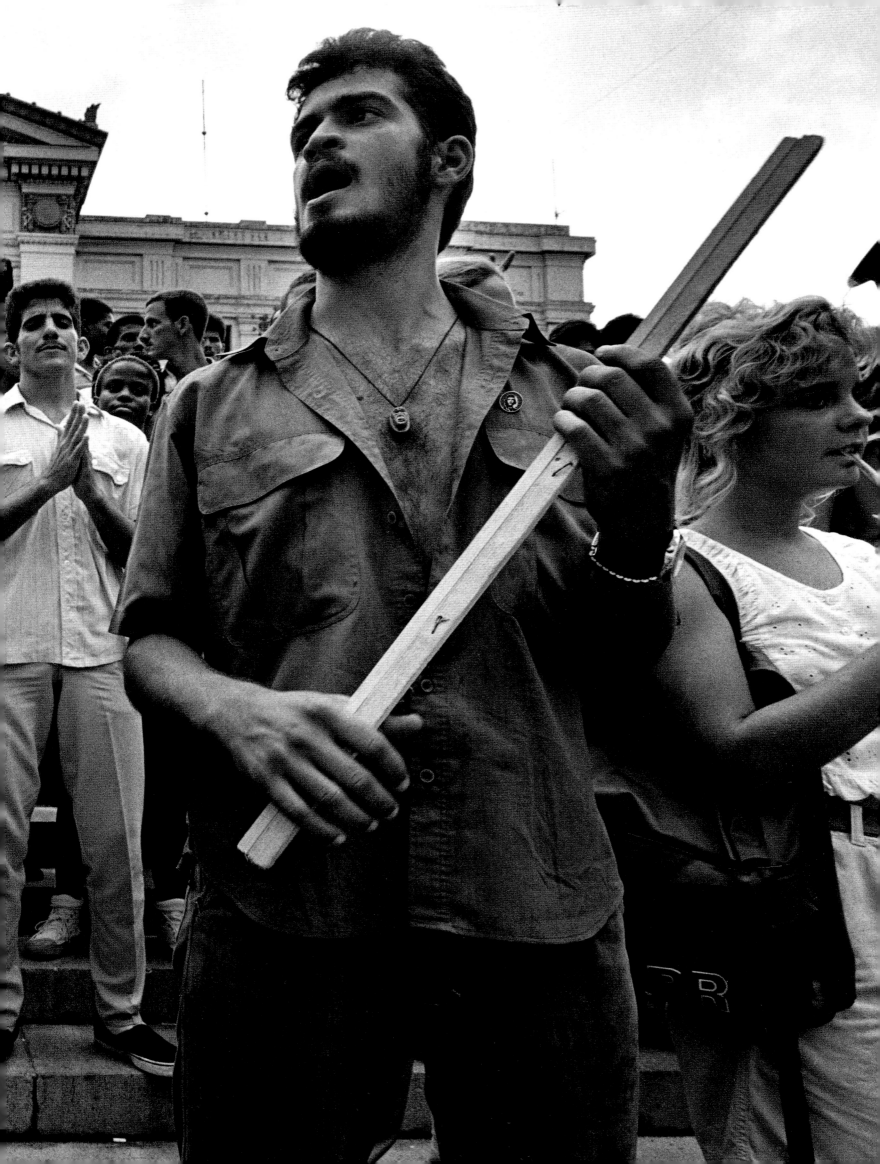

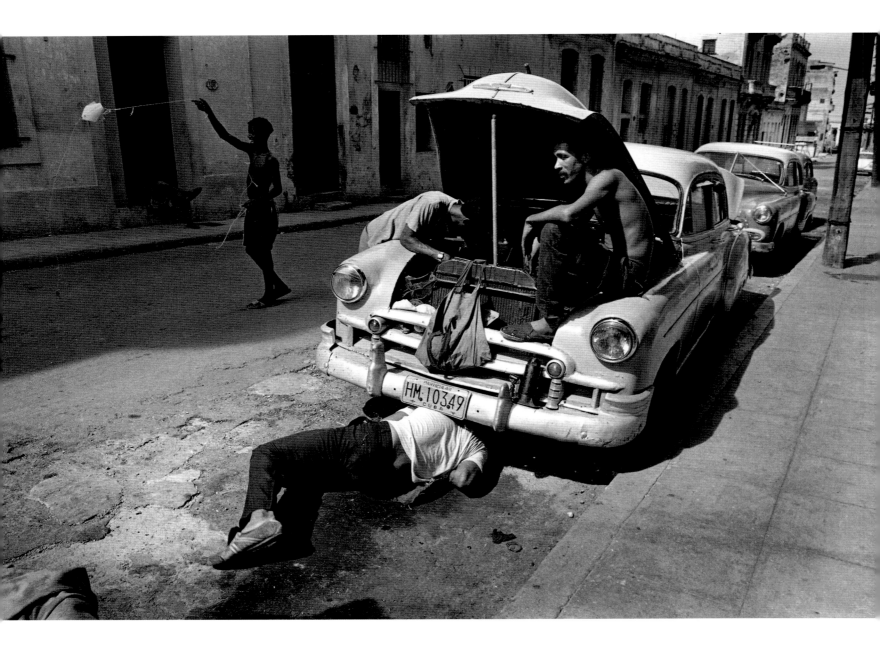

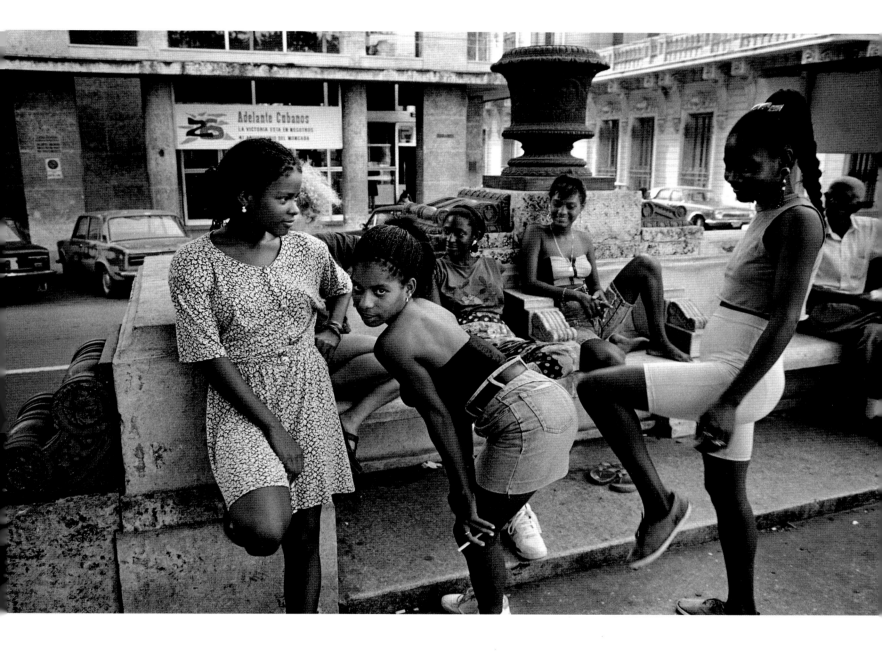

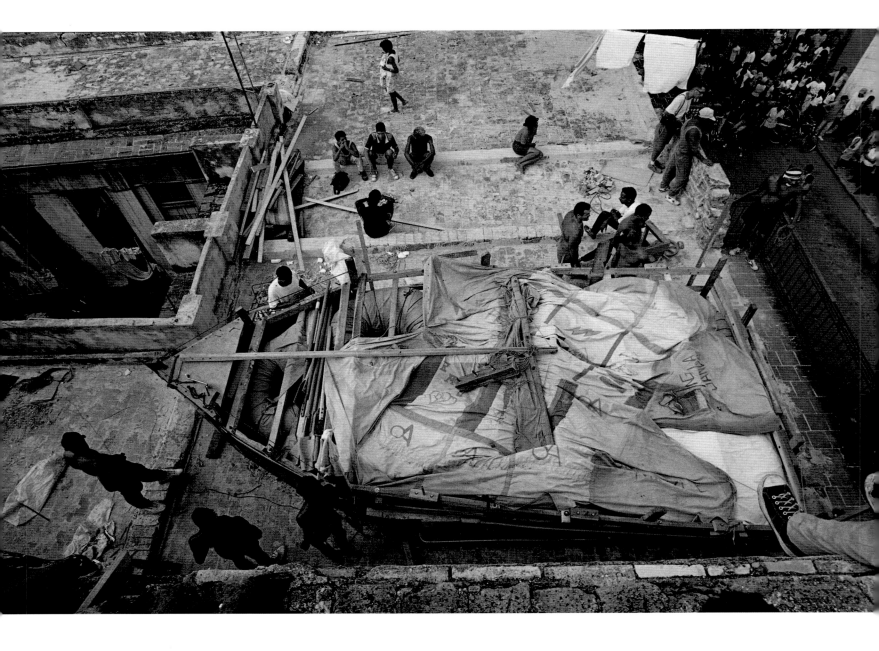

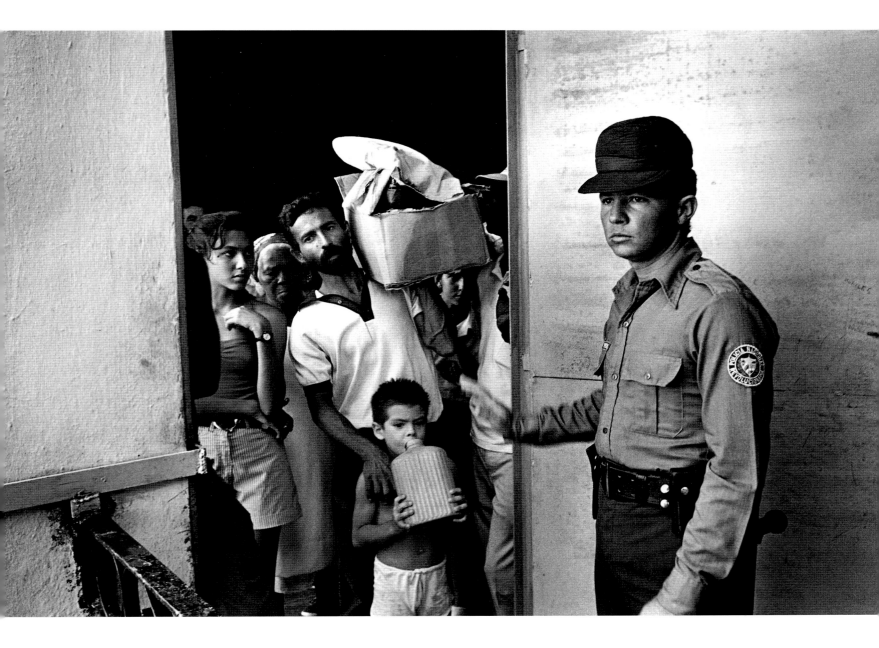

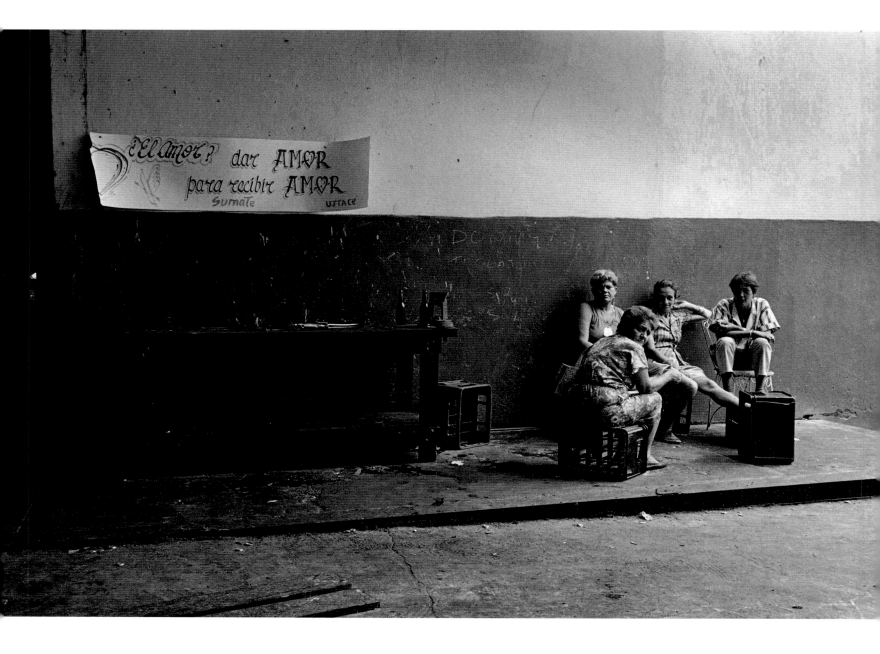

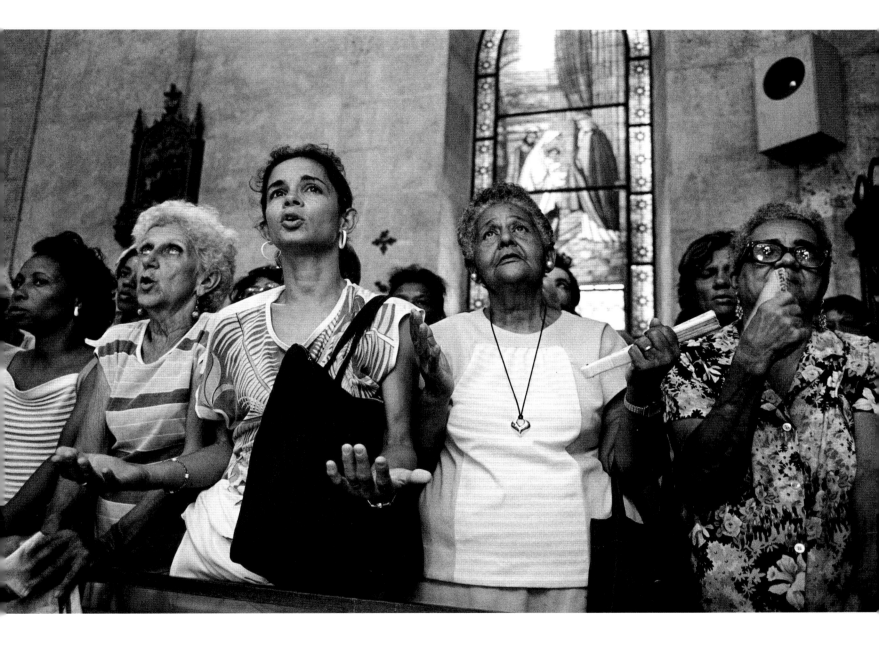

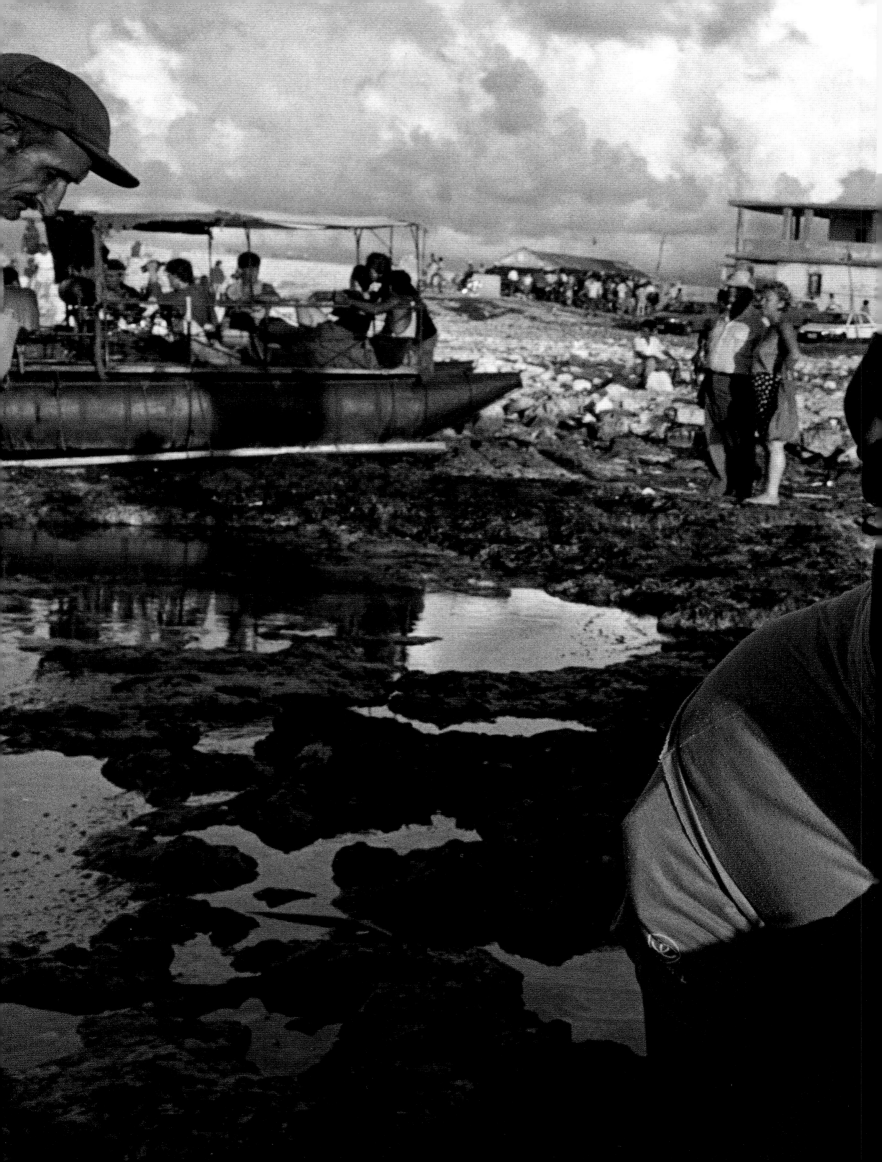

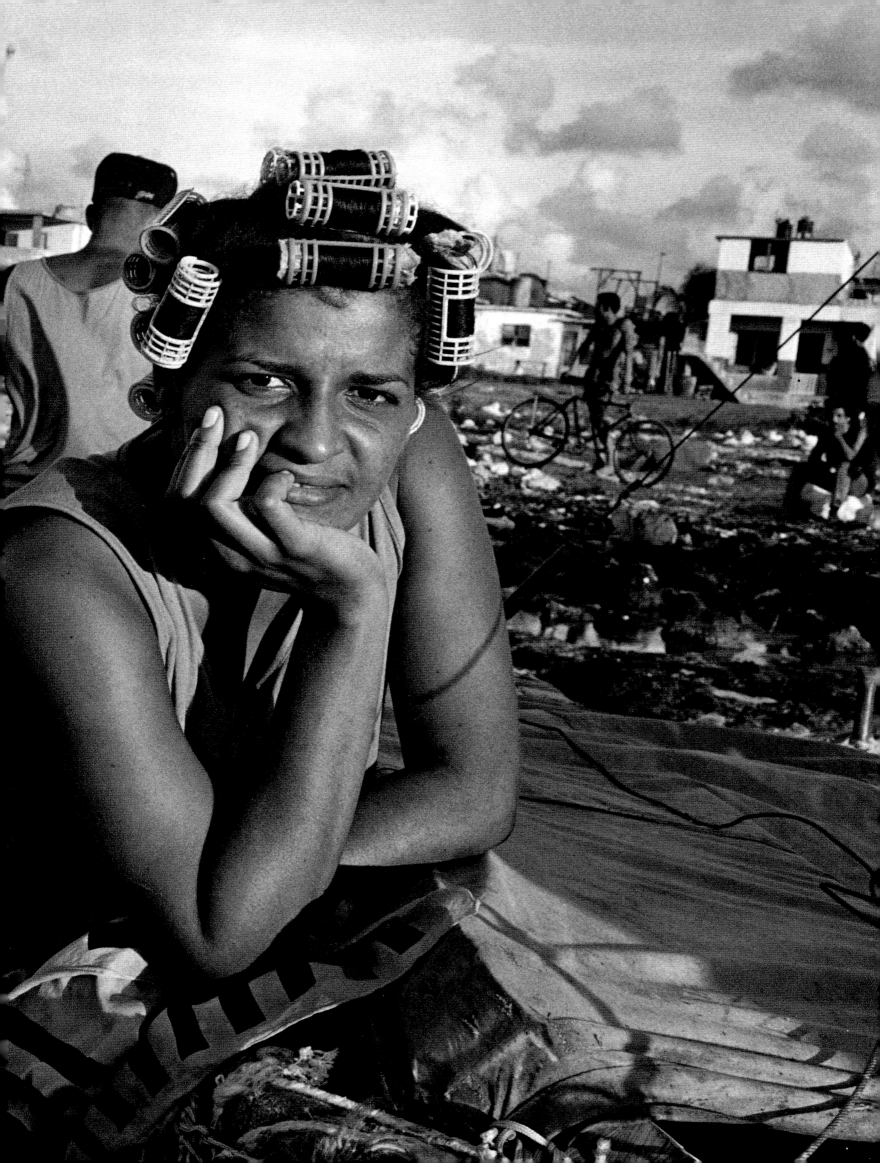

July 1993

Fundamental changes are made in existing laws governing asylum in the Federal Republic of Germany. Previously, the German constitution provided that those subject to political persecution were to be granted the right of asylum. The new changes introduce significant restrictions in asylum rights. The greatest obstacle for asylum-seekers is the third country provision. Refugees who arrive in Germany from a safe neighboring country (third country) are not entitled to asylum in Germany but are instead returned to the safe third country from which they have come. Since all countries neighboring Germany are considered safe third countries, it is now very difficult to gain political asylum in Germany. Additionally, security personnel has been strengthened along German borders, and the Federal Border Police have been equipped with modern technology for use in control operations (e.g. night-vision devices).

1995

Some 30 000 people are detained after attempting to enter Germany illegally, nearly five per cent fewer than in the preceding year. More than 120 000 people are refused entry at the border. When asylum proceedings end in rejection of an asylum application, a deportation order is issued. In many cases, refugees are placed in confinement for deportation purposes. Deportation arrest may be ordered for up to six months and extended up to 18 months. For those affected, confinement produces severe psychological stress. Since 1993, 14 people have committed suicide while confined for deportation purposes in Germany.

Early 1997

Germany has taken in approximately 320 000 refugees from Bosnia and Herzegovina since the outbreak of war in the former Yugoslavia in 1991. Following the conclusion of the Dayton Treaty of November 1995, the interior ministers of the German states have demanded the prompt return of Bosnian refugees to the homelands. Humanitarian organizations warn against hasty deportation of these refugees, as the majority of their home villages are not yet secure.

In the yard of the deportation arrest facility, Hamburg, Germany, 1996
Deportation arrest facility, Hamburg, Germany, 1996
Deportation arrest facility, Hamburg, Germany, 1996
Identity check in the deportation arrest facility, Hamburg, Germany, 1996
Kurdish refugee in the deportation arrest facility, Hamburg, Germany, 1996
Refugee from Mali in the deportation arrest facility, Hamburg, Germany, 1996
"Deportation arrest: House No. 3," Hamburg, Germany, 1996
Deportation arrest facility, Hamburg, Germany, 1996
Deportation arrest facility, Hamburg, Germany, 1996
Deportation arrest facility, Hamburg, Germany, 1996

# LAST STATION: DEPORTATION ARREST

Photographed by Andreas Herzau in June 1996

Following the revision of German asylum laws in 1993, it has become very difficult
for refugees to gain asylum in Germany. The third country provision
enables authorities to deport those who enter Germany from a safe neighboring country.
Border controls have been intensified during this period as well.
For many, flight from their homeland ends in confinement, where they are forced to wait
as long as six months before being deported. Fourteen refugees have
committed suicide in deportation arrest in Germany since the summer of 1993.

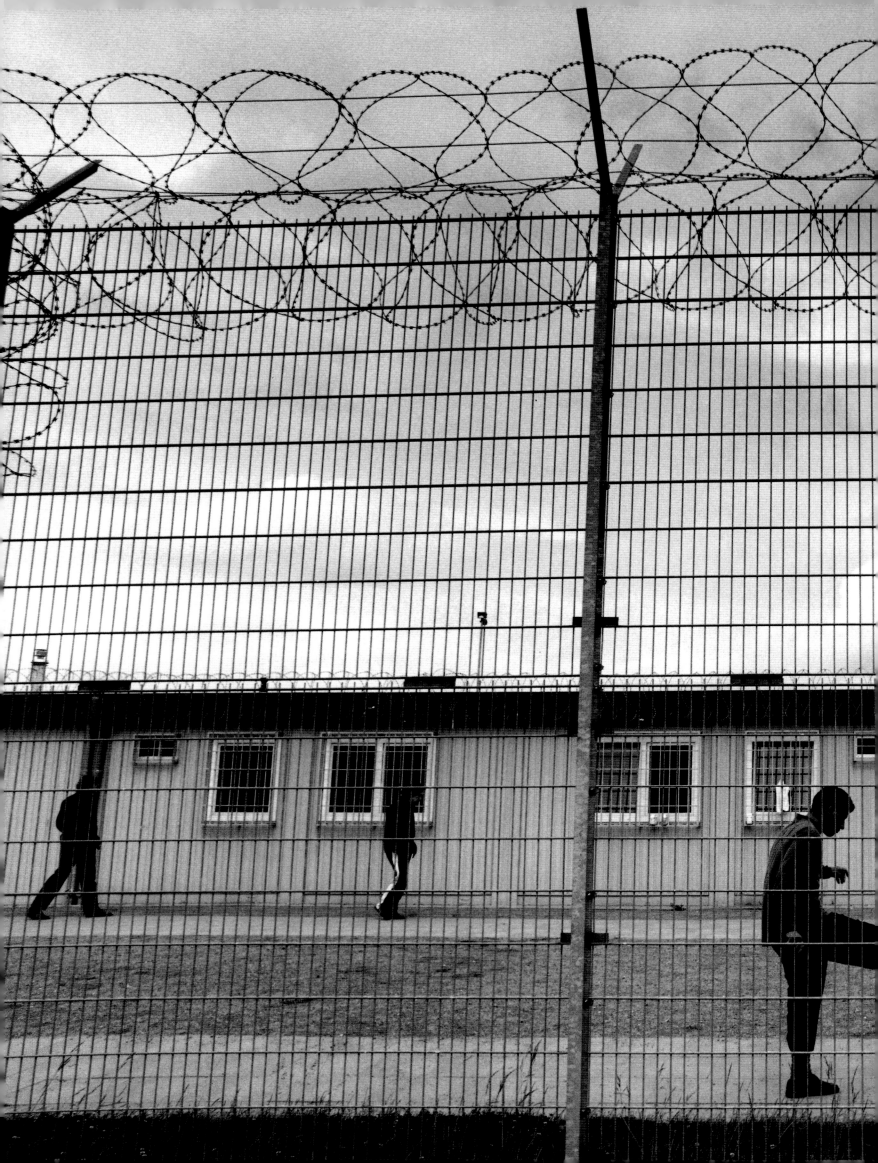

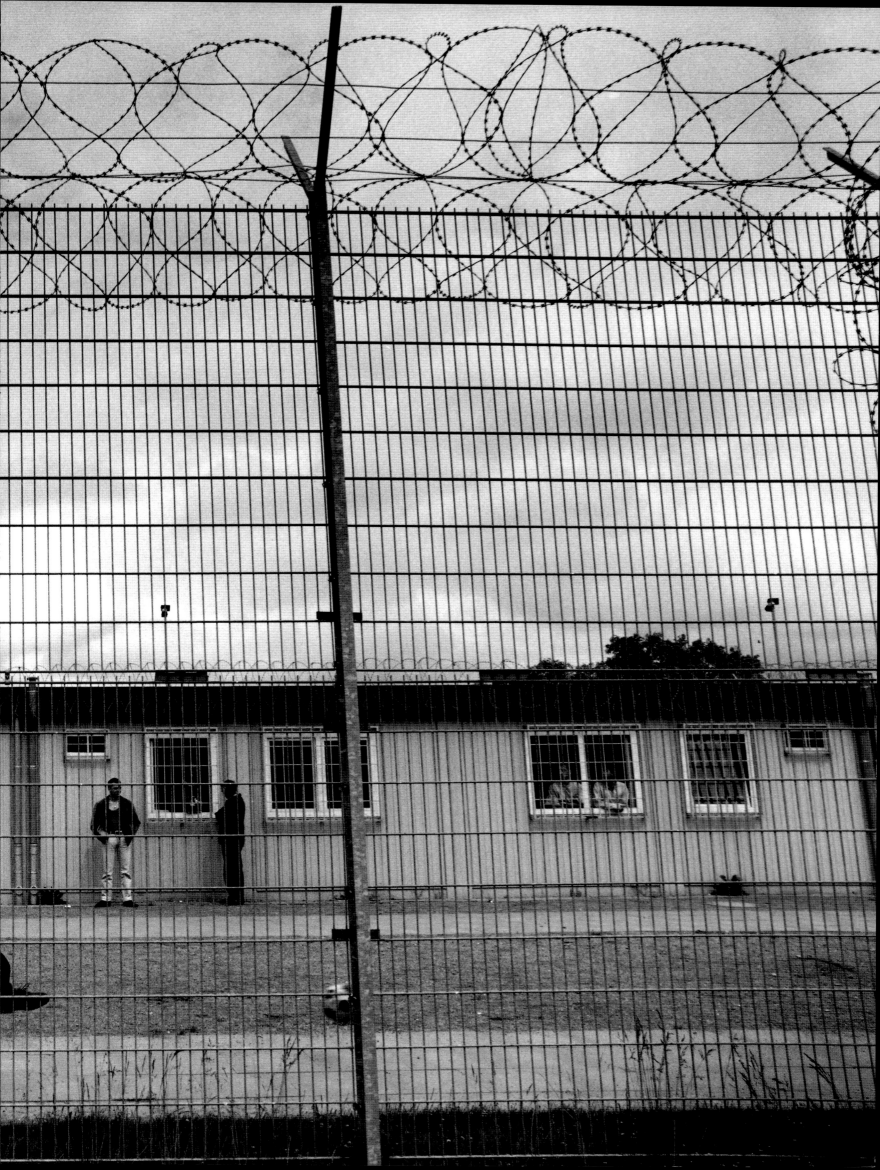

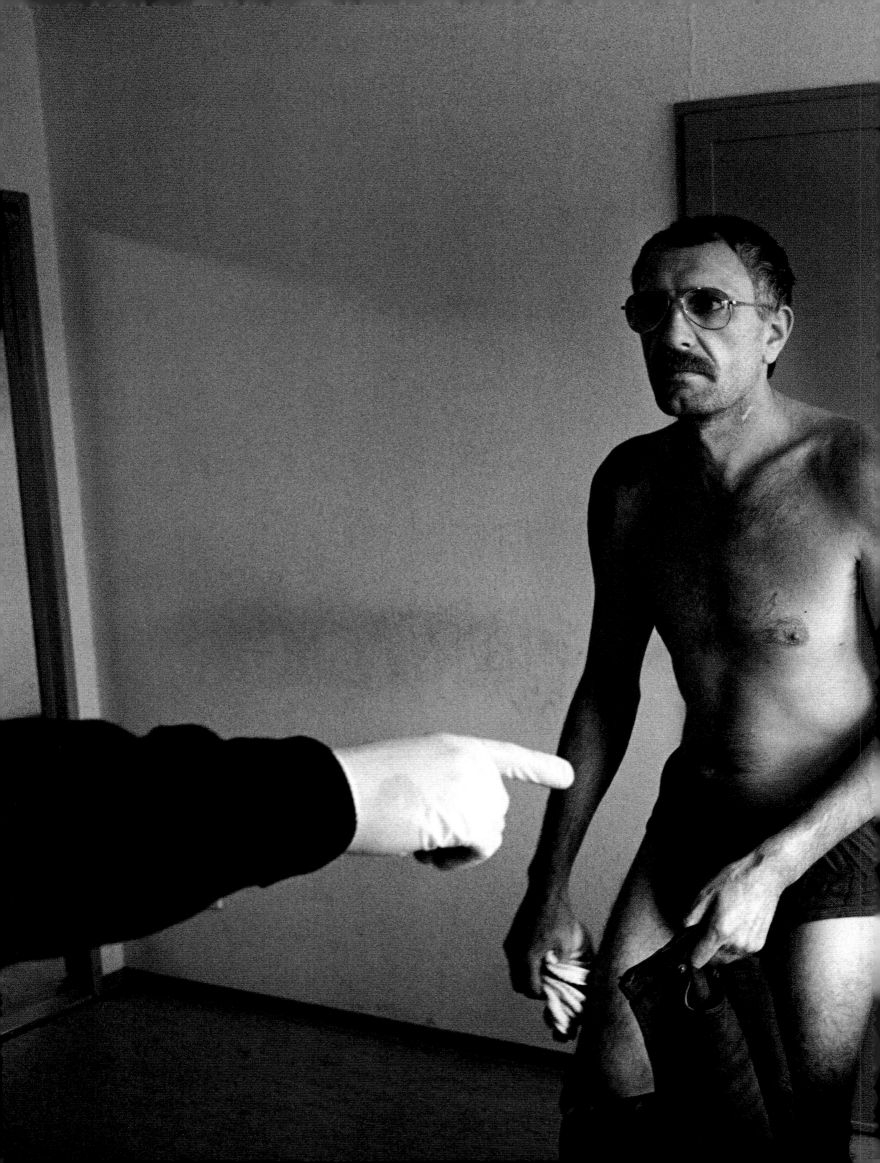

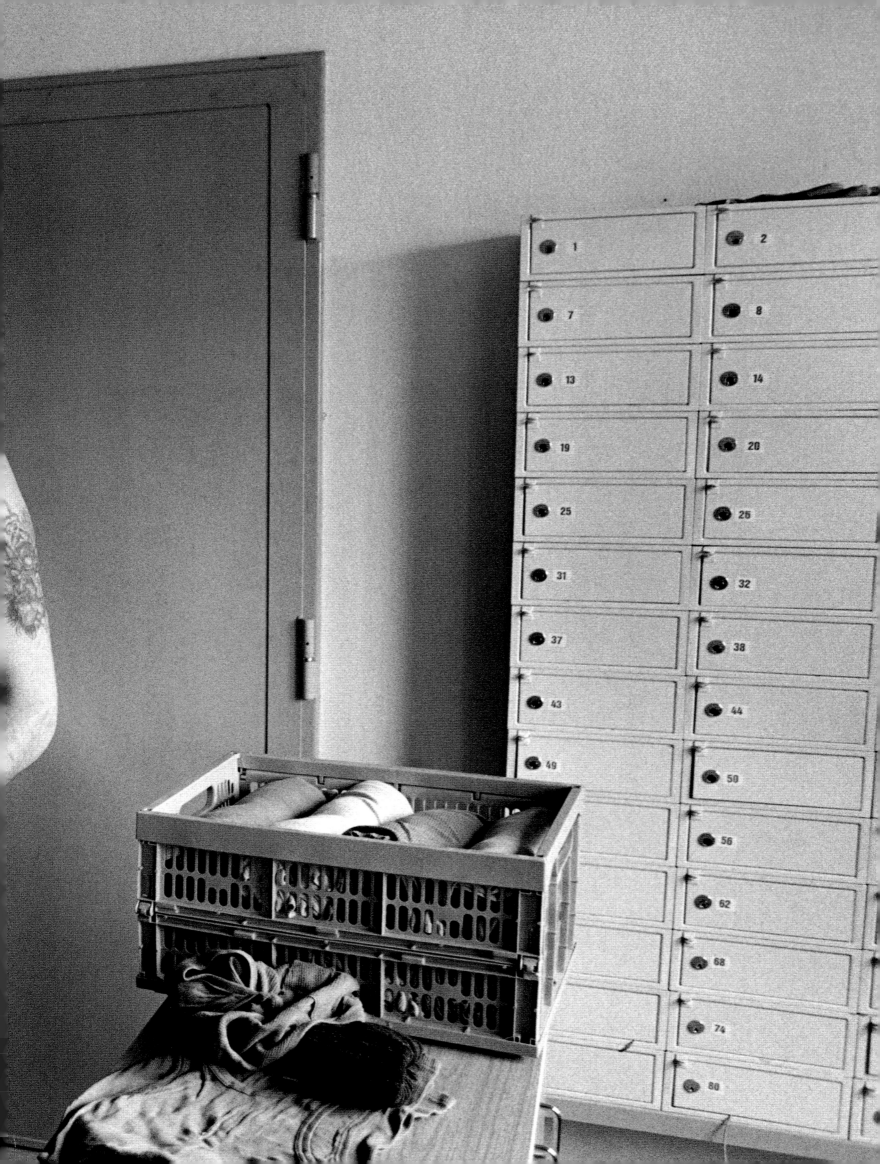

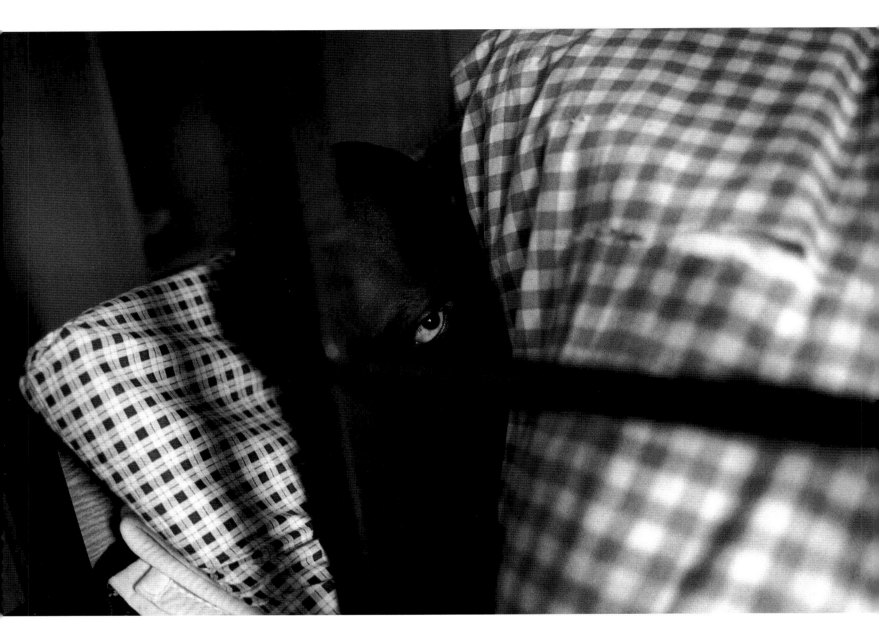

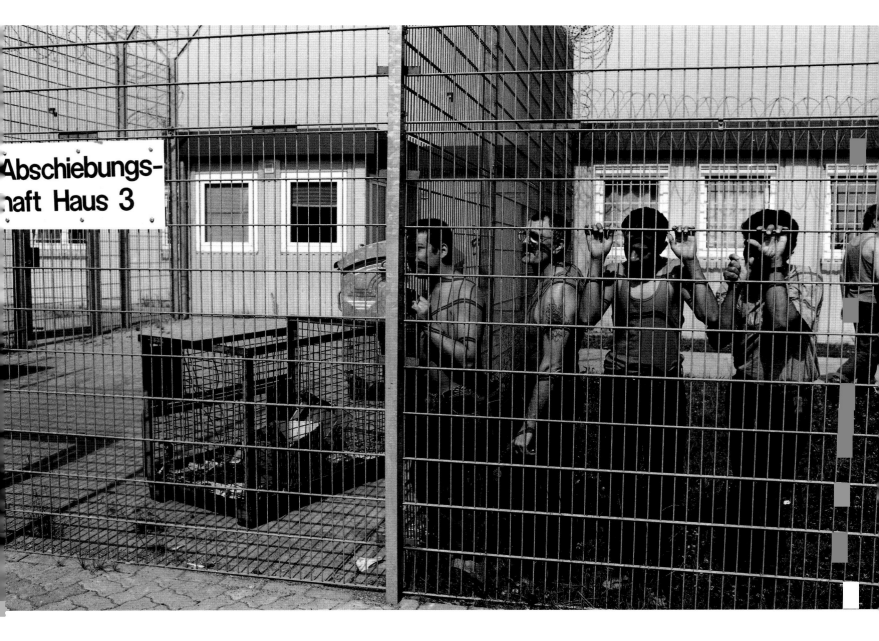

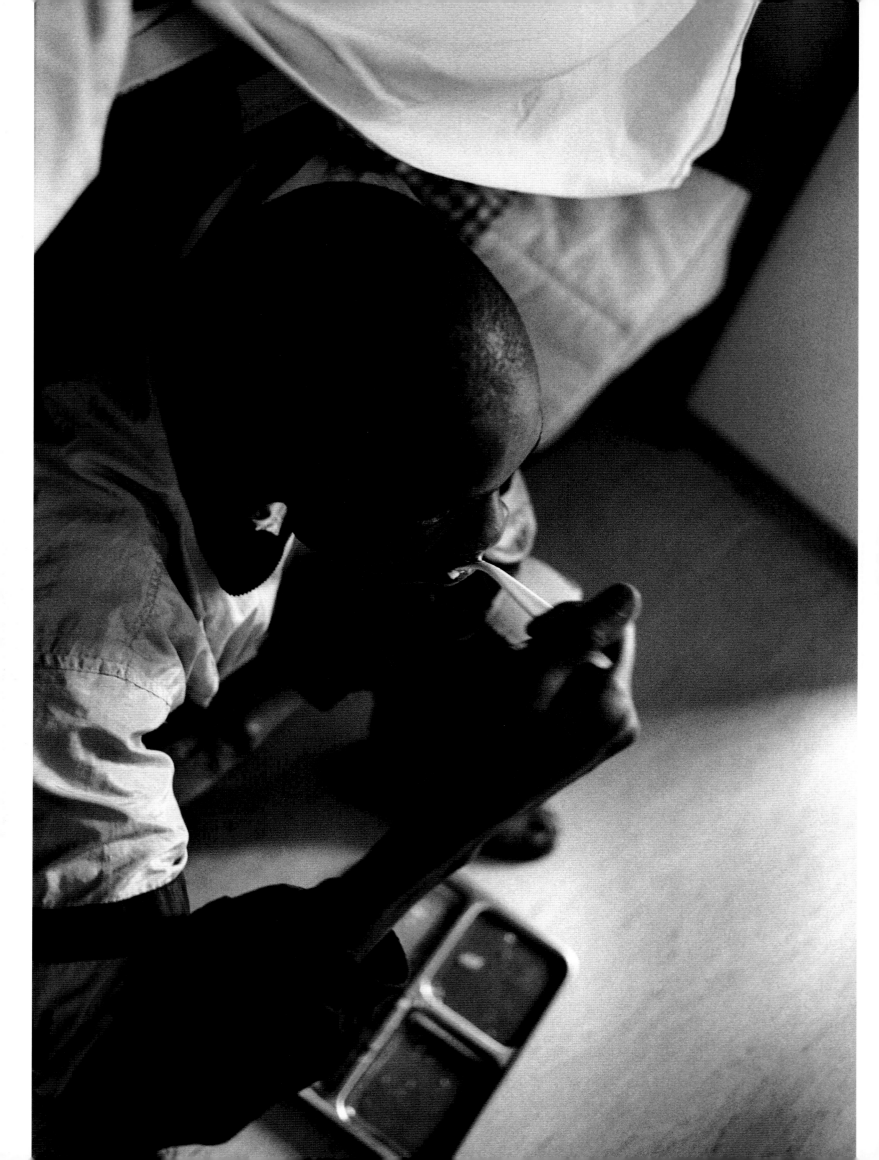

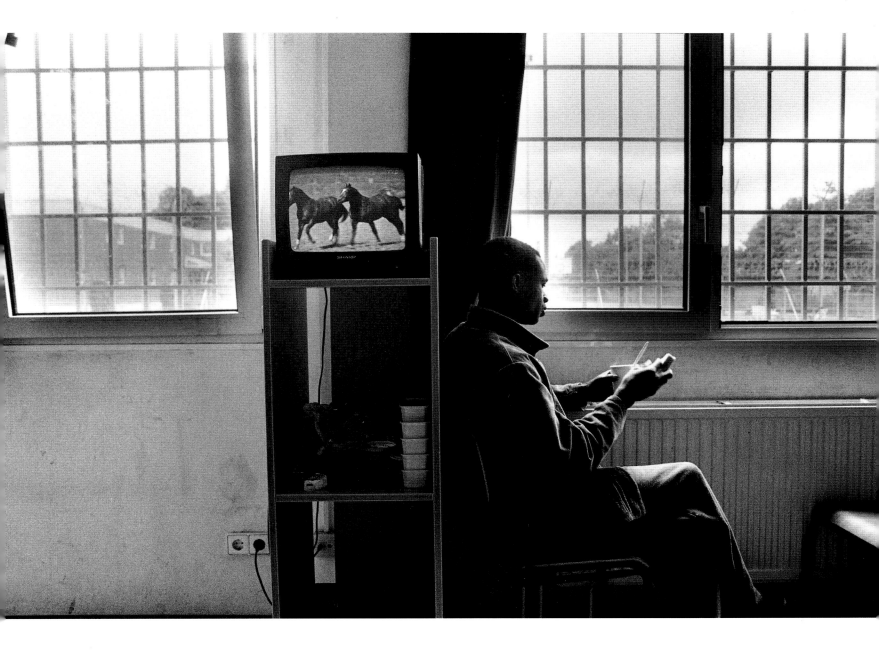

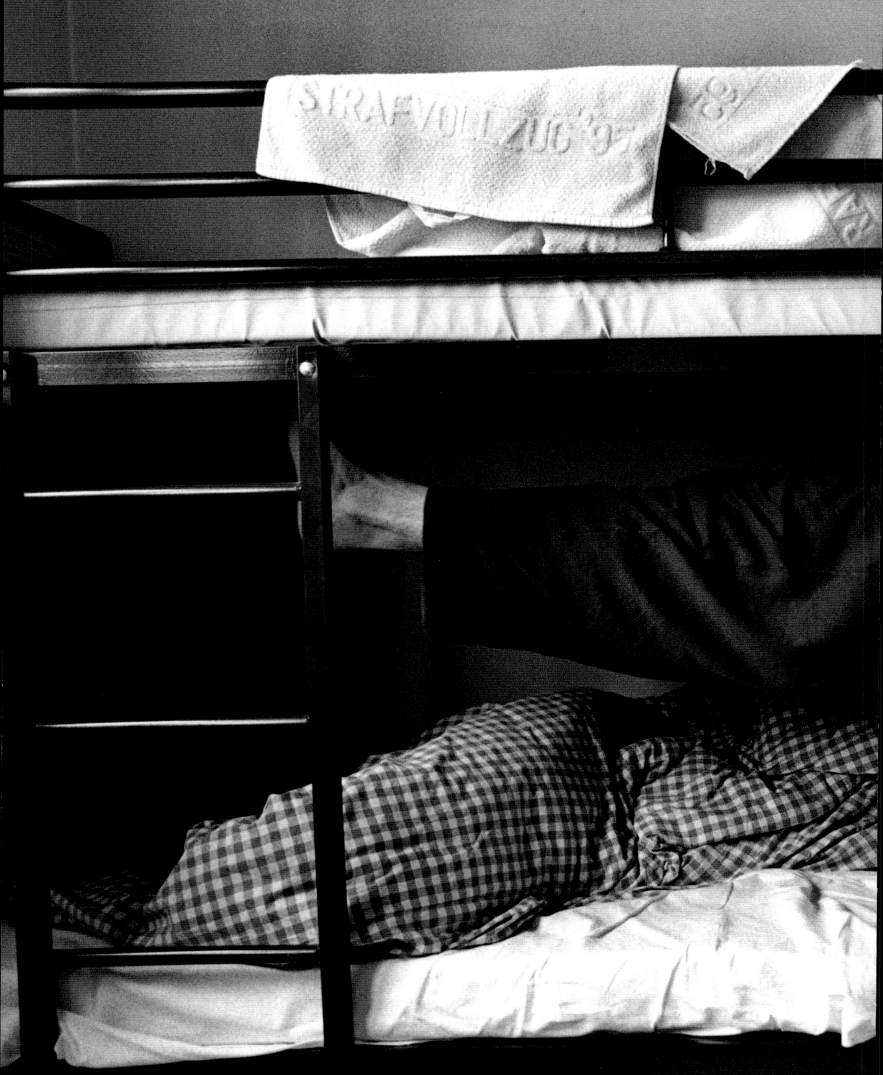

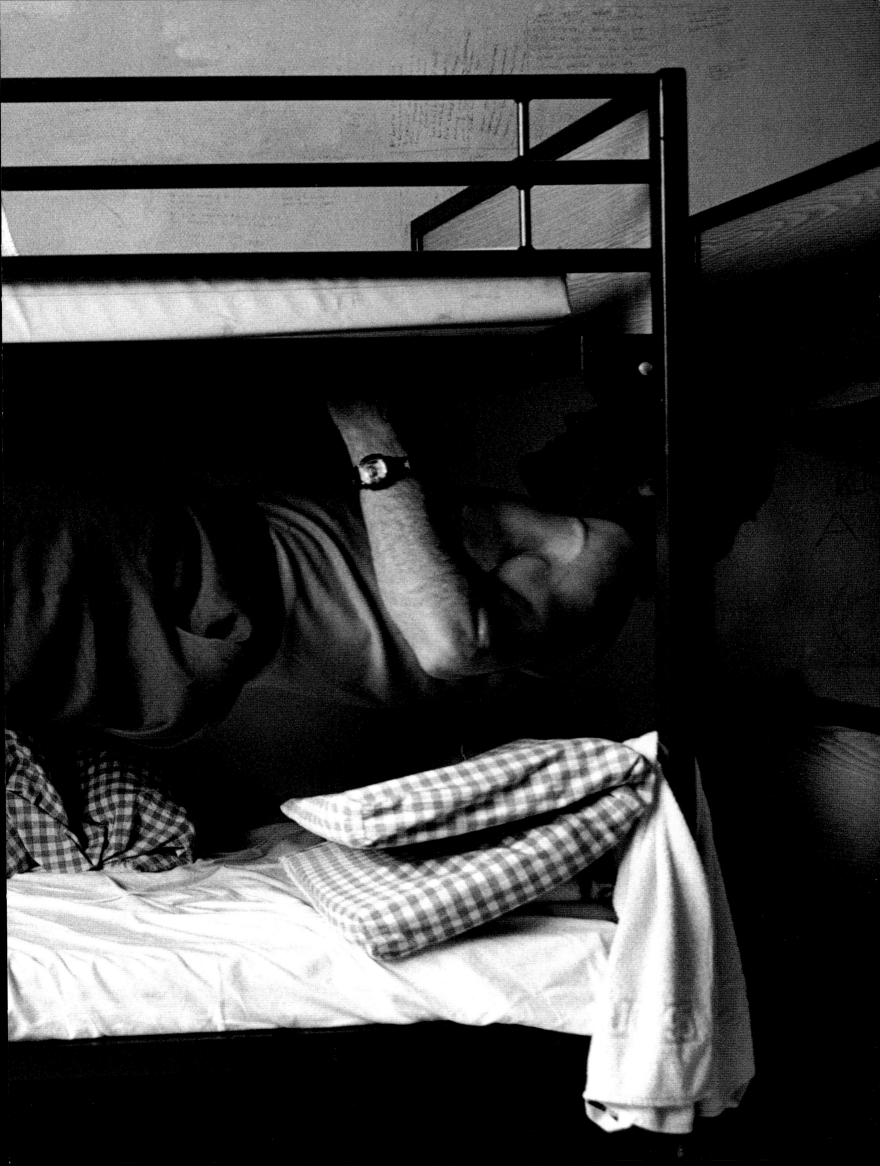

1990
First free elections are held in the six republics of the former state of Yugoslavia.

May 1991
Tensions between Serbs and Croats intensify in Croatia. Twelve Croatian policemen are killed in fighting with Serb paramilitary forces in Borovo Selo.

June 1991
Independence is declared by Croatia (25 June) and Slovenia (26 June). War begins in Slovenia between Slovenian units and the Yugoslavian People's Army (YNA). Fighting breaks out between Serb paramilitary forces ("Marticevci") and Croatian police in Banija (Croatian Crajina). Further fighting occurs in East Slavonia.

July 1991
Mediation efforts on the part of the EC troika bring an end to the "Ten-Day War." The Treaty of Brioni is signed. All YNA troops are pulled out of Slovenia. In Croatia, the formation of "Serb Republic of Crajina" is declared.

Fall 1991
Heavy fighting takes place between YNA and Serb paramilitary forces united against Croatian units. The Serbs attack the historical city of Dubrovnik and surround and destroy Vukovar. Former US Secretary of State Cyrus Vance is appointed Special Representative of the UN Secretary General.

December 1991
The recognition of Croatia and Slovenia as independent states by the European Community brings no end to the fighting.

January 1992
The mediation efforts of Special Representative Vance produce a cease-fire between Croatia and the Yugoslavian People's Army, bringing a temporary end to the war in Croatia. The peace treaty provides for the sending of a UN peace-keeping force (UNPROFOR) to Croatia.

February/March 1992
In a referendum required by the European Community as a condition for recognition as independent states, 99 per cent of all voters support independence for Bosnia and Herzegovina. Bosnian Serbs boycott the referendum. Bosnia and Herzegovina declares its independence.

April 1992
Bosnia and Herzegovina is recognized by the European Community and the US. The war begins in Bosnia and Herzegovina. Heavy fighting takes place around Sarajevo, and Bosnian Serbs lay siege to the capital. By September 1992, Bosnian Serbs have occupied nearly 70 per cent of the country's territory. Non-Serbs are forcibly expelled from northern and eastern Bosnia.

March 1993
Bosnian Croats declare formation of their Republic of "Herzeg-Bosna," with Mostar as its capital and prepare for a merger with Croatia. The coalition of Bosnian Croats and Muslims collapses. The "war-within-a-war" breaks out, as three warring parties are now involved in fighting on constantly changing fronts.

March 1994
International arbitrators mediate in the conflict between Croats and Muslims, resulting in an agreement on a mutual confederation.

May/August 1995
Strengthened by illegal arms imports, the Croatian army launches a campaign to reoccupy Crajina. Within just a few days, more than 170 000 Serbs flee Croatia to Bosnia and Herzegovina and the Federal Republic of Yugoslavia.

July 1995
Bosnian Serbs take the UN protected enclave of Srebrenica. All Muslim residents are expelled from area. Thousands of men are reported missing in the aftermath of the campaign. Consequently, representatives of the NATO contact group countries (the US, Great Britain, France, Germany and Russia) agree in London to respond with greater force.

August 1995
NATO partners resolve to respond to attacks on the protected enclaves of Gorazde, Bihac, Sarajevo and Tuzla with air strikes. At the same time, the US assumes a new role in the conflict, and President Clinton sends a team of negotiators to the crisis-torn region.

September 1995
Air strikes by NATO forces against Serb positions provide indirect support for Bosnian and Croatian troops in their efforts to retake territory held by the Serbs.

November 1995
The war ends after 21 days of intensive negotiations in Dayton, Ohio.

December 1995
The Dayton Peace Treaty for Bosnia and Herzegovina is signed in Paris.

Bridge over the Neretva River, formerly the front separating
Croats and Muslims, Mostar, Bosnia, 1996
Refugee camp at the Tuzla airport: refugees from Srebrenica,
Tuzla, Bosnia, 1995
Reunion after successful flight, Davor, Croatia, 1995
In the transit camp, Banja Luka, Bosnia, 1995
Refugee camp at the Tuzla airport: one of the few men who managed
to escape from Srebrenica, Tuzla, Bosnia, 1995
Refugees from Banja Luka crossing the Sava River,
Davor, Croatia, 1995
Successful flight from Banja Luka across the Sava River,
Davor, Croatia, 1995
Wartime life in Bihac, Bosnia, 1995
Destroyed village, Vakuf, Bosnia, 1995
Black market, Bihac, Bosnia, 1995
Refugee camp at the Tuzla airport: refugee child from Srebrenica,
Tuzla, Bosnia, 1995
Refugee camp at the Tuzla airport: refugees from Srebrenica,
Tuzla, Bosnia, 1995

# THE FORMER YUGOSLAVIA
## PEACE, BUT NO FUTURE

**Photographed by Christian Jungeblodt in 1995 and 1996**

The war in the former Yugoslavia, which lasted from the early summer of 1991 to the fall of 1995,
left behind more than a million refugees and over 1.6 million displaced persons,
hundreds of thousands of dead and wounded as well as widespread destruction in Croatia and
Bosnia and Herzegovina. The war in Yugoslavia was composed of three main phases:
the so-called "Ten-Day War" in Slovenia (June/July 1991), the war in Croatia (June 1991 to January 1992;
May and August 1995) and the war in Bosnia and Herzegovina (April 1992 to November 1995).
The signing of the Dayton Treaty in Paris in December of 1995
brought to an end the cruelest war waged on European soil since World War II.

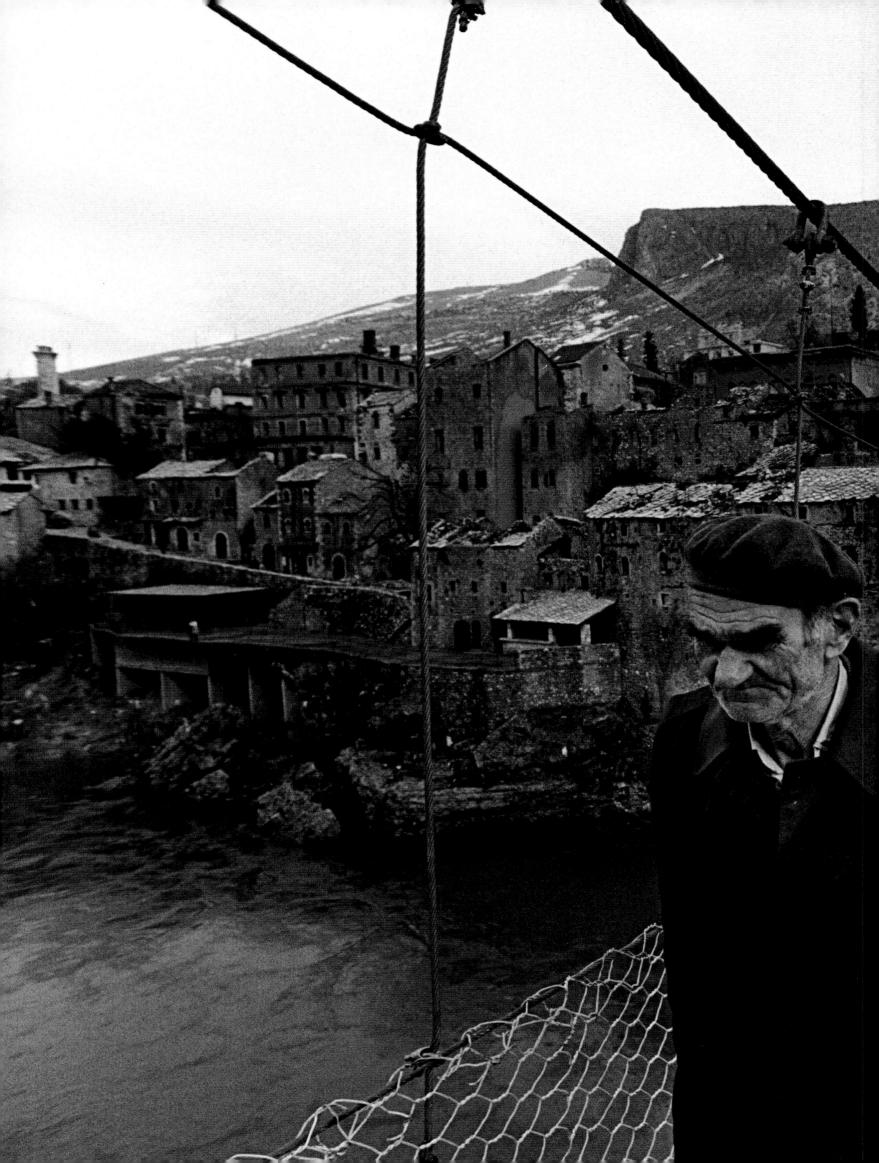

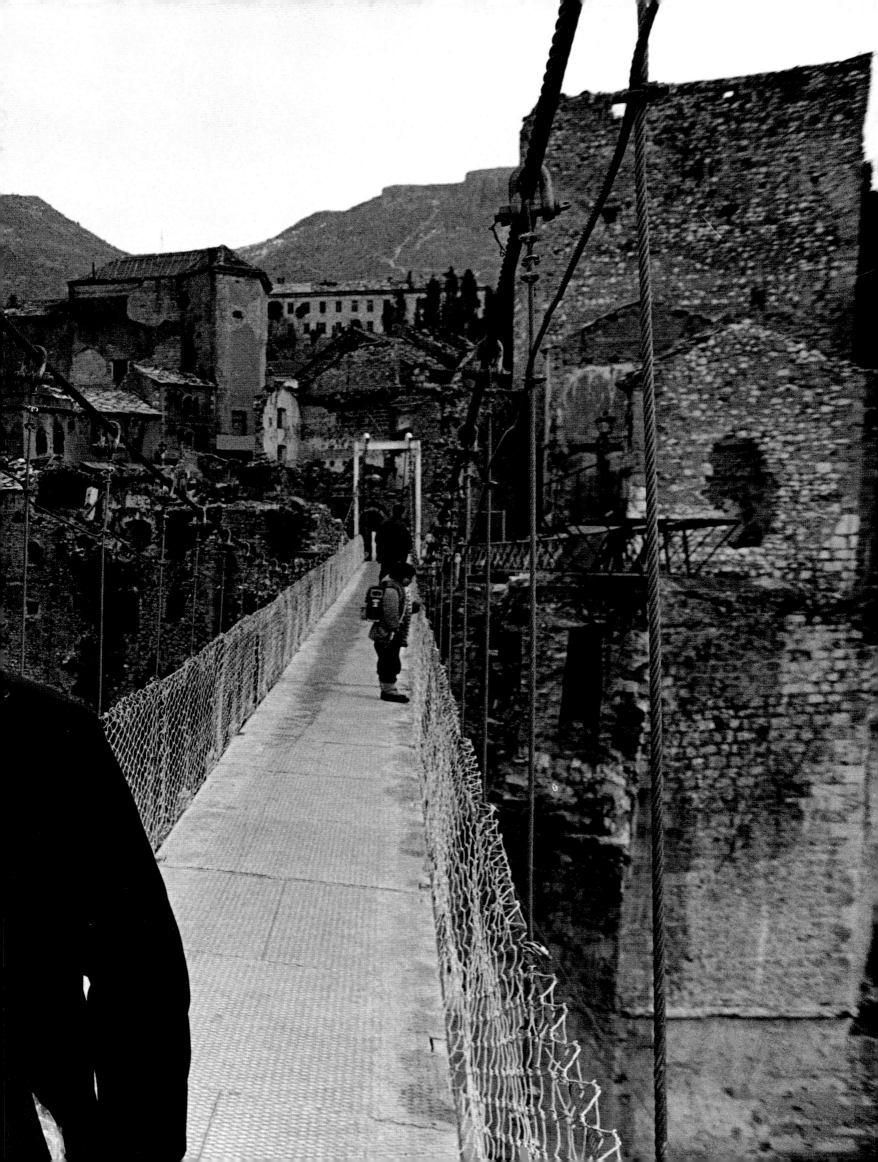

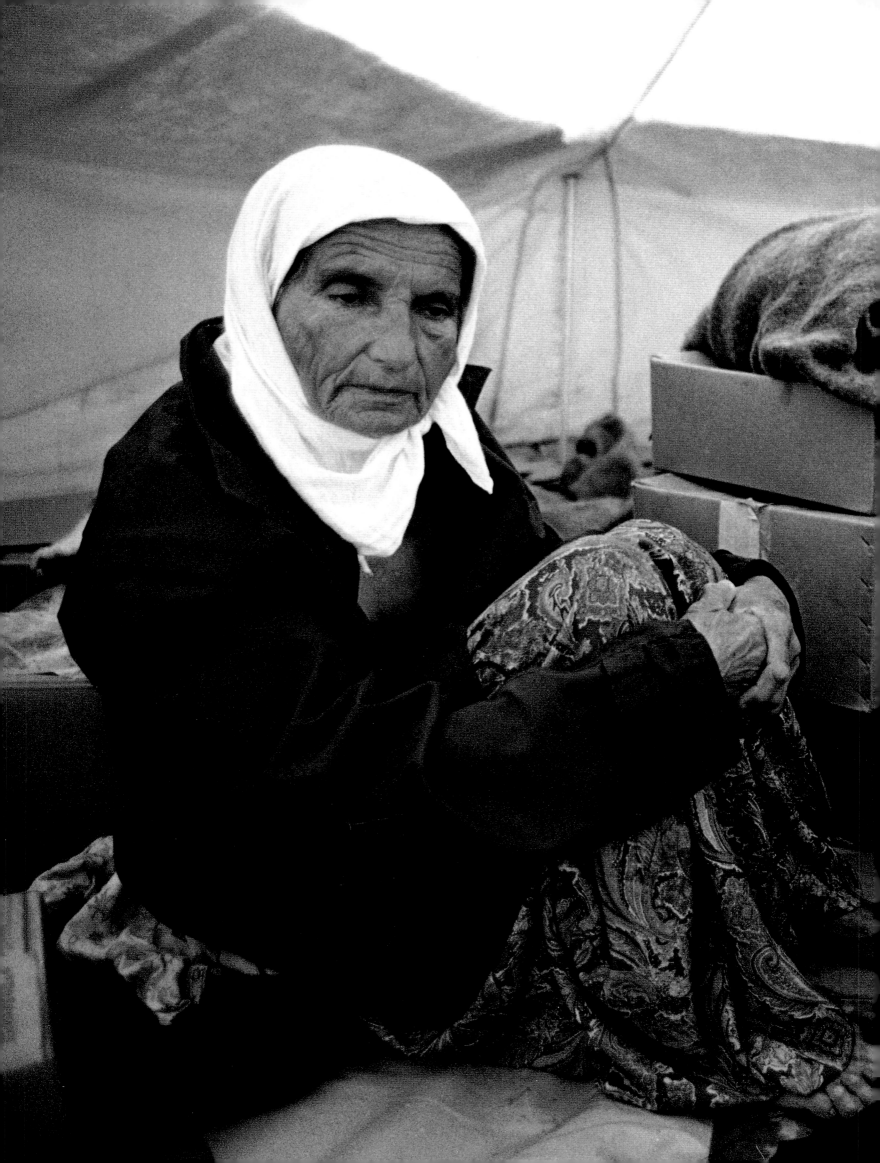

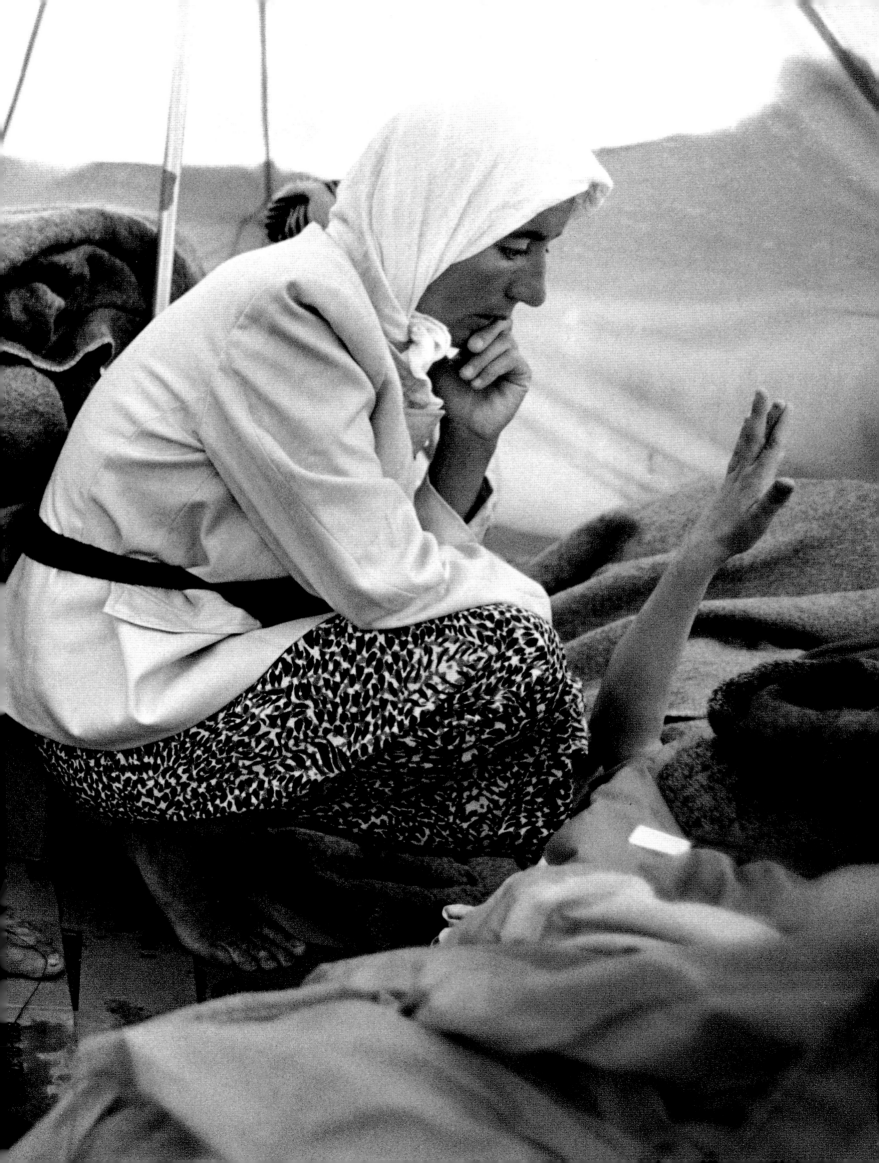

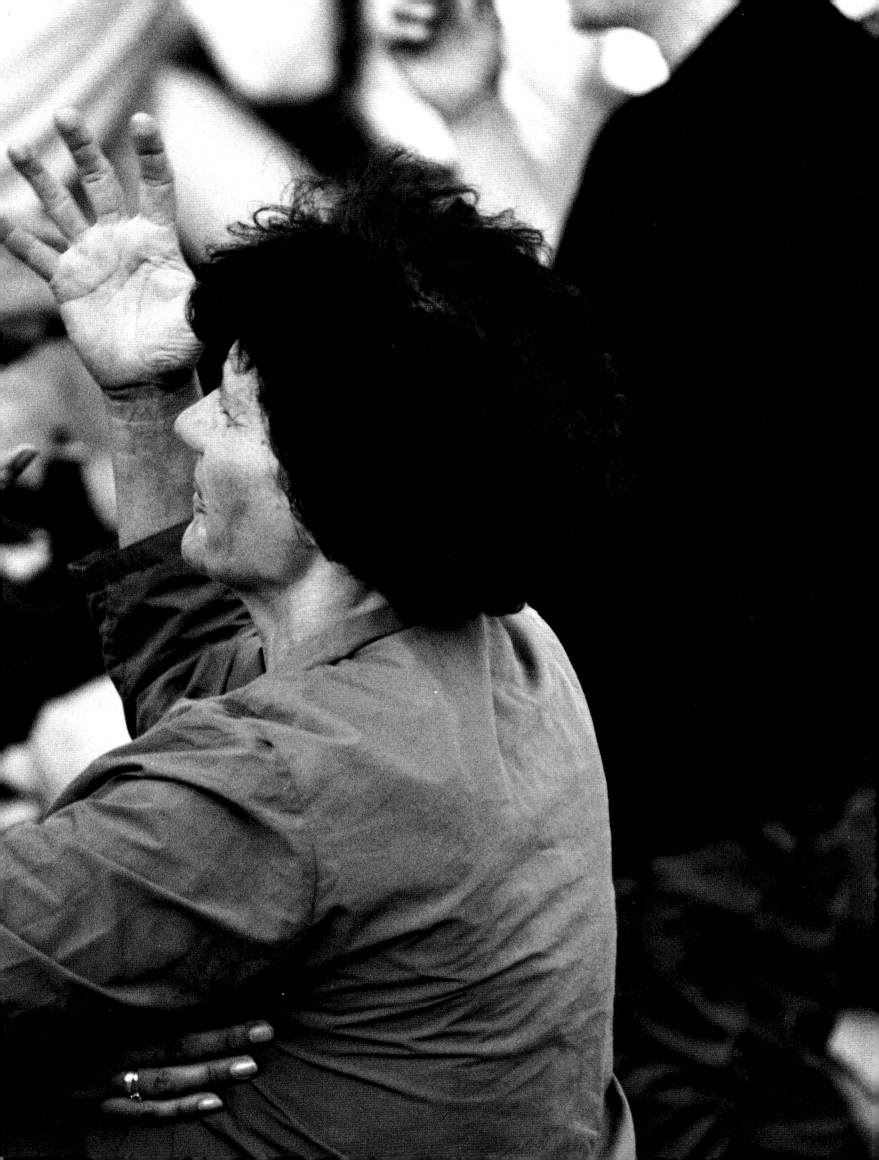

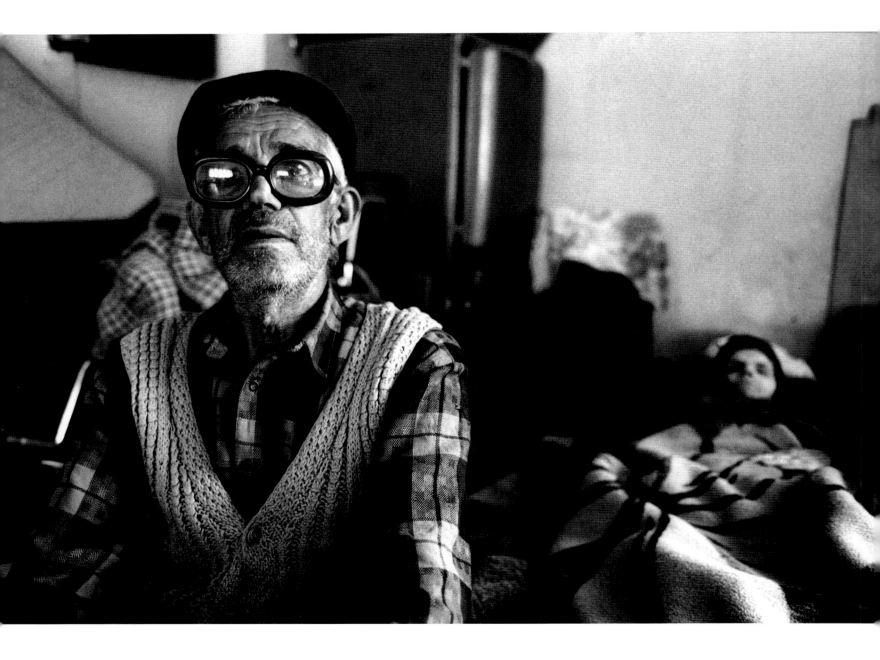

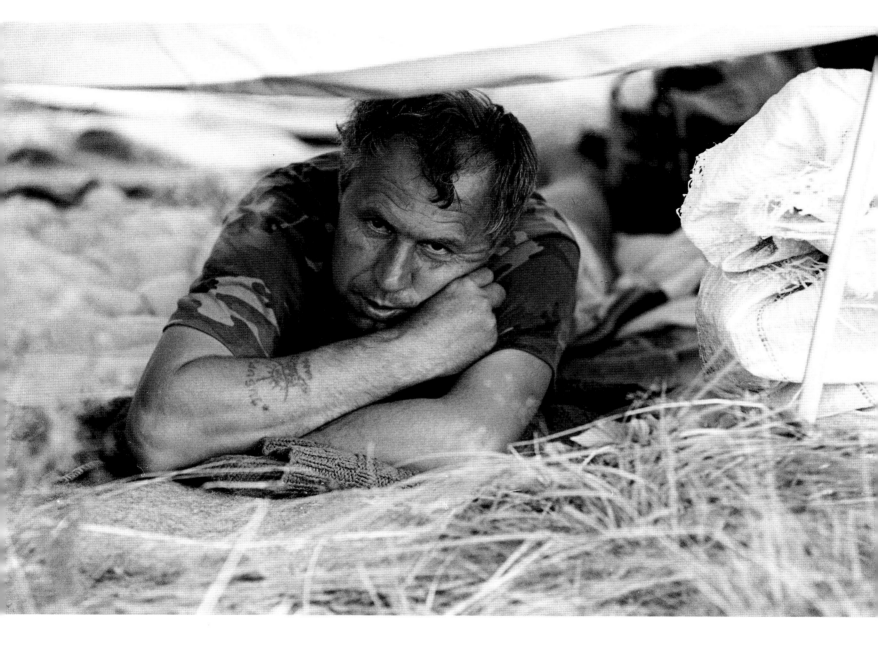

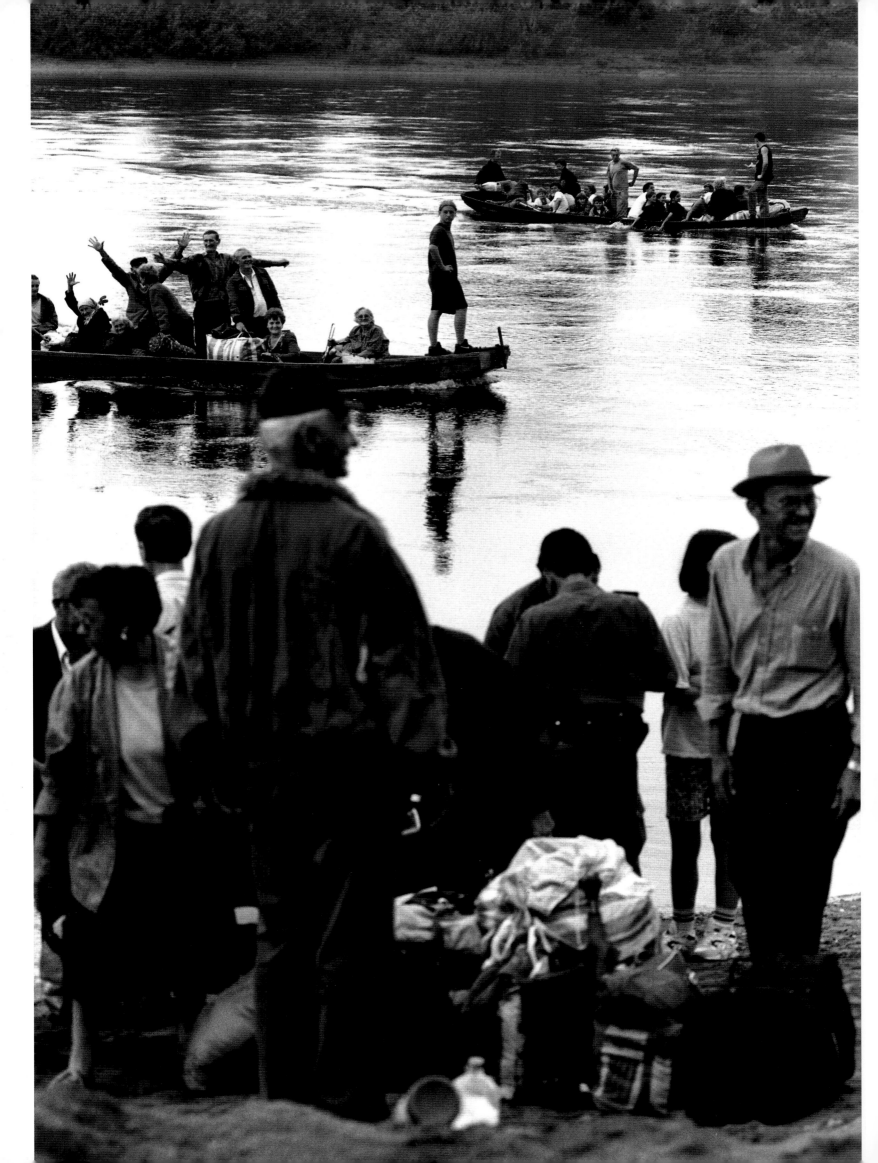

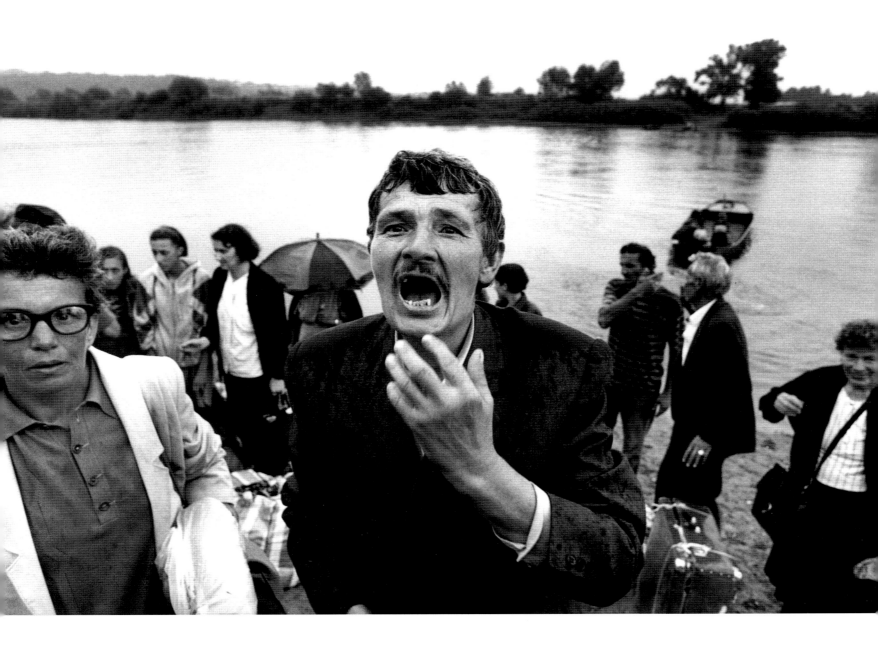

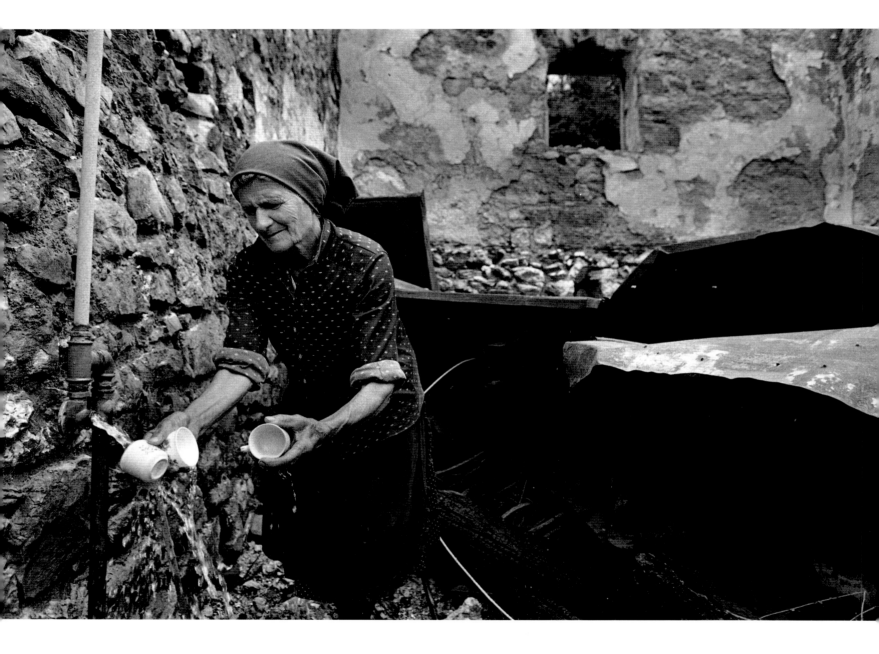

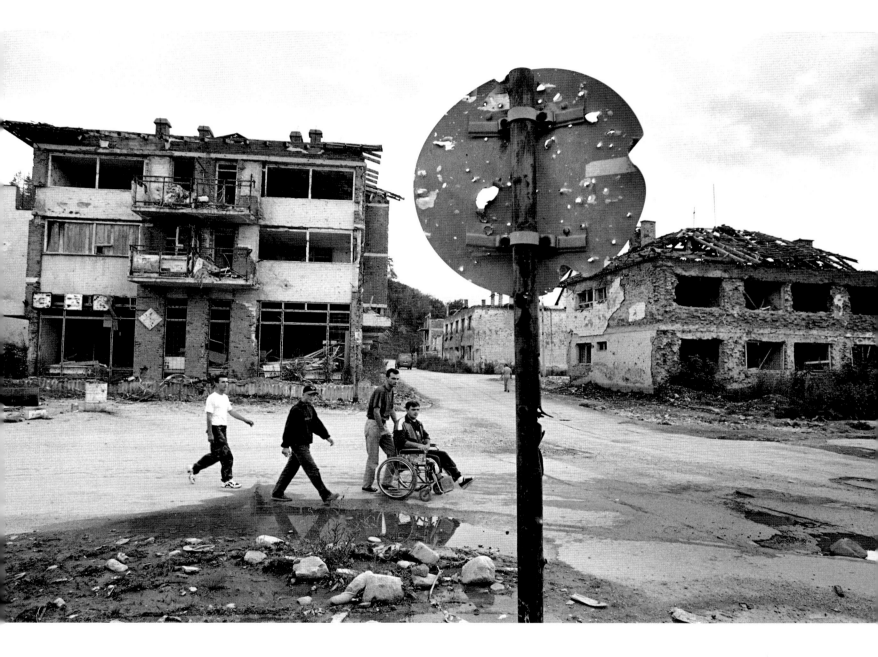

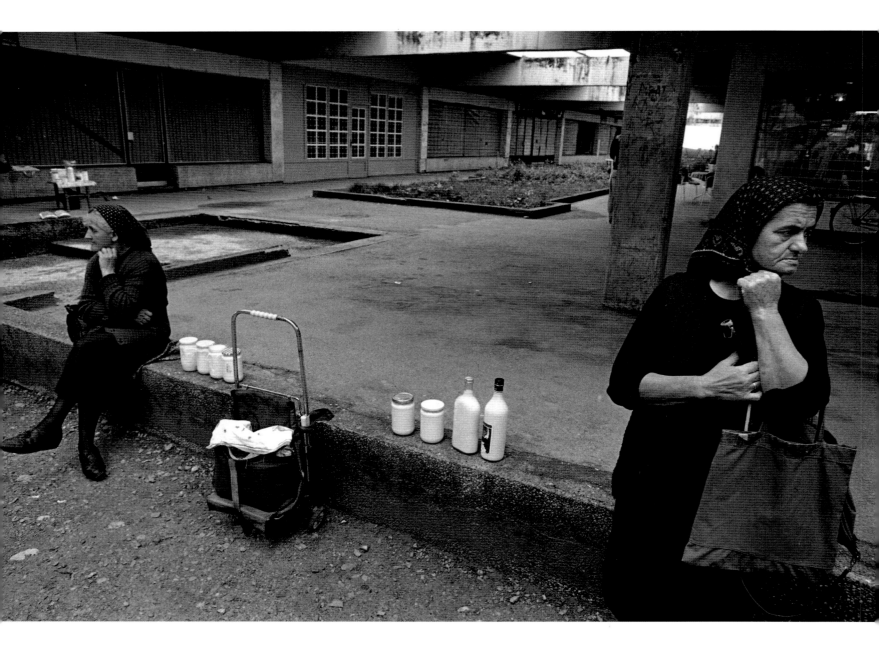

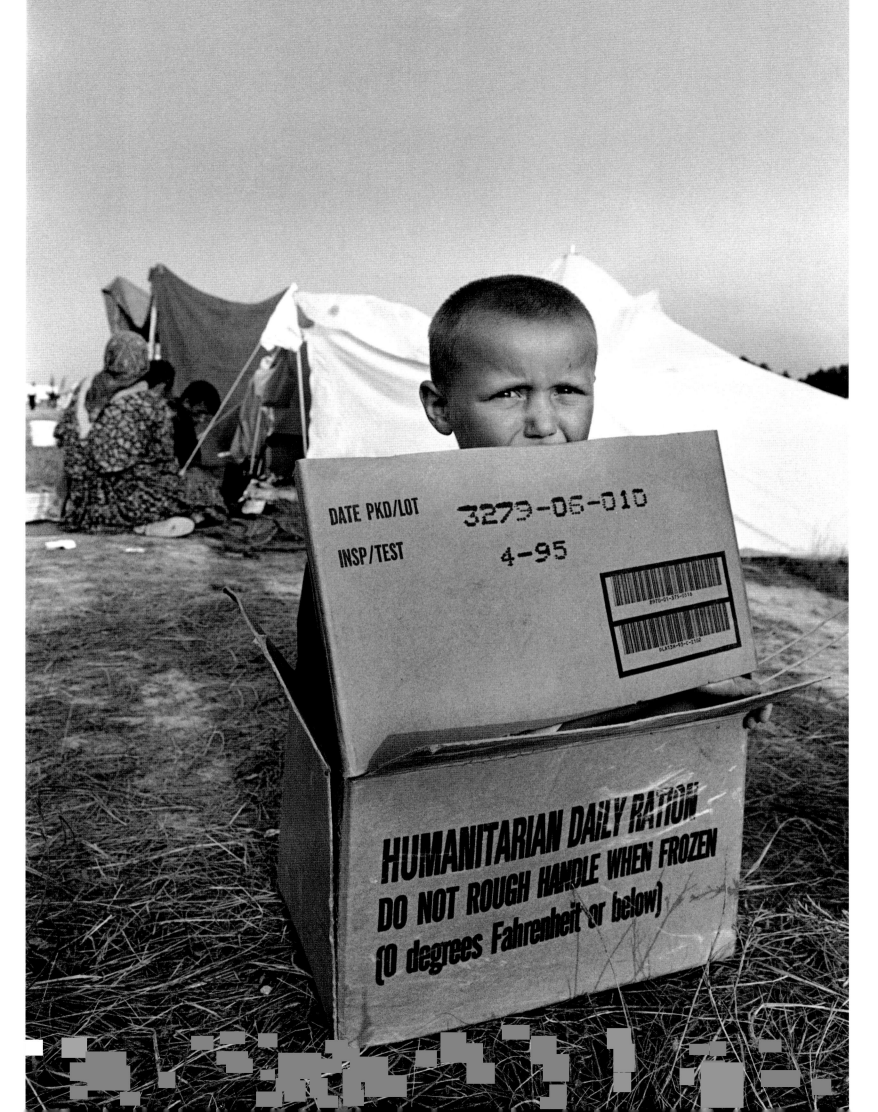

DATE PKD/LOT    3279-06-010

INSP/TEST         4-95

HUMANITARIAN DAILY RATION
DO NOT ROUGH HANDLE WHEN FROZEN
(0 degrees Fahrenheit or below)

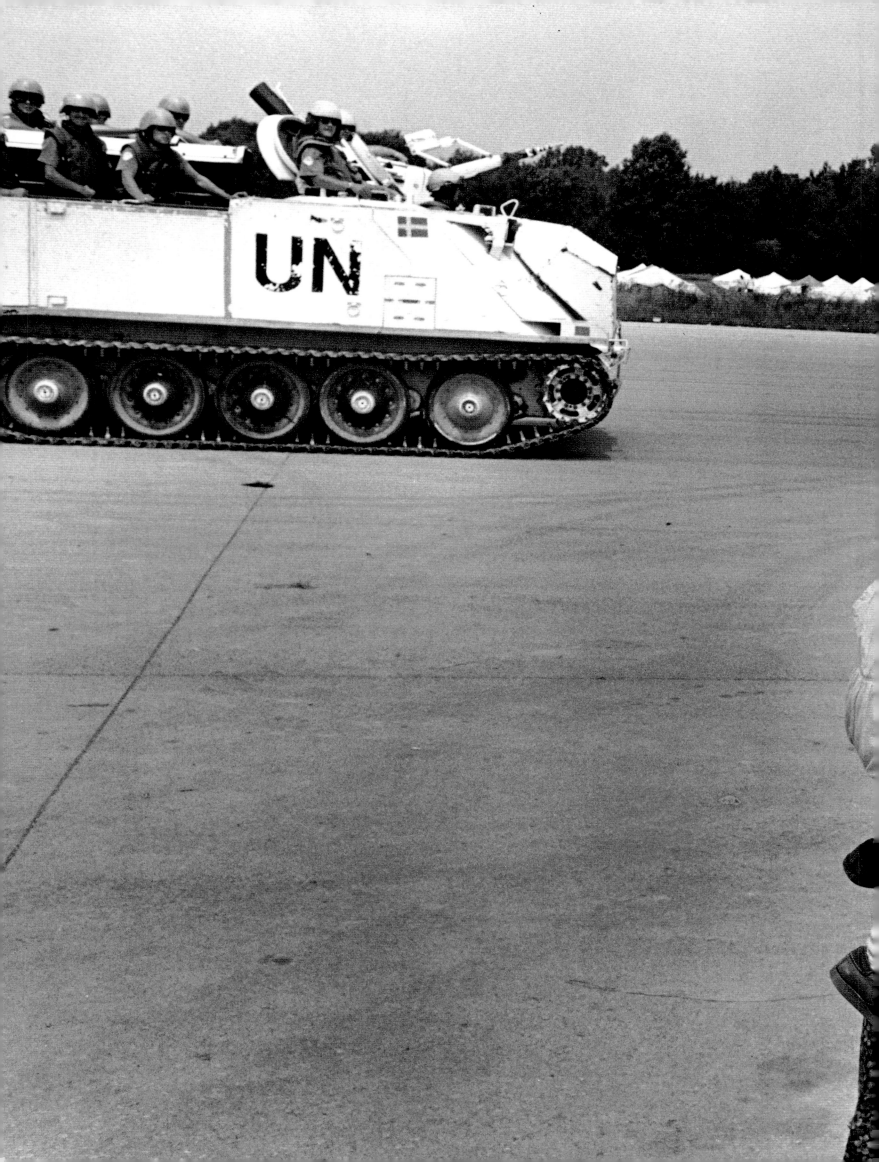

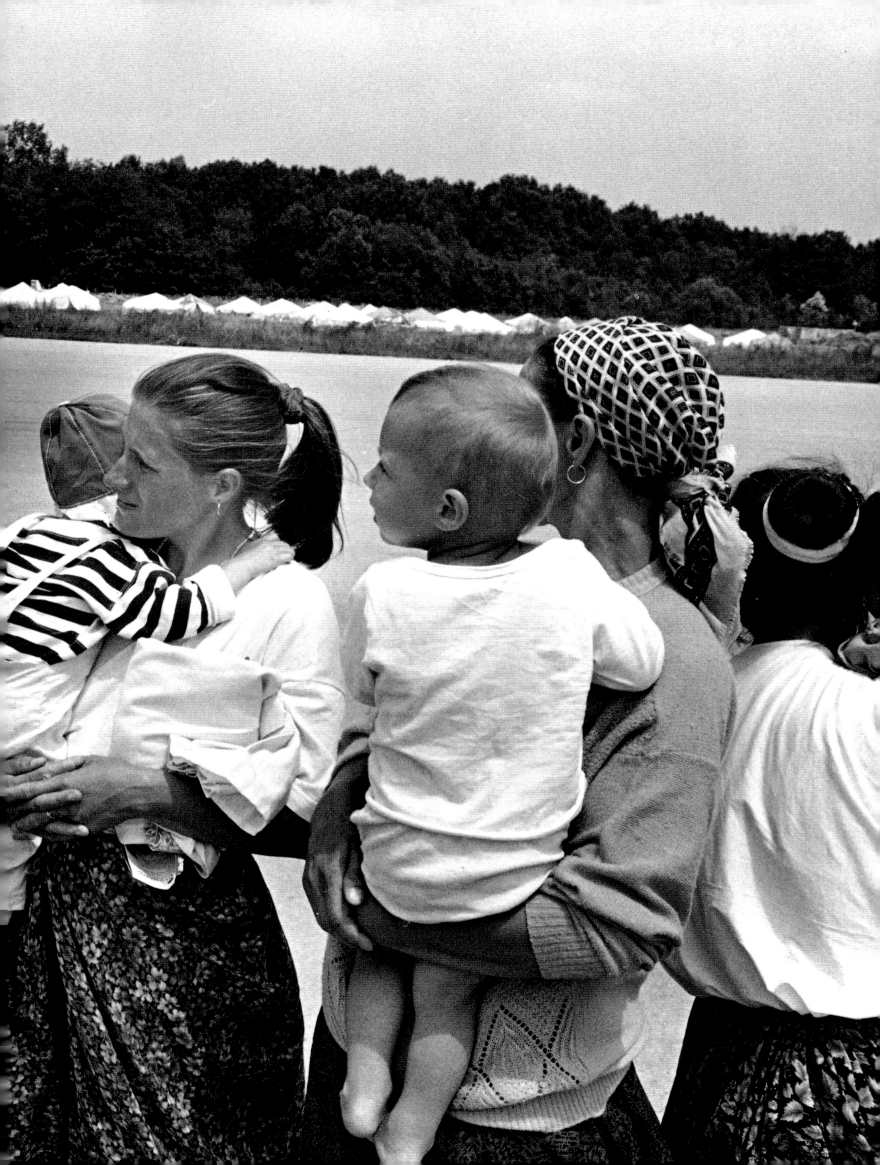

December 1979
Soviet troops march into Afghanistan following the outbreak of a popular uprising in opposition to the socialist reign of terror. Some six million Afghanis flee to Pakistan and Iran. Several different mujahedin groups begin a national war of liberation.

February 1989
In accordance with the terms of the Geneva agreements signed by Afghanistan, the Soviet Union, the US and Pakistan, the last Soviet troops leave Afghanistan. Afghani resistance groups are not party to the agreement. Hoping for peace, 1.5 million refugees return to their homelands in Afghanistan.

April 1992
Mujahedin forces take the city of Kabul and depose the Soviet-appointed government of President Najibullah. Bitter fighting ensues among the various mujahedin factions in the struggle for power in Kabul. In the following years, the city is laid to waste.

March 1993
The major warring factions meet in Islamabad and sign a treaty calling for a new interim government. Burhanuddin Rabbani is confirmed as president. Gulbuddin Hekmatyar is named Prime Minister. The peace treaty lasts no more than a few weeks, as the struggle for power in the country continues.

January 1994
The fight for control of Kabul is intensified as groups previously hostile to one another unite in an attack on Rabbani's forces. More than 4000 people are killed or severely wounded in Kabul during the first few weeks of the year. Some 60 000 people flee the battlegrounds of Kabul.

January 1995
A new group enters the war: Taliban units (Koran students from Pakistan) take Kandahar, the second largest city in the country. In the course of the year they achieve control over significant portions of Afghanistan.

September 1996
The Taliban overrun Jalalabad and take Kabul only a few weeks later. The northern region of the country remains under the control of General Rashid Dostum, while the Panshir mountain region, held by troops loyal to Rabbani, also remains inaccessible to Taliban control. More than two million Afghanis now live in Iran, Pakistan, India or the CIS republics as refugees. Hundreds of thousands are displaced within their own country.

May 1997
Following an internal revolt by his leading military commanders, General Dostum loses control of the northern part of the country and is forced to flee Afghanistan. The conquest of Mazar-i-Sharif by Taliban forces is only a matter of time.

Young girl in front of a refugee camp, Jalalabad, Afghanistan, 1996
Military position, forces of General Rashid Dostum, Balkh, Afghanistan, 1996
Refugee camp, Jalalabad, Afghanistan, 1996
A view through the *burka* (veil), Kabul, Afghanistan, 1996
Woman refugee from Kabul: Taliban rebels cut off the tip of her thumb because she was wearing fingernail polish, Kabul, Afghanistan, 1996
Money-changer in Kabul, Afghanistan, 1996
Woman wearing a veil, outskirts of Kabul, Afghanistan, 1996
Feeding refugee children from Kabul in a refugee camp, Mazar-i-Sharif, Afghanistan, 1996
A refugee-camp bakery, Mazar-i-Sharif, Afghanistan, 1996
Victims of land mines at the orthopedic center, Kabul, Afghanistan, 1996
Young boy with firewood in the old section of Kabul, Afghanistan, 1996

# AFGHANISTAN

# THE NEVER-ENDING WAR

**Photographed by Christian Jungeblodt in December 1996**

The people of Afghanistan have lived in a constant state of civil war since 1979. While the various mujahedin groups initially united in their fight against the Soviet army, they have waged destruction in Afghanistan since 1992 in a bloody power struggle. Kabul is particularly hard hit by the fighting. By 1992, more than six million people had left their homeland in fear of falling victim to the ongoing warfare. In early 1995, Taliban groups composed of radical Koran students intervened in the conflict. Having occupied large portions of Afghani territory, their activities result in a new wave of refugee movements in 1996. Women in particular are eager to escape their radical rule.

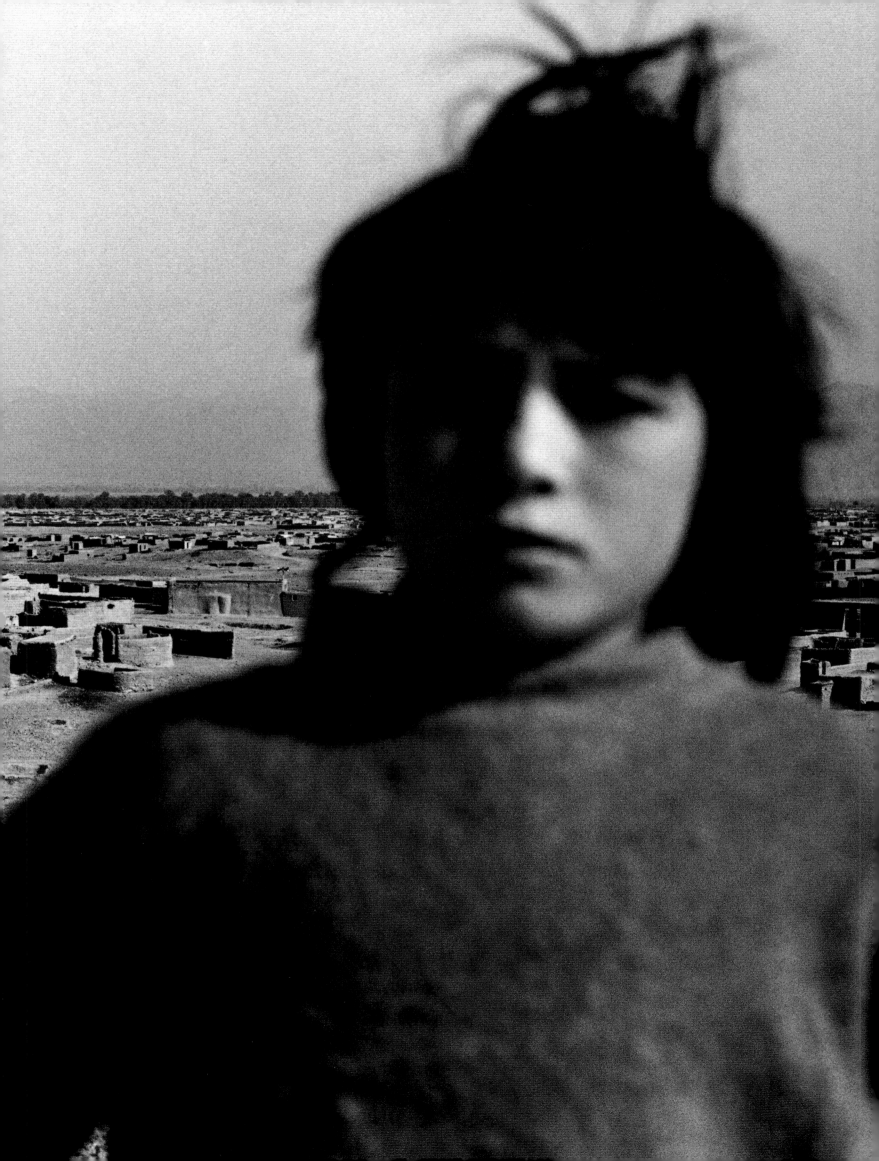

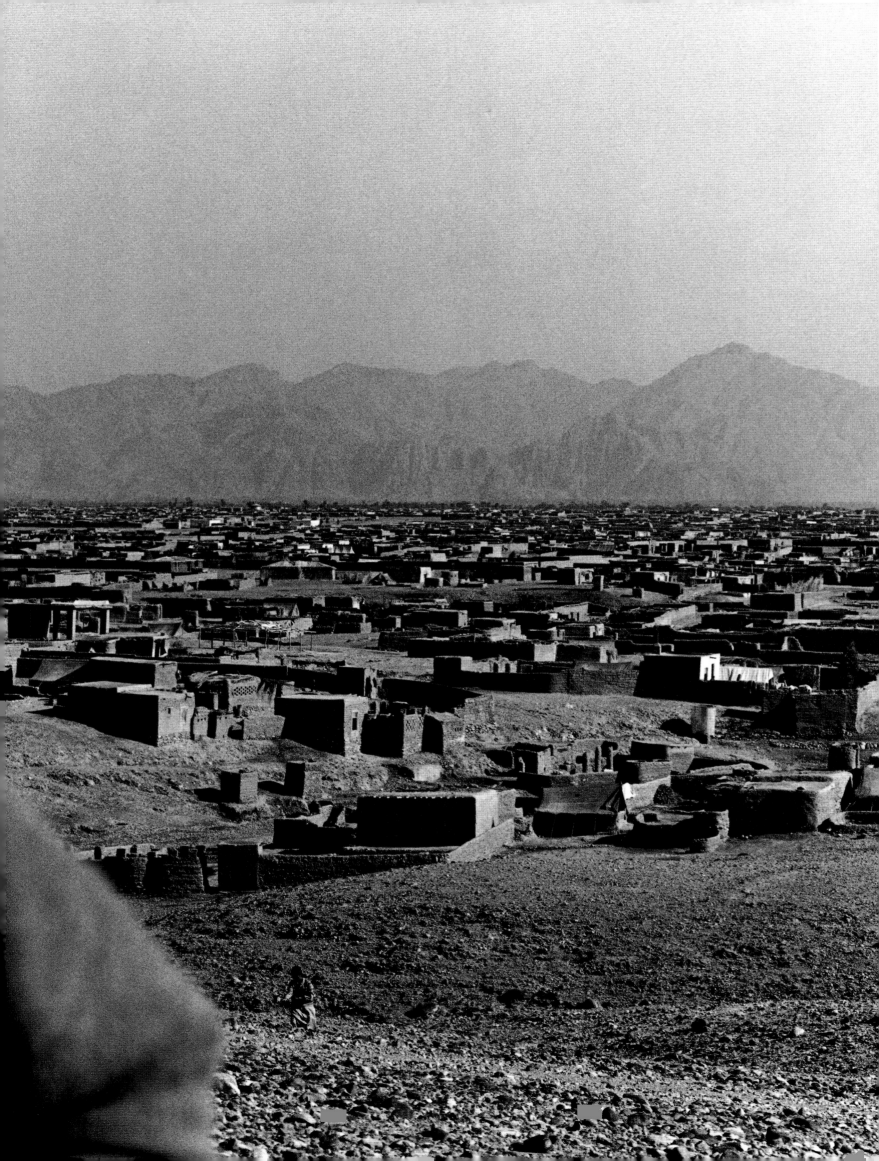

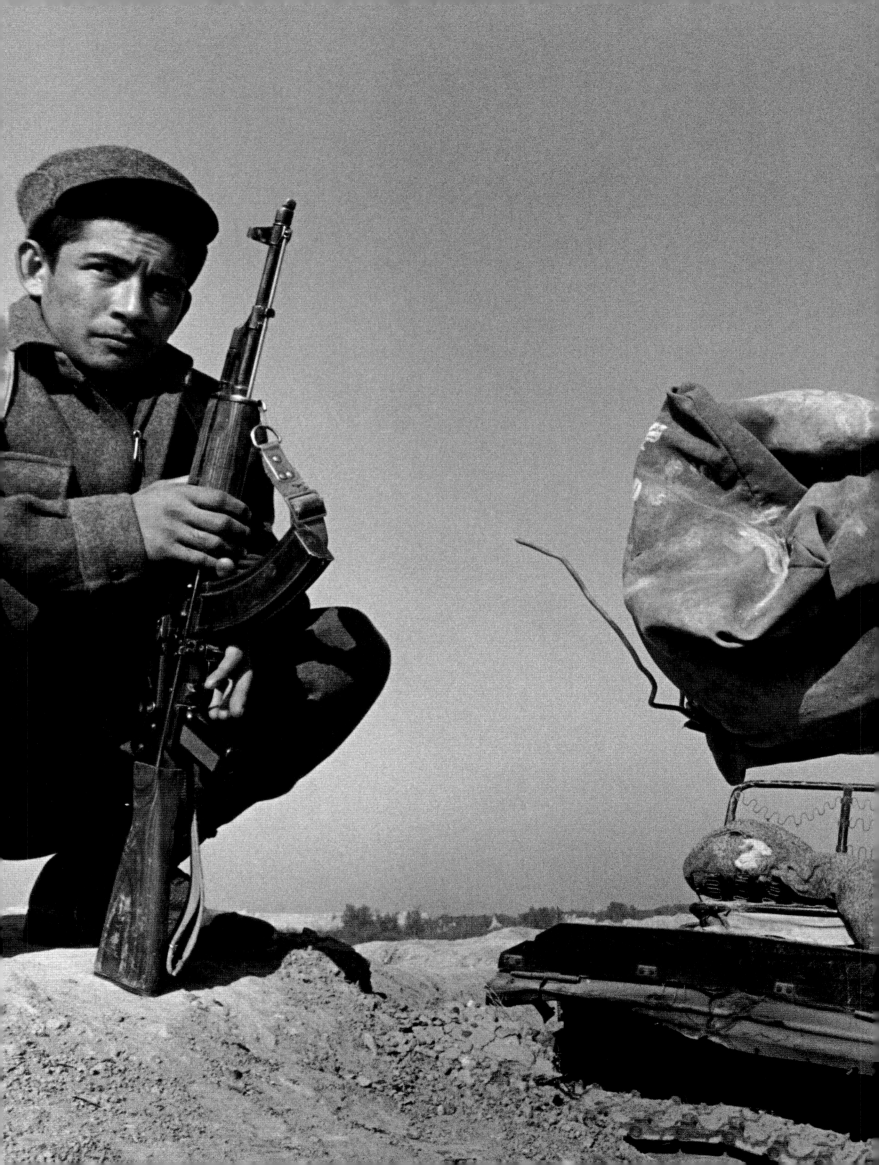

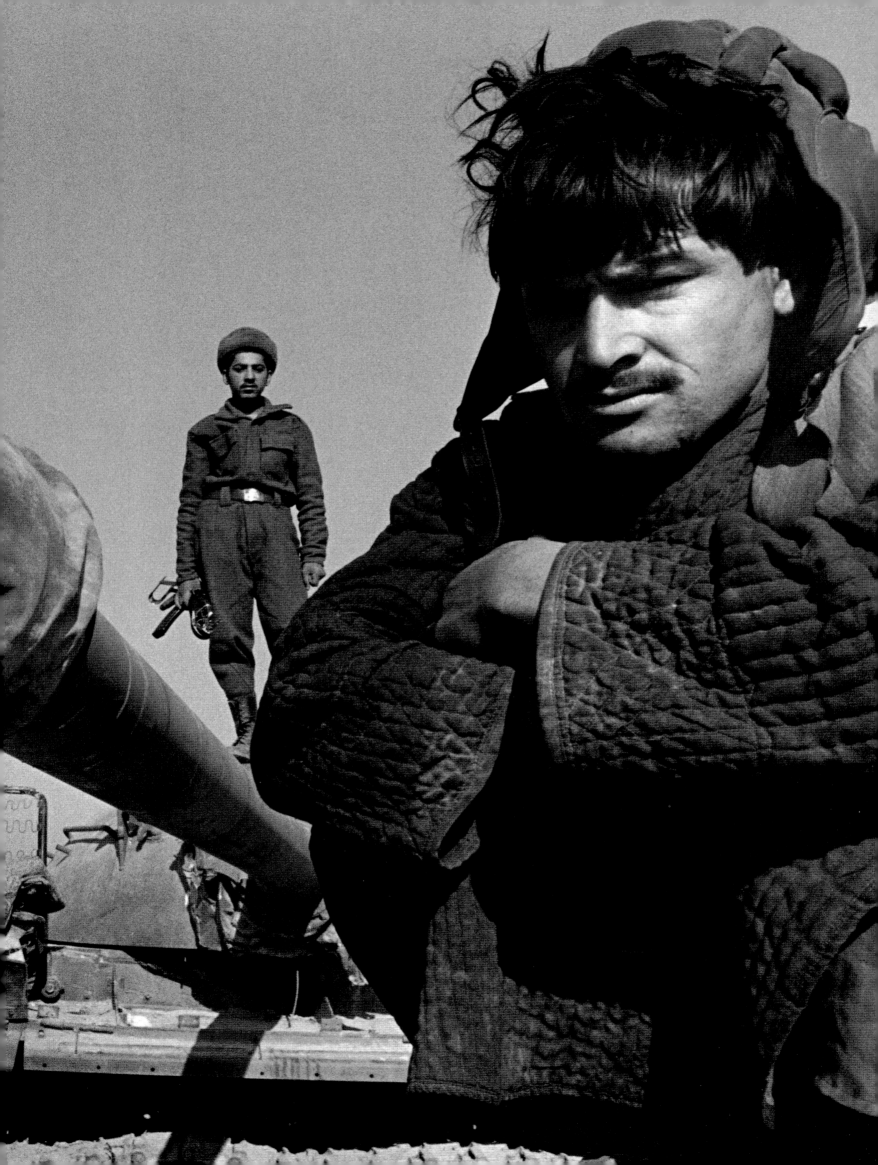

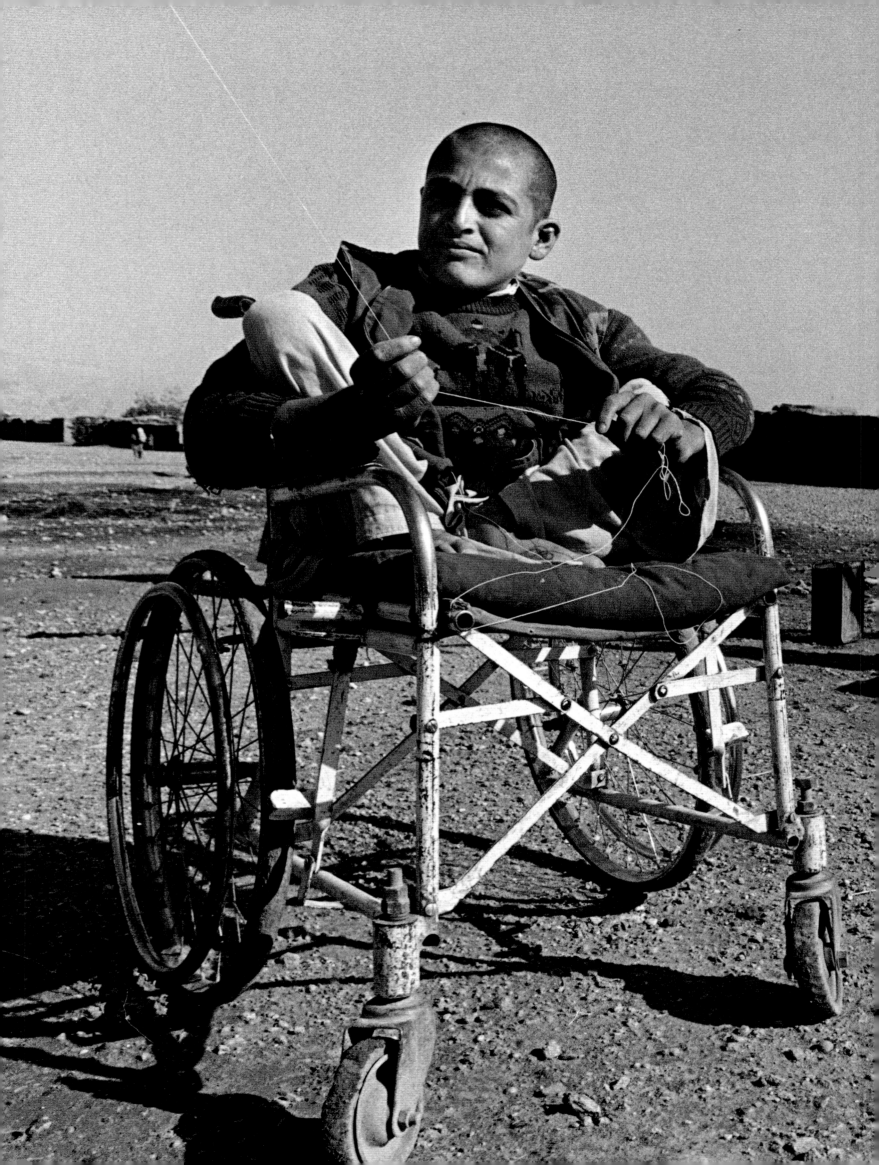

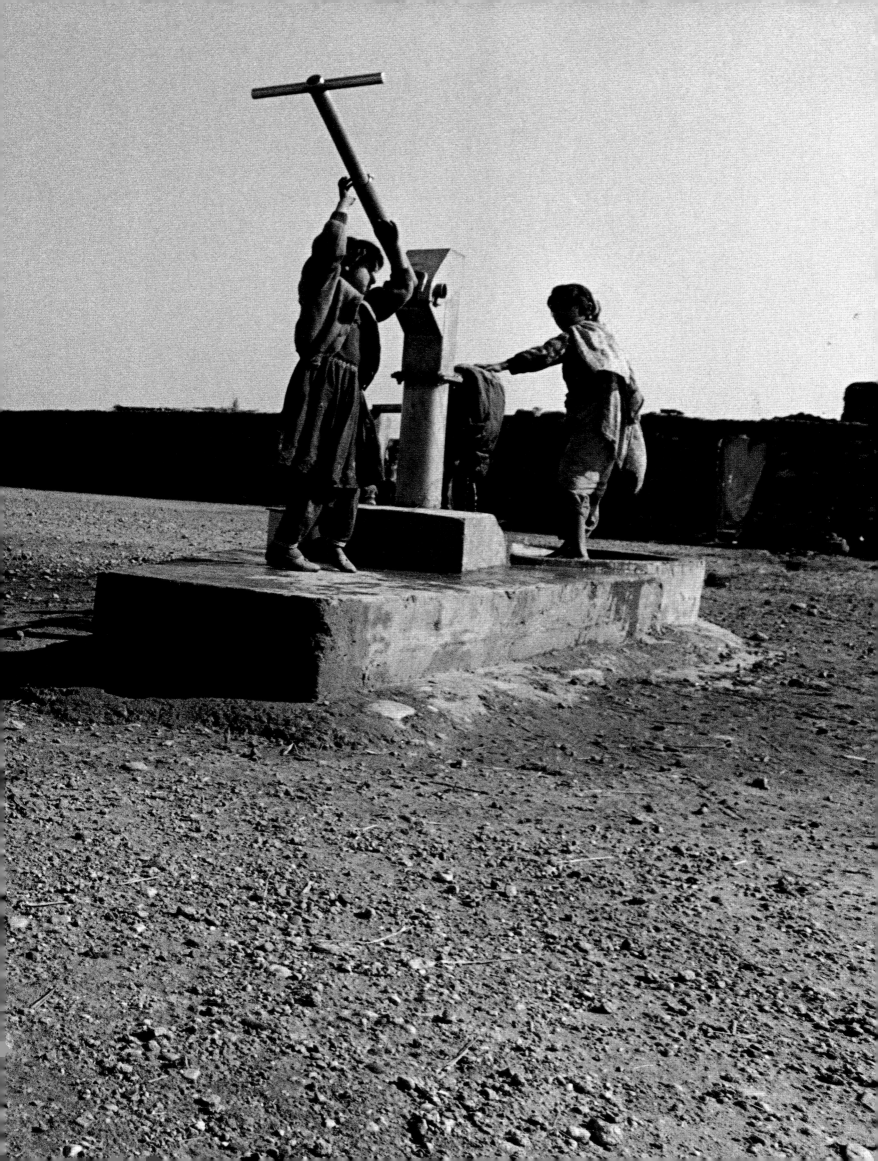

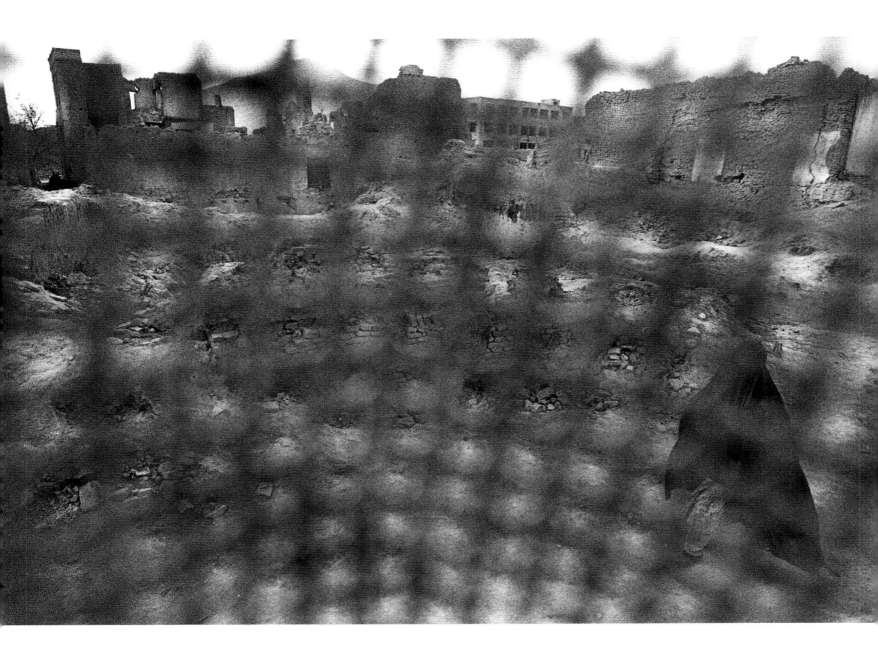

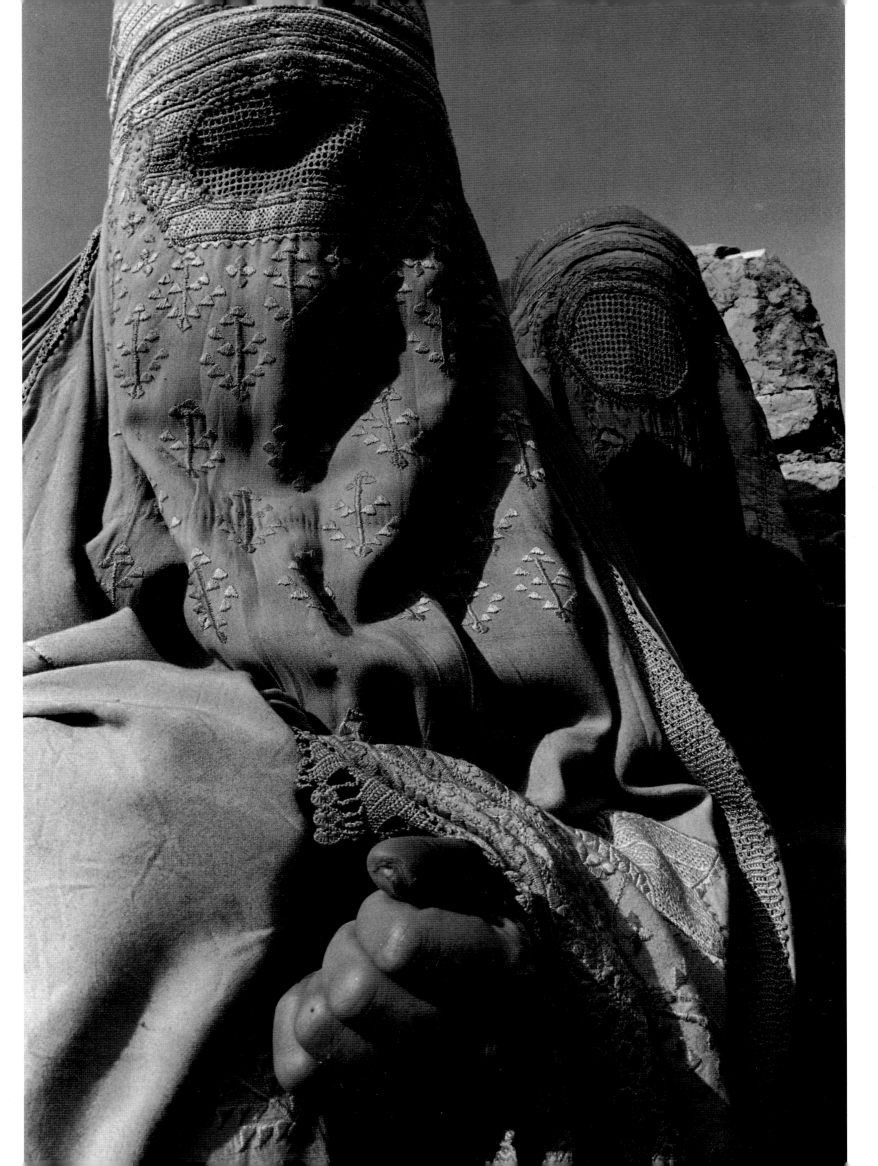

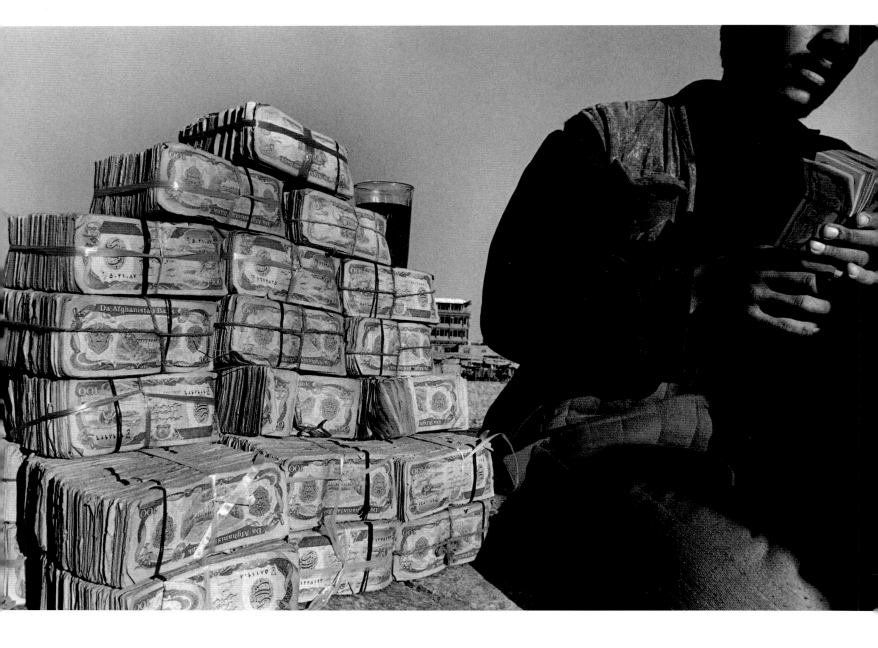

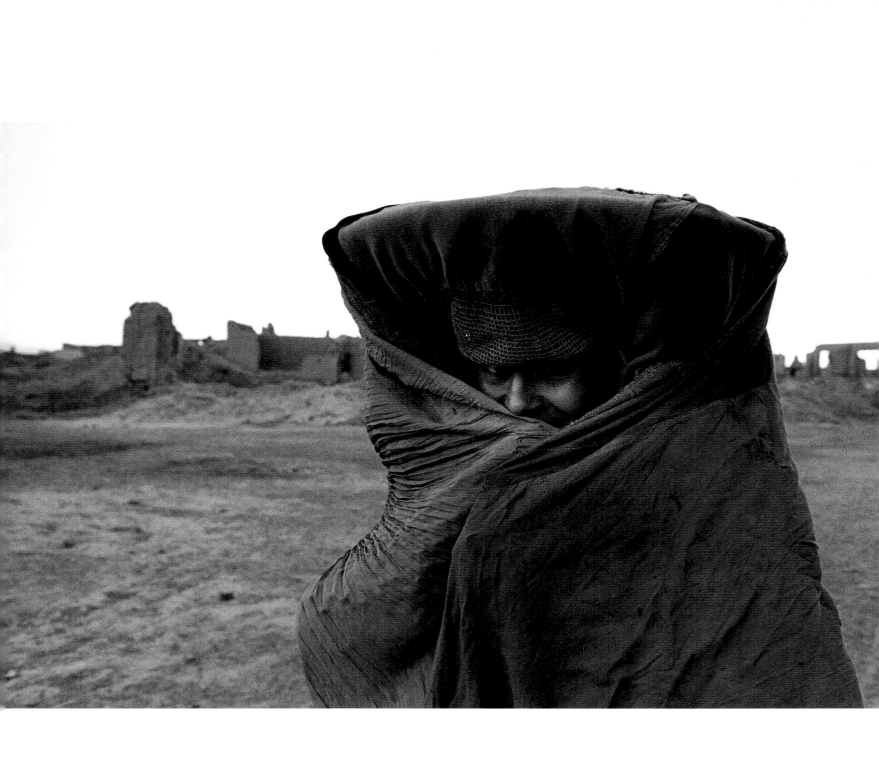

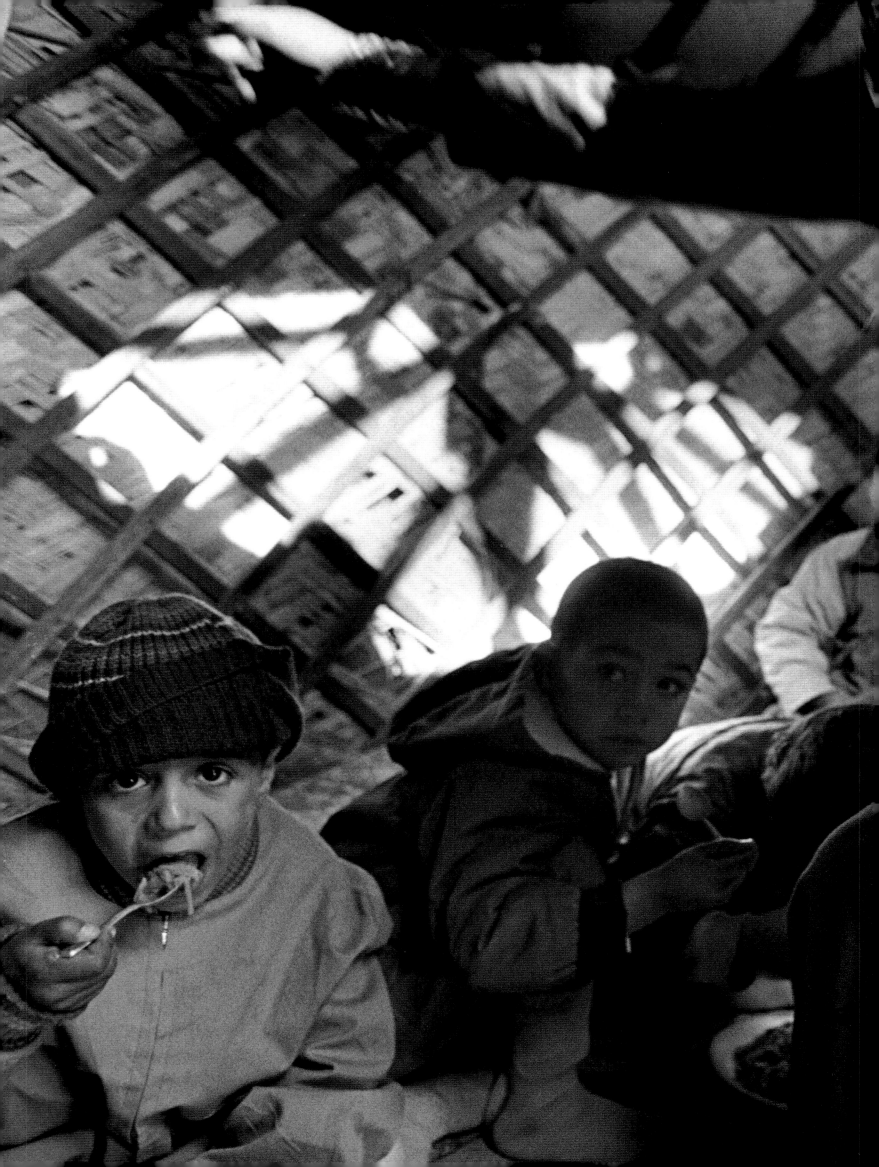

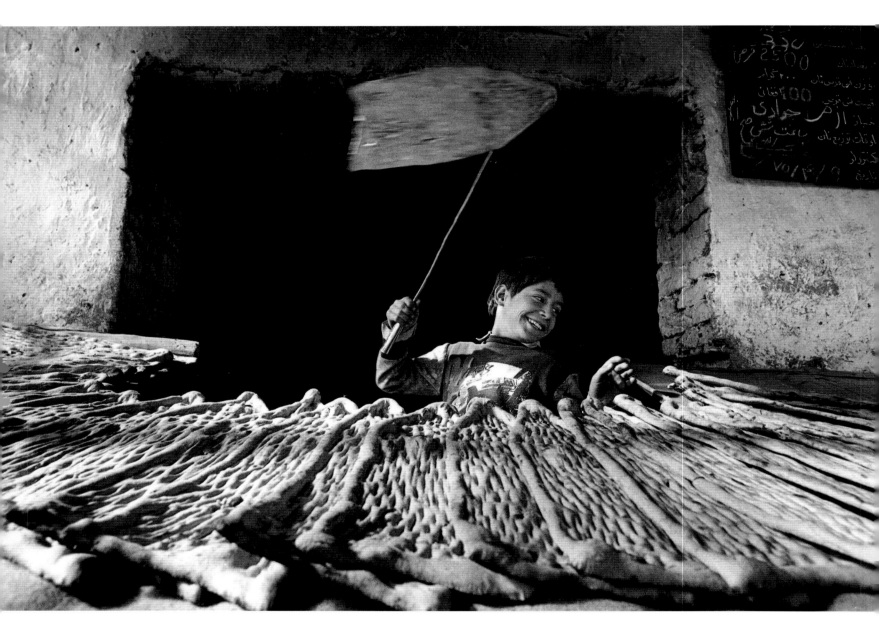

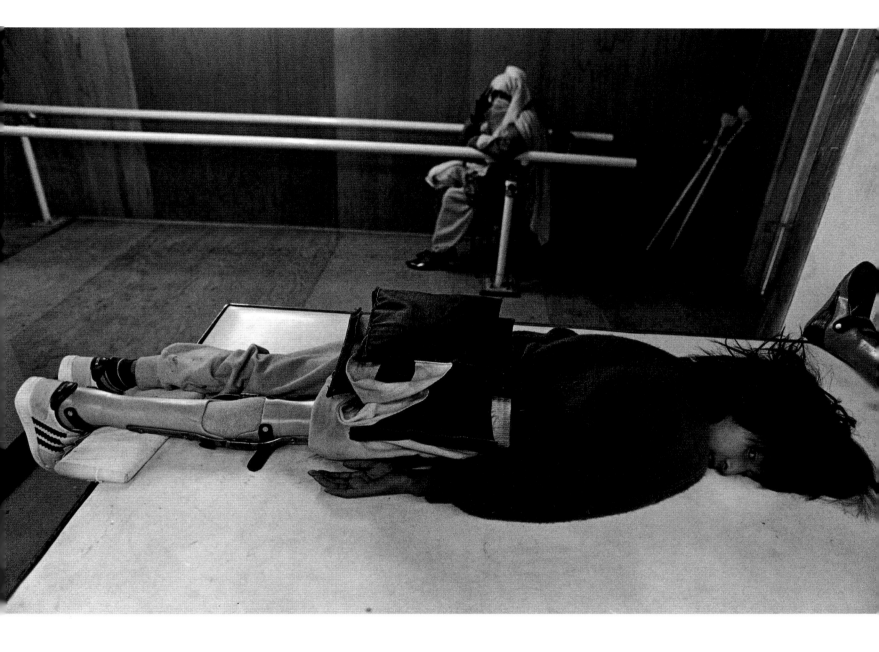

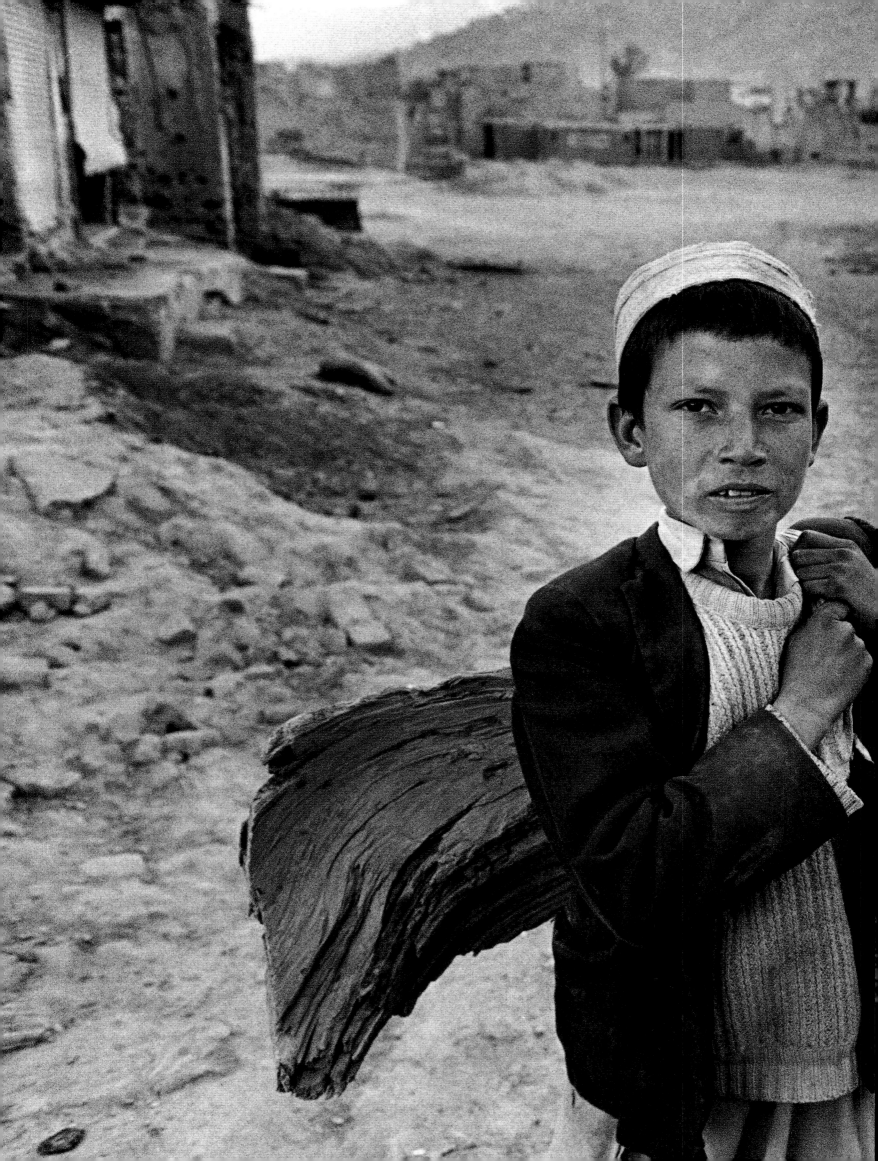

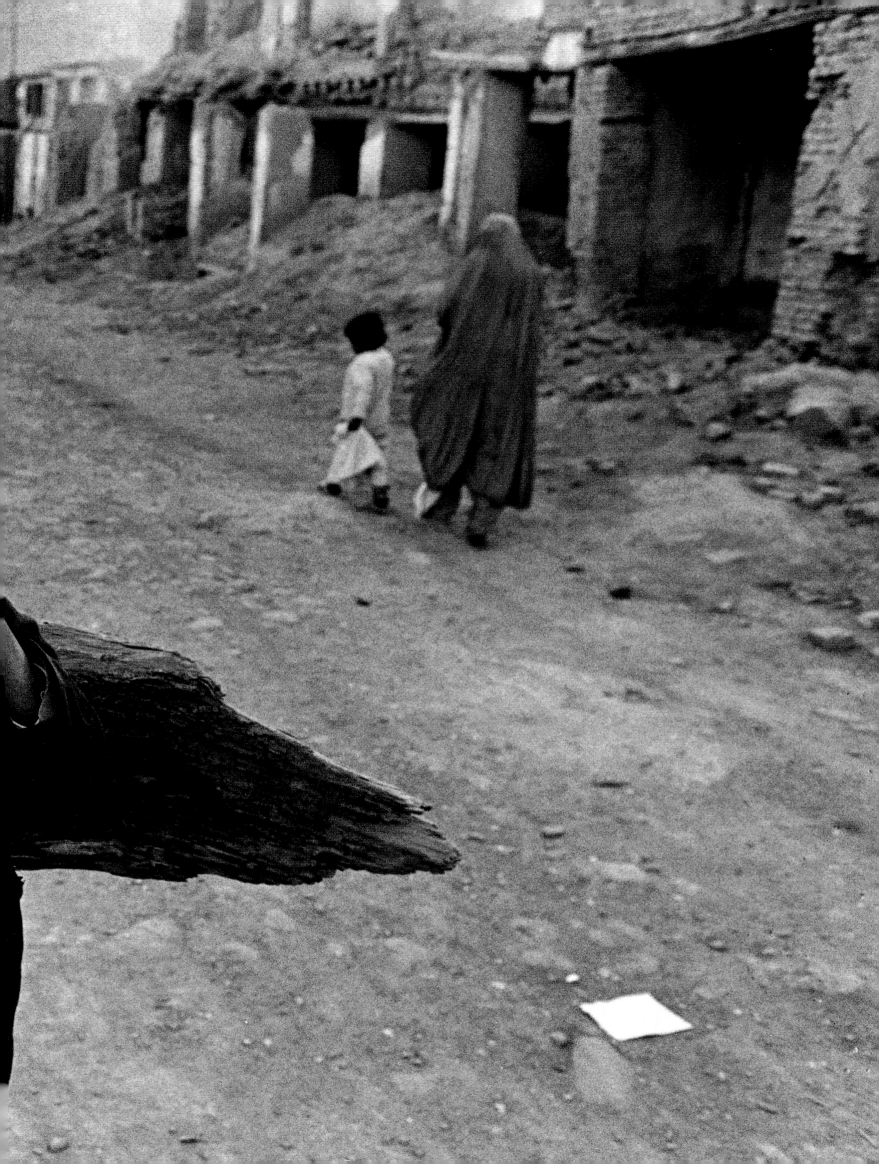

To the late sixties
The Mexican government pursues an inward-oriented economic policy intended to protect domestic industry and commerce from international competition. Its goal is national industrialization by means of import substitution.

Early 1970s
President Echaverría seeks to counteract the effects of the trade deficit associated with the import substitution policy and the problems involved with shortages in the domestic supply of complex capital goods through government investment. Broad segments of the private sector protest this government intervention.

Late 1970s
Substantial discoveries of oil and the income derived from oil production serve to alleviate the crisis caused by the inward-oriented policy and rising foreign debt.

1981/82
The sudden collapse of international oil prices exacerbates the situation caused by massive government spending financed through credit. High US interest rates force Mexico to declare itself insolvent; international credit sources quickly run dry. Corruption, the general inefficiency of Mexican production and the inability of state-owned industries to compete on the international market due to the lack of domestic competition become increasingly obvious. The import substitution policy has failed.

Since 1982
The government embraces a neo-liberal economic policy: diminishing state involvement in the economy, the opening of markets (GATT membership in 1986; free-trade agreement with the US and Canada [NAFTA] in 1992; free-trade agreement with Colombia and Venezuela in 1994). The negative social consequences of this policy become increasingly difficult to ignore. Gross domestic product slumps, the inflation rate rises by nearly 100 per cent and both average and minimum wages fall by up to 50 per cent. Approximately two million Mexicans immigrate illegally to the US during the 1980s.

1989
The US initiates construction of a fence along the border to Mexico in order to stem the tide of refugees. Those who do succeed in reaching the alleged paradise find themselves caught between fronts. African Americans regard the Hispanics as unwanted competition; white taxpayers see them as a financial burden. The majority of Californians voted to exclude illegal immigrants from entitlement to social benefits, to refuse their children admission to schools and to provide medical care only in emergencies.

Border fence between Mexico and the US, Tijuana, USA, 1996
Waiting for an opportunity to cross the border into the US, Tijuana, Mexico, 1996
Children sniffing glue at the border to the US, Tijuana, Mexico, 1996
Illegal immigrants from Mexico being registered by US border patrol officers, Tijuana, USA, 1996
Waiting for an opportunity to cross the border into the US, Tijuana, Mexico, 1996
Waiting for an opportunity to cross the border into the US, Tijuana, Mexico, 1996
Waiting for an opportunity to cross the border into the US, Tijuana, Mexico, 1996

# MEXICO

## ACROSS THE FENCE

**Photographed by Clive Shirley in February 1996**

Population growth, unemployment, inflation and social conflicts have cast thousands of Mexicans
into financial ruin. Government aid is virtually non-existent. Thus, for many, the last hope
is *el norte* – the southern United States, where often a day's wages for workers in agriculture,
industry or the restaurant business amounts to a monthly paycheck in Mexico.
Encouraged by these circumstances, nearly two million Mexicans have immigrated illegally to the US
since the eighties. In order to keep Mexican economic refugees out, the US government
has sealed off a portion of the two-thousand-mile border to Mexico with a twelve-foot high fence.

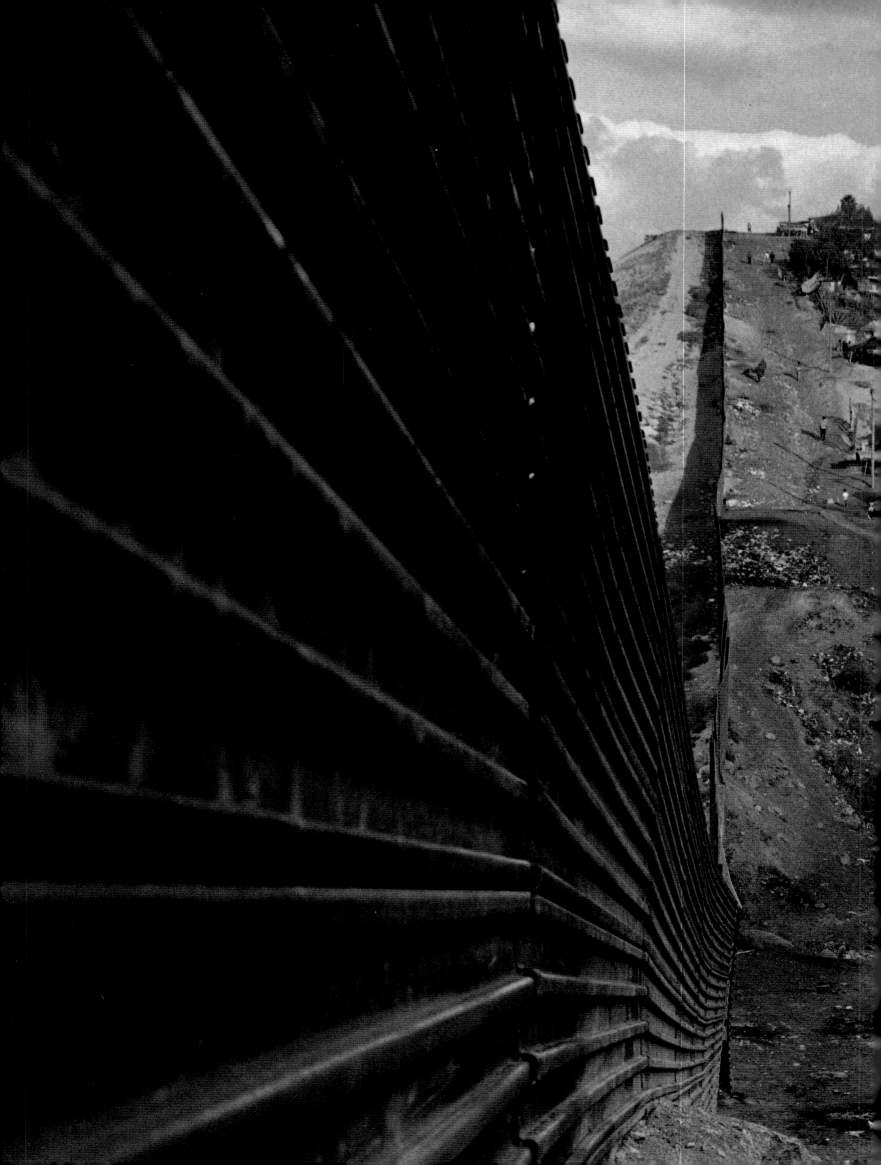

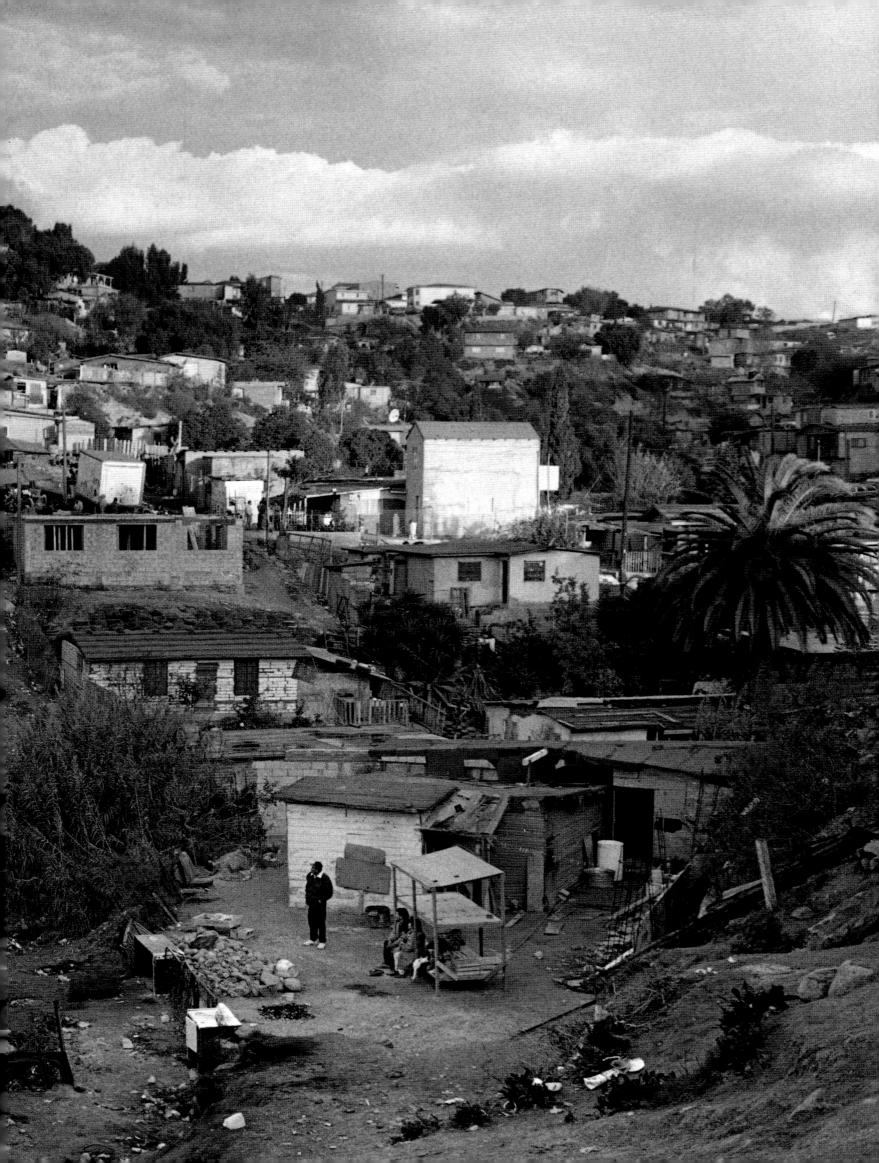

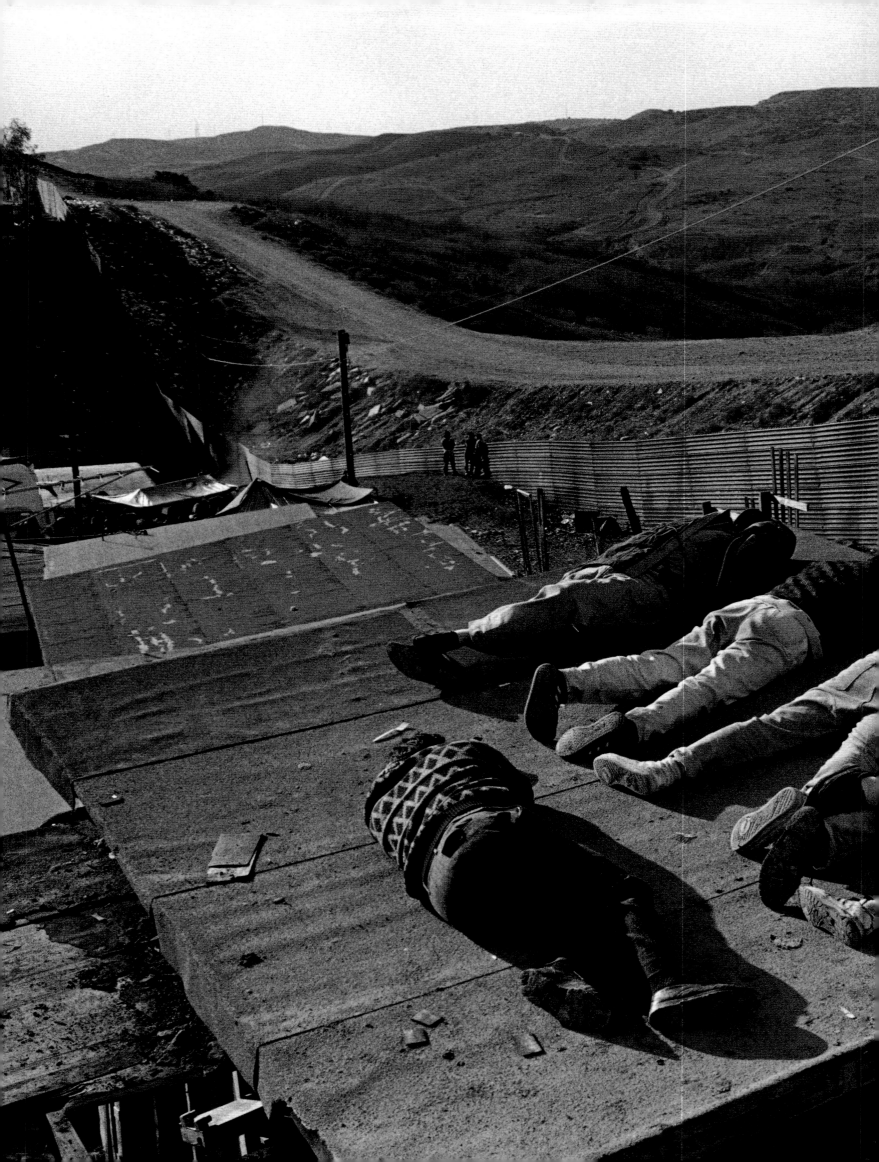

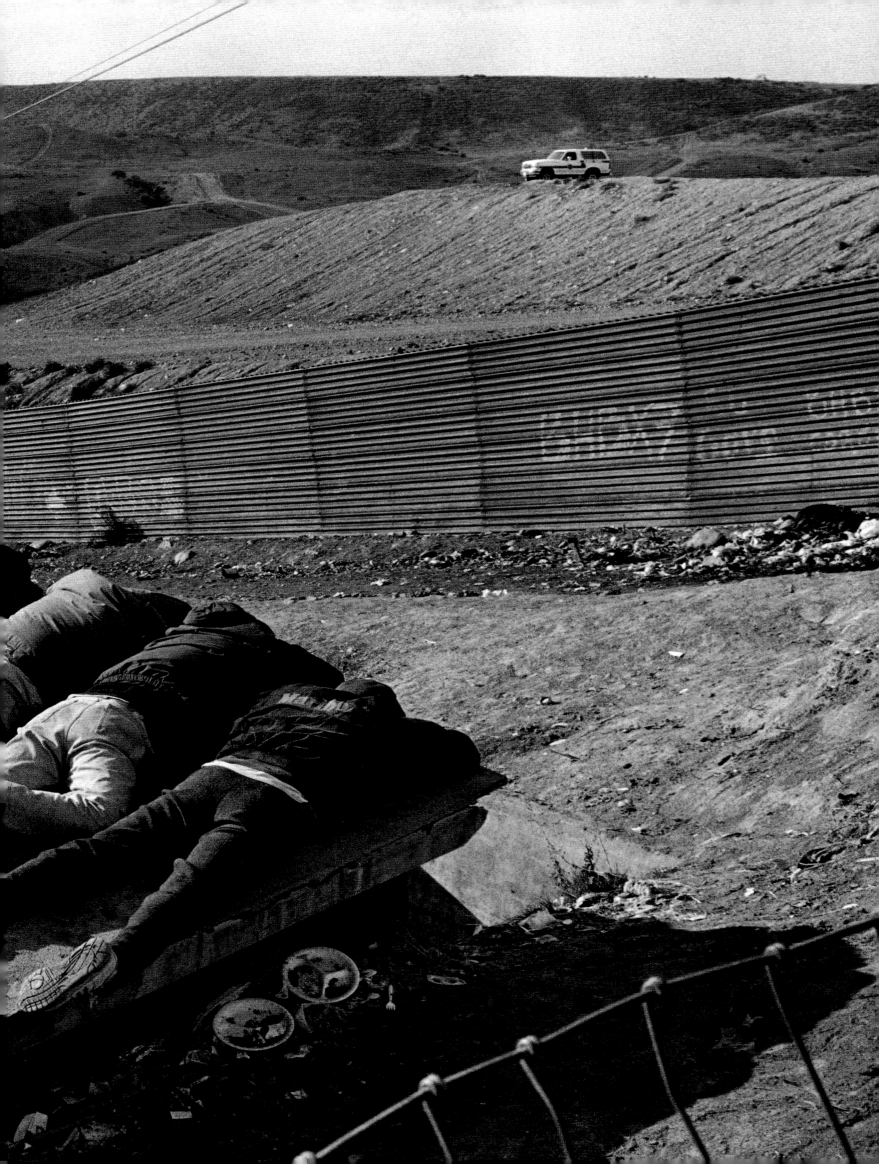

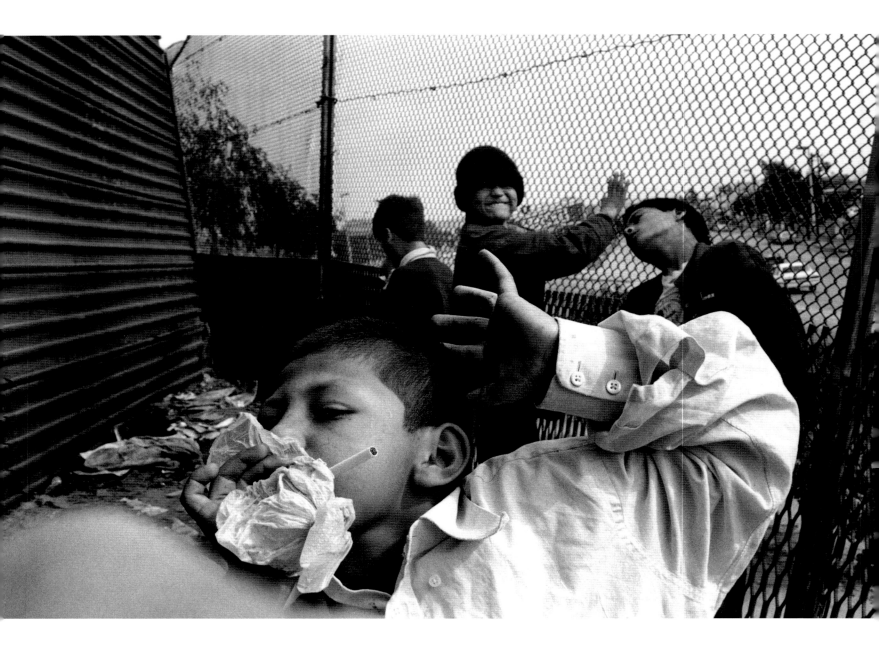

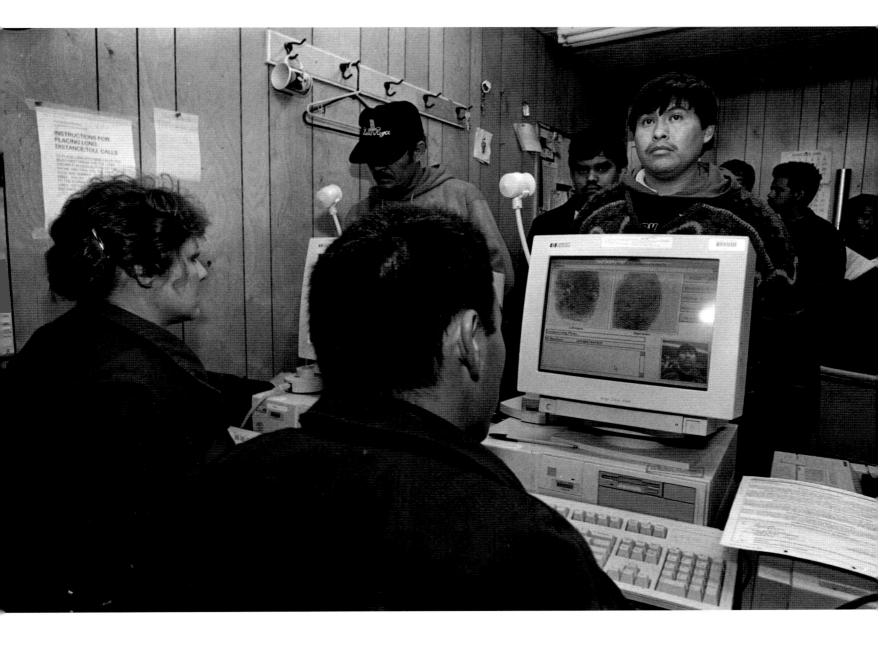

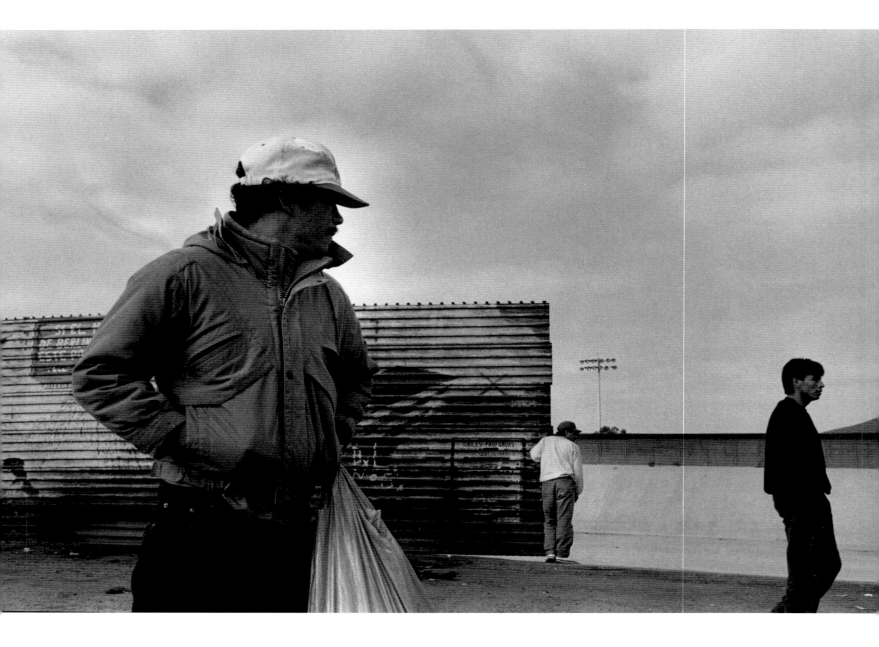

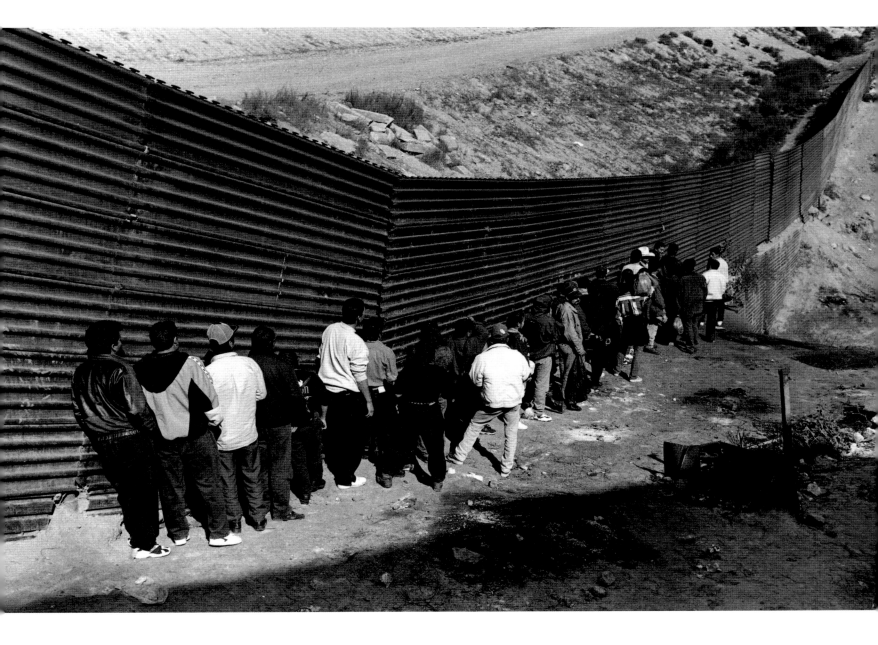

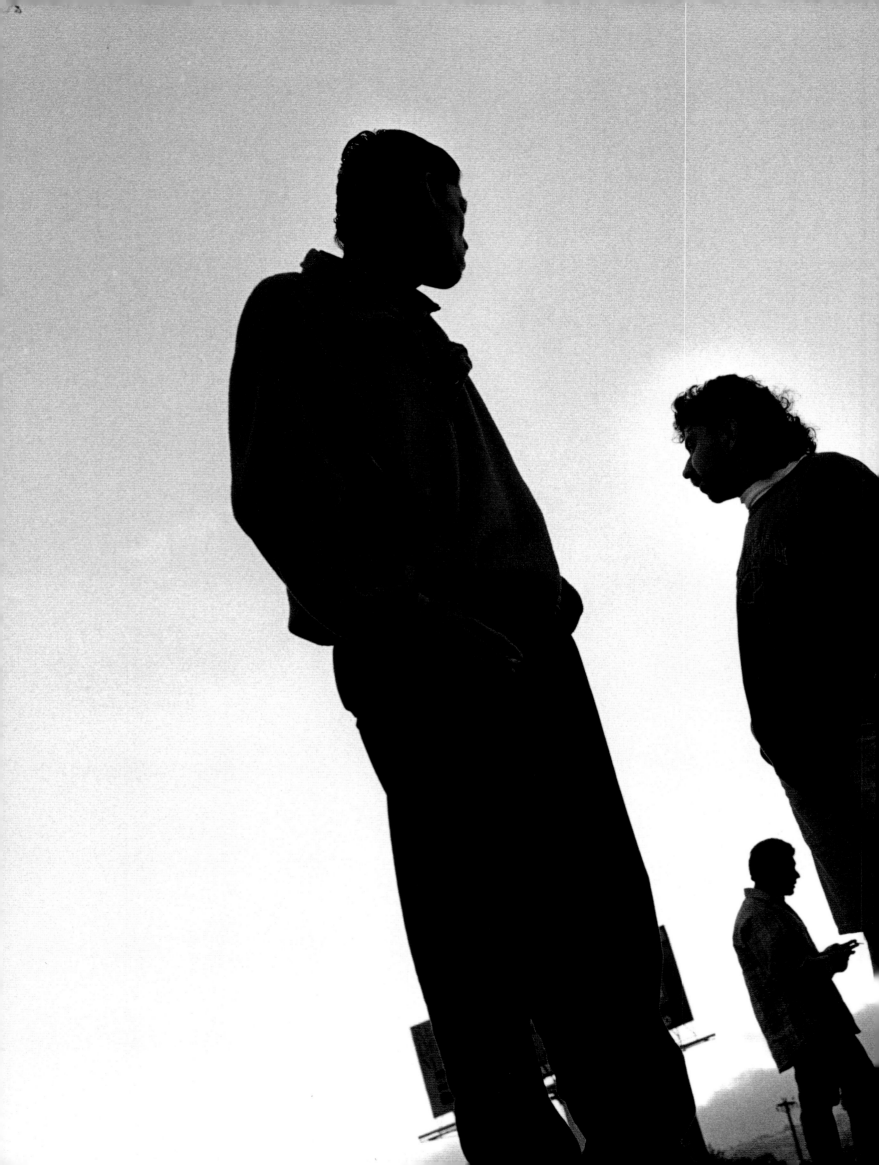

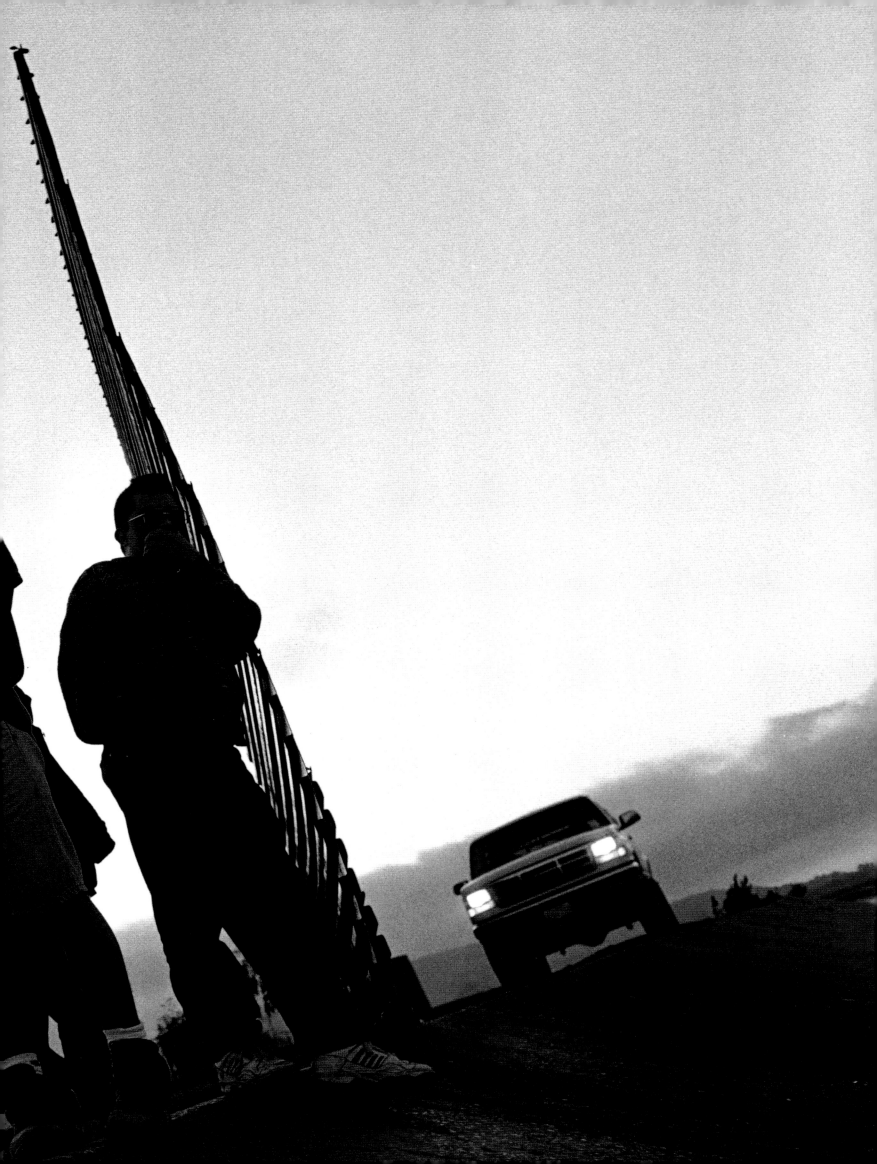

1967 – 1992

Sierra Leone is ruled by succession of one-party and military governments. In 1991, the rebel organization Revolutionary United Front (RUF) emerges under the leadership of Foday Sankoh. A civil war begins, in the course of which the country witnesses the deaths of more than 14 000 people, the total collapse of law and order and the plight of an estimated 2.4 million people driven from their homes, seeking refuge either elsewhere in the country or abroad – more than half of the total population of Sierra Leone. Human rights violations committed by government and RUF forces are daily routine. In 1992, President Joseph Momoh is deposed in a takeover of power by the military. Captain Valentine Strasser, Chairman of the National Provisional Ruling Council (NPRC) becomes head of government, commander in chief of military forces and defense minister in one.

1995

The government's report on human rights in Sierra Leone indicates a slight improvement in the situation. Although massacres are still carried out by government and RUF troops, most of the deaths recorded are casualties of the armed conflict.

1996

Valentine Strasser is deposed during a palace revolt. Brigadier General Julius Maada Bio assumes the office of NPRC Chairman. The elections held on 26 and 27 February, in which several different parties take part, open a new chapter in the history of Sierra Leone. Despite the danger of military intervention and threats to disrupt the election by Foday Sankoh's RUF, the election is carried out successfully. On March 29, Julius Maada Bio transfers the reigns of government during an official ceremony to Ahmad Tejan Kabbah, the democratically elected president. In his inaugural address, Kabbah praises the army and the people of Sierra Leone for their committed support of the elections that would pave the way for a return to democracy.

Women refugees receiving inoculations, Bo, Sierra Leone, 1996
Woman refugee in her dwelling in downtown Bo, Sierra Leone, 1996
Diamond seeker, Bo, Sierra Leone, 1996
Full taxi, Kenema, Sierra Leone, 1996
Child leading a blind man, Kenema, Sierra Leone, 1996
Downtown Bo, a city overflowing with refugees, Sierra Leone, 1996
Makeshift huts for displaced persons, Bo, Sierra Leone, 1996
Refugees from Liberia at Camp Waterloo, Freetown, Sierra Leone, 1996
Muslim funeral, Kenema, Sierra Leone, 1996
Folkdance, Kenema, Sierra Leone, 1996

**Photographed by Andreas Herzau in September 1996**

A succession of military and one-party governments ruled Sierra Leone for a period of thirty years.
A civil war broke out in 1991, leaving 14 000 dead, a devastated legal system
and 2.4 million refugees and displaced persons in its wake. Although rich in mineral resources,
the country's exports fell sharply. Today, the country's economy is in shambles.
Nevertheless, the elections held under the eyes of international observers in February 1996,
the formation of a civilian government and the initiation of negotiations
with the rebels have once again fueled hopes for democratization
and stabilization in Sierra Leone.

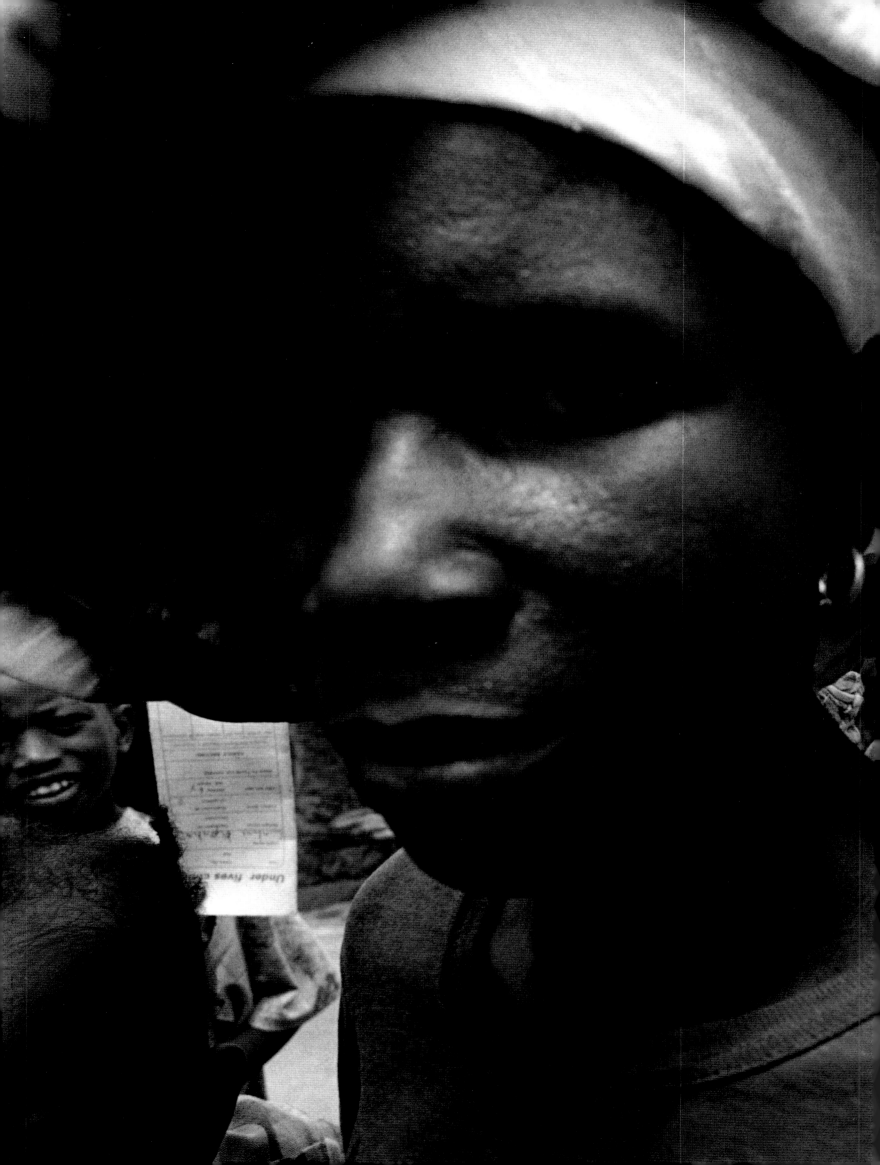

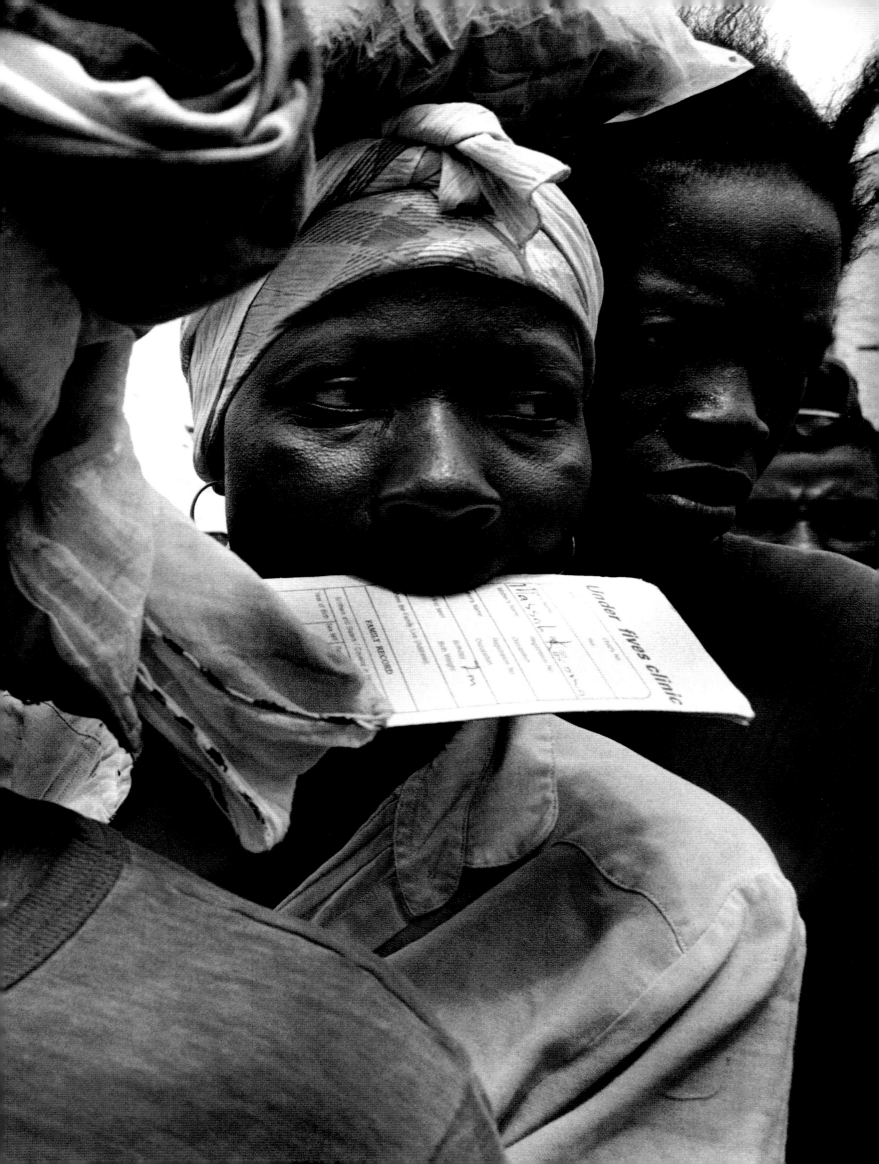

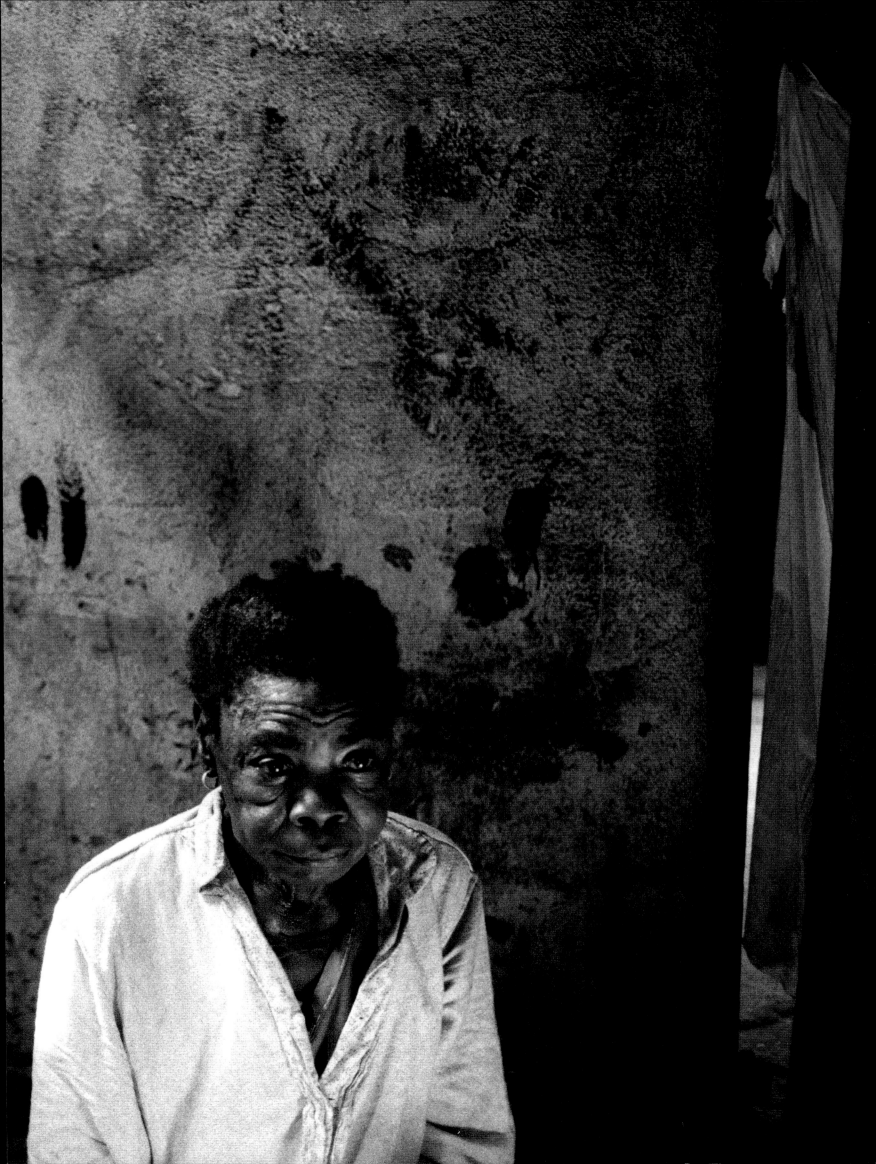

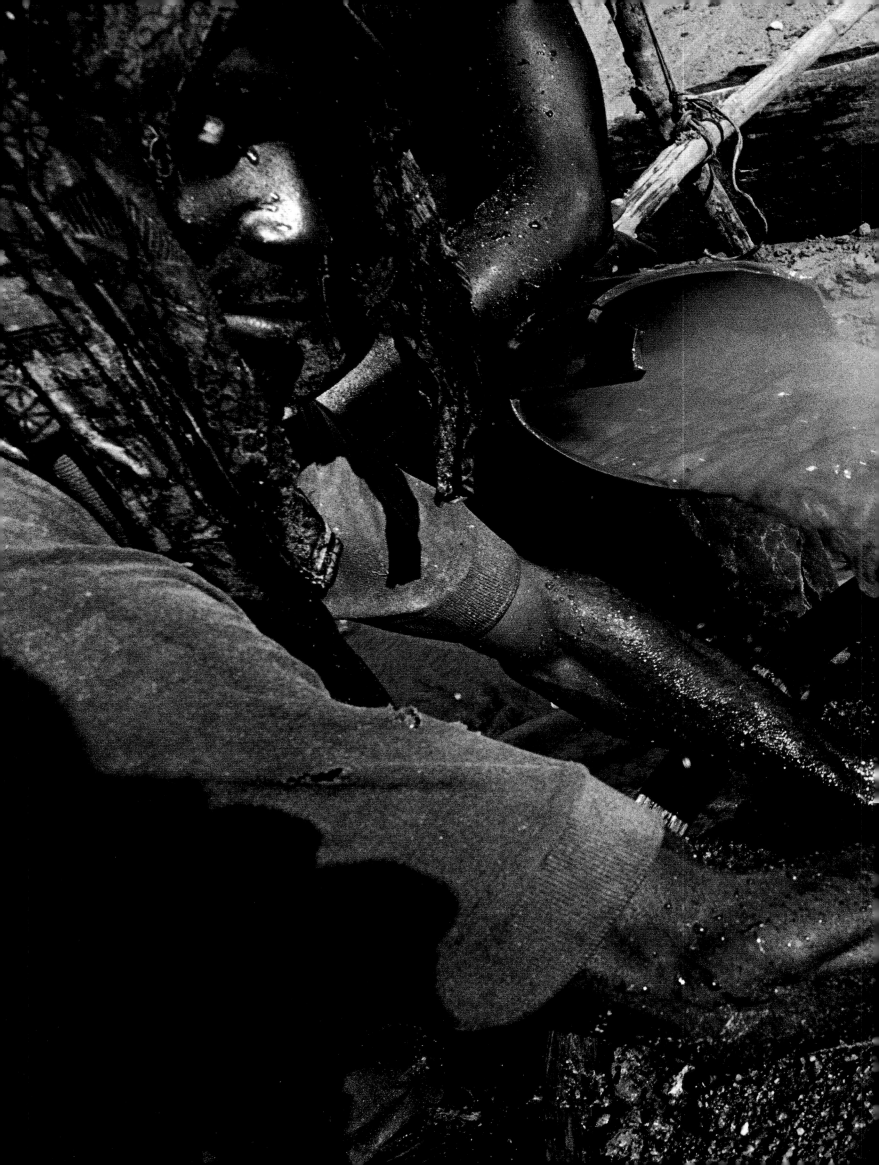

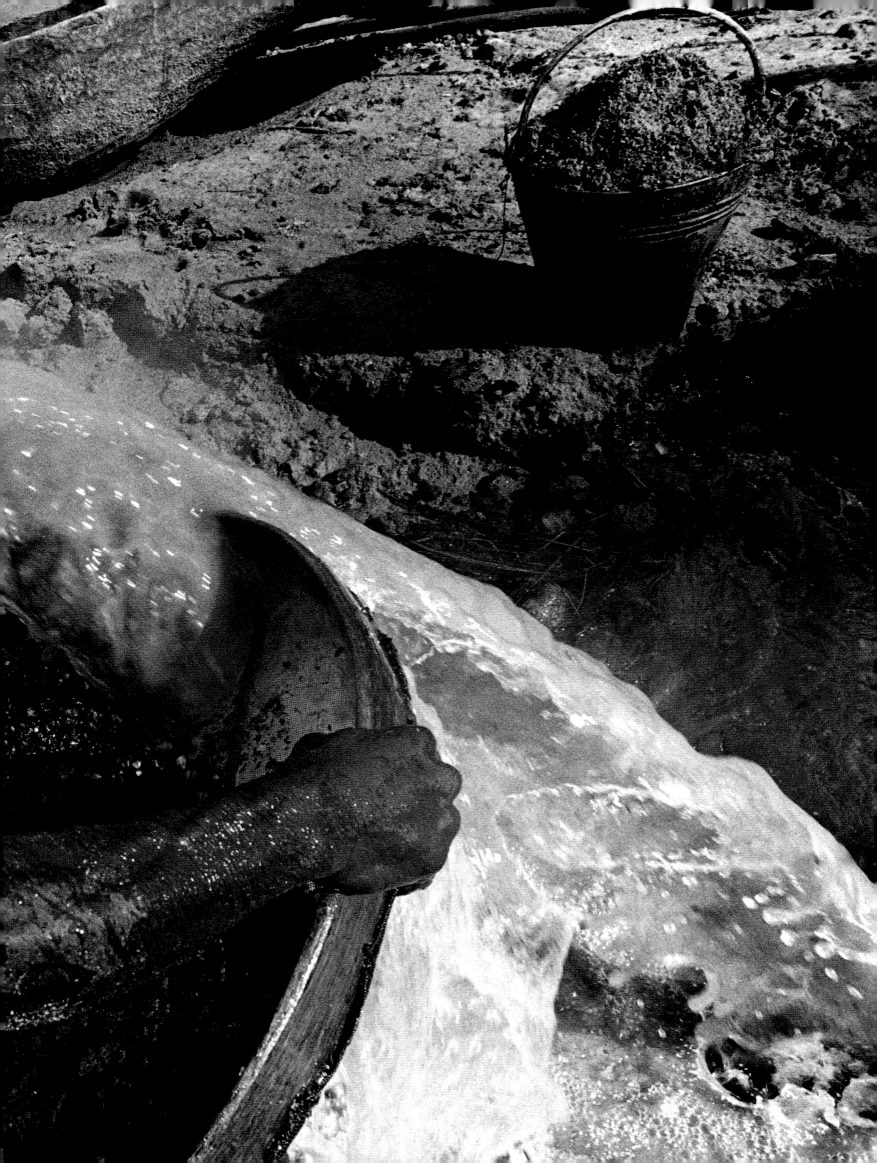

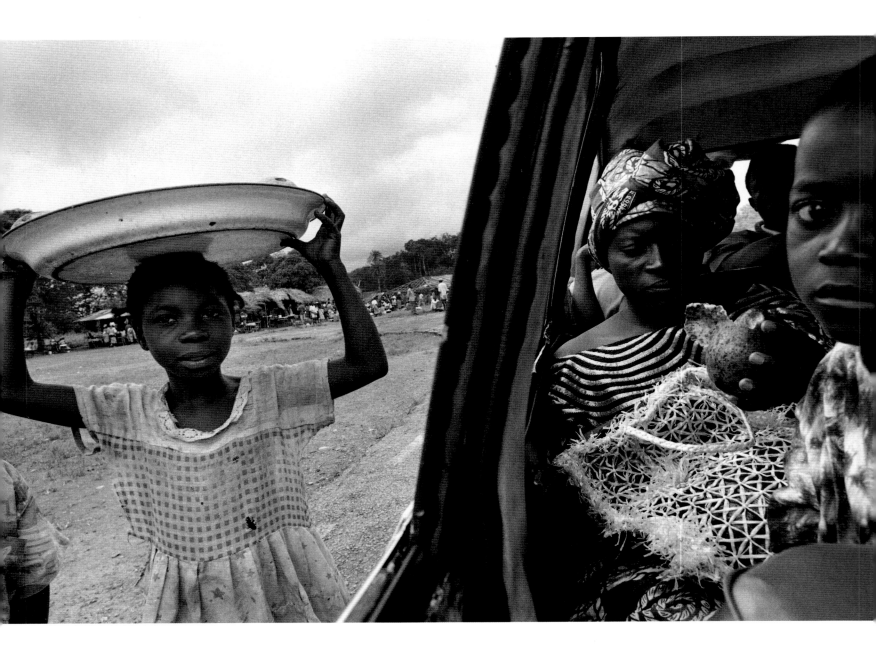

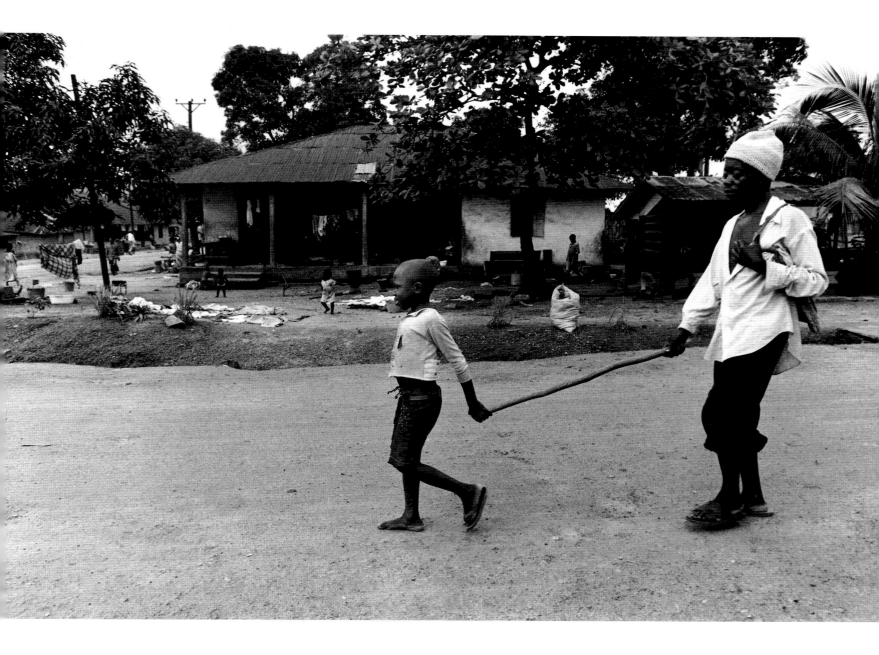

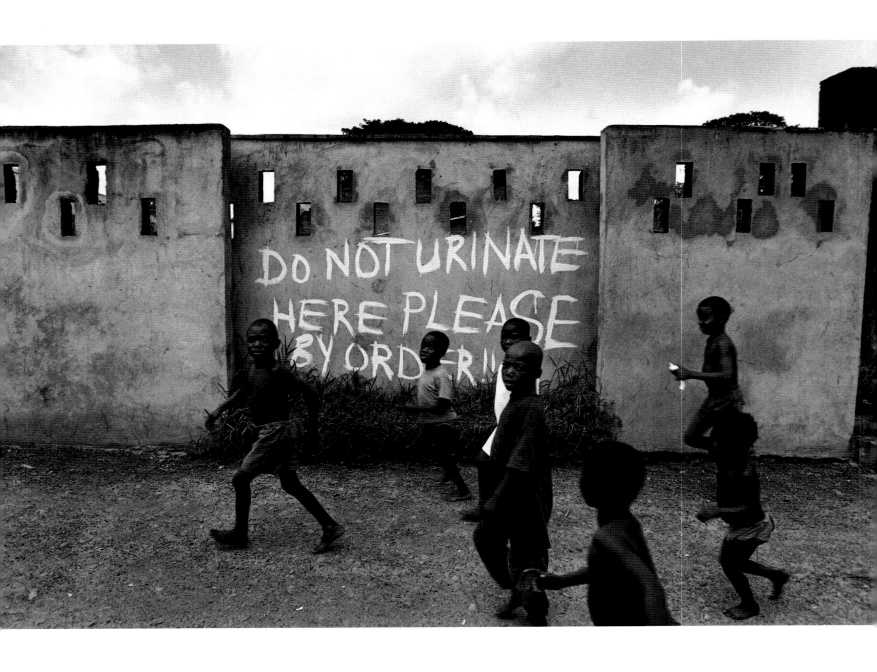

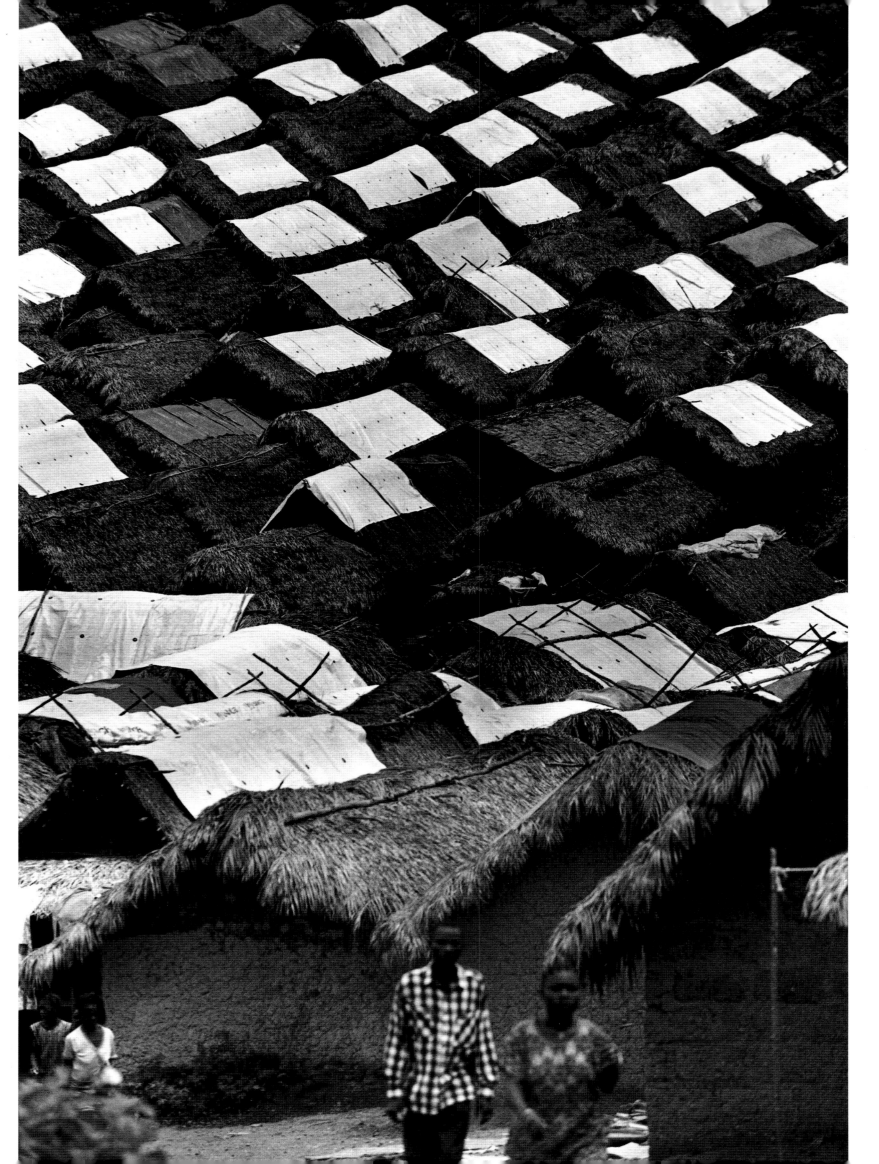

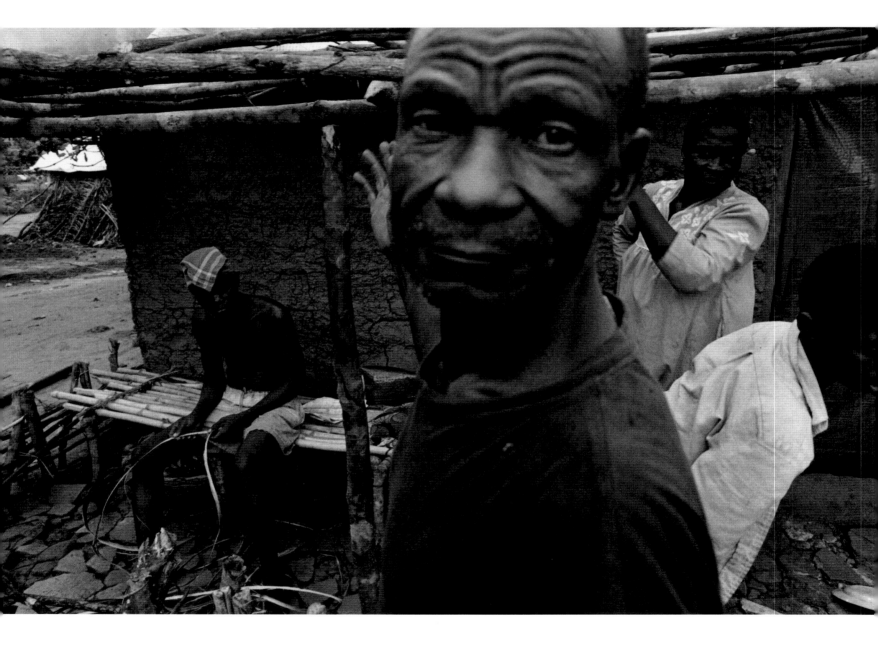

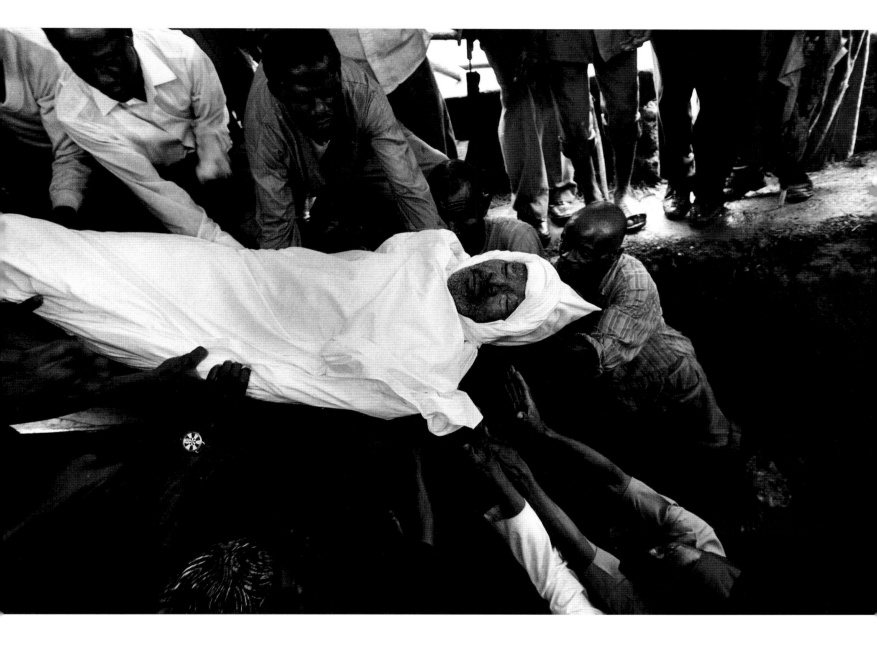

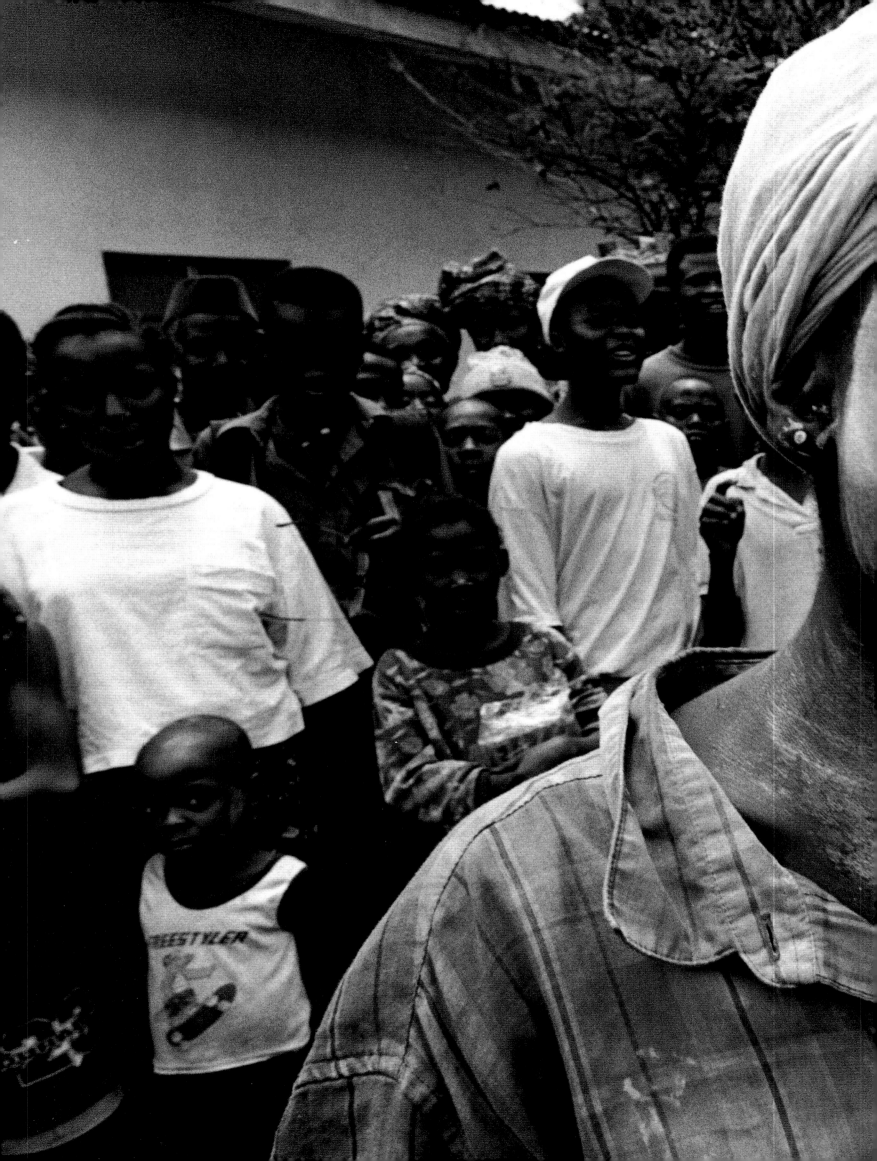

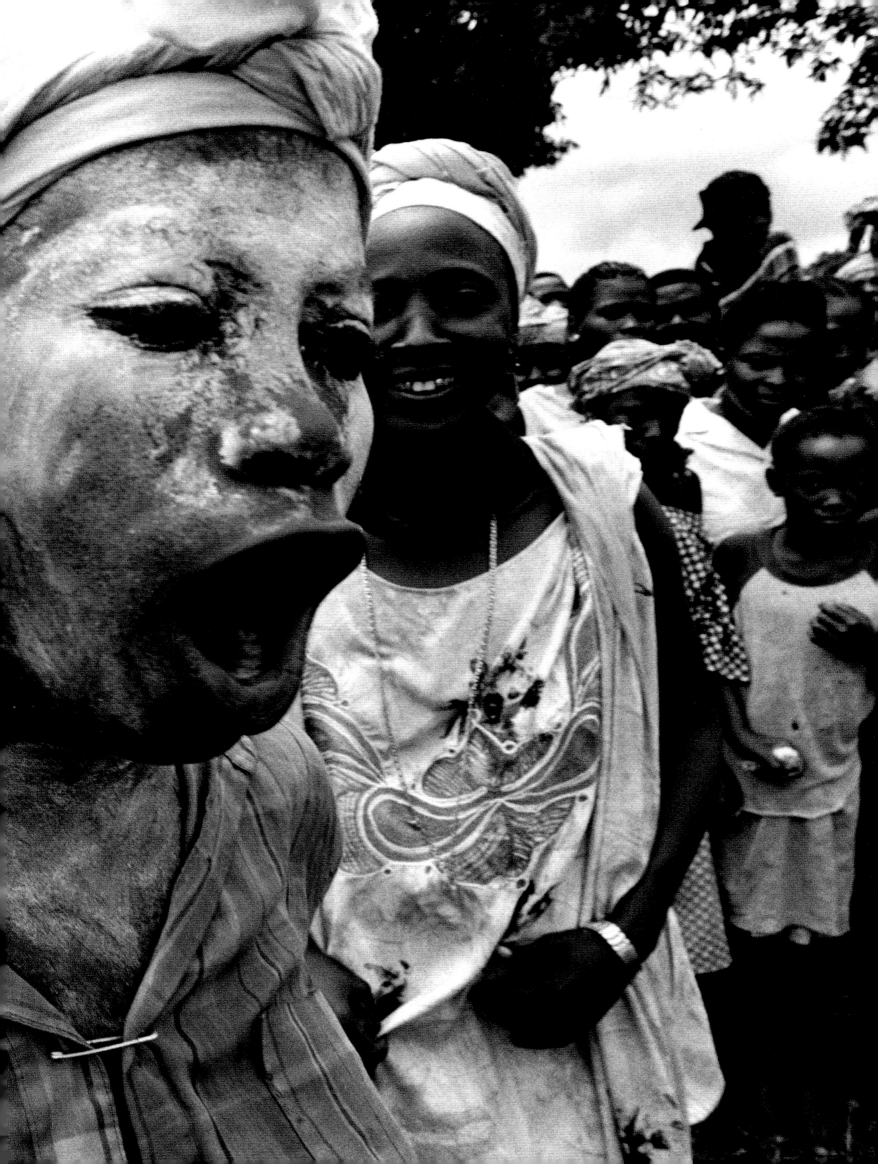

18th century
The British colonial authorities find the island divided among two Sinhalese kingdoms in the South and a Tamil kingdom in the North. The island is united under British rule.

February 1948
Sri Lanka gains its independence. Framers of the constitution seek to integrate the two cultures within a federal system. Tamils – 20 per cent of the population – occupy the northern and eastern regions of the island. The remaining 80 per cent are Sinhalese, who form the governing faction. The following decades witness bloody conflicts between the ethnic groups, as the government pursues a policy of nationalist orientation. Sinhalese is declared the sole official language.

June 1983
The Liberation Tigers of Tamil Eelam (LTTE), an outgrowth of a union of militant student groups, carry out attacks in Jaffna in support of their demand for a separate Tamil state. The government declares a national emergency and occupies the Jaffna peninsula. The conflict turns to full-blown civil war following an attack in which 13 Sinhalese soldiers are killed. More than 3000 Tamils are killed in a series of ensuing pogroms.

September 1987
India stations 100 000 soldiers in the northern and eastern sections of Sri Lanka. Tamil forces control Jaffna and extensive areas in the East. A peace plan presented by the Indian government fails. Indian troops depart in 1990.

August 1994
Preliminary peace talks are held between the government of Prime Minister Kamaratunga and LTTE representatives but are broken off without results in response to assassinations of politicians by Tamils.

January 1995
In an effort to bring about a political solution to the conflict, the Kamaratunga government participates in peace negotiations with the LTTE. The LTTE declares a cease-fire for the first time. The difficult negotiations that continue during the months that follow are repeatedly jeopardized by terrorist attacks and acts of retribution.

December 1995
Government troops take the city of Jaffna, headquarters of the LTTE. Fighting triggers a mass exodus of 500 000 refugees. The government forces take control of nearly the entire Jaffna peninsula in a major offensive. The civil war continues in full force. Peace efforts have brought no success thus far.

Camp for Tamil refugees, Vavuniya, Sri Lanka, 1996
Refugee camp bakery, Vavuniya, Sri Lanka, 1996
Head of a family, Anuradhapura, Sri Lanka, 1996
Camp for Tamil refugees, Vavuniya, Sri Lanka, 1996
Refugee camp bakery, Vavuniya, Sri Lanka, 1996
Old man in his quarters, Vavuniya, Sri Lanka, 1996
Religious service in the refugee camp, Vavuniya, Sri Lanka, 1996

# SRI LANKA

## HOME IN A REFUGEE CAMP

**Photographed by Michael Meyborg in February 1996**

The civil war between the Sinhalese majority government and the Tamil minority has cost
more than 30 000 lives since 1983. The civilian population in the northern
and eastern regions of the island are particularly hard-hit by the conflict. Fighting has taken
its toll of victims among Tamils and Sinhalese alike. Many people are
unwilling to return to their home villages, having begun a new life in refugee camps.

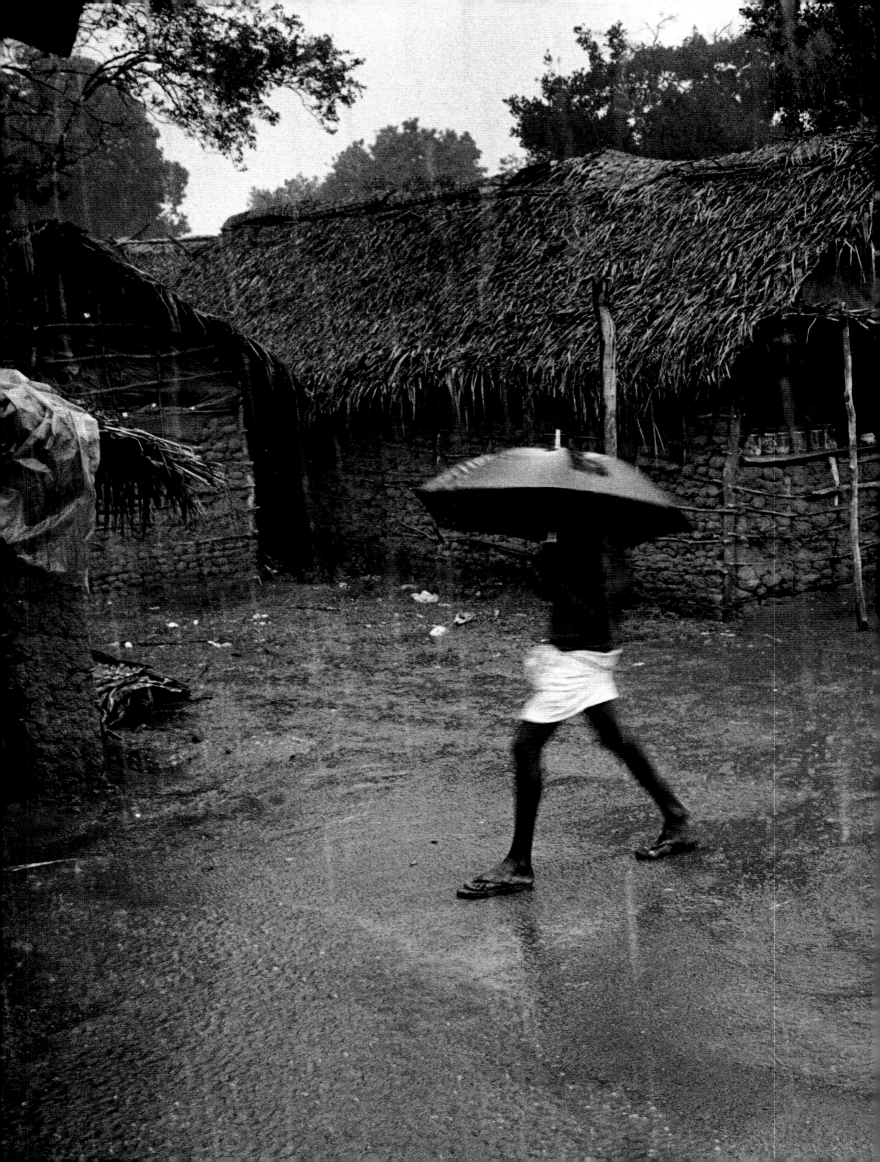

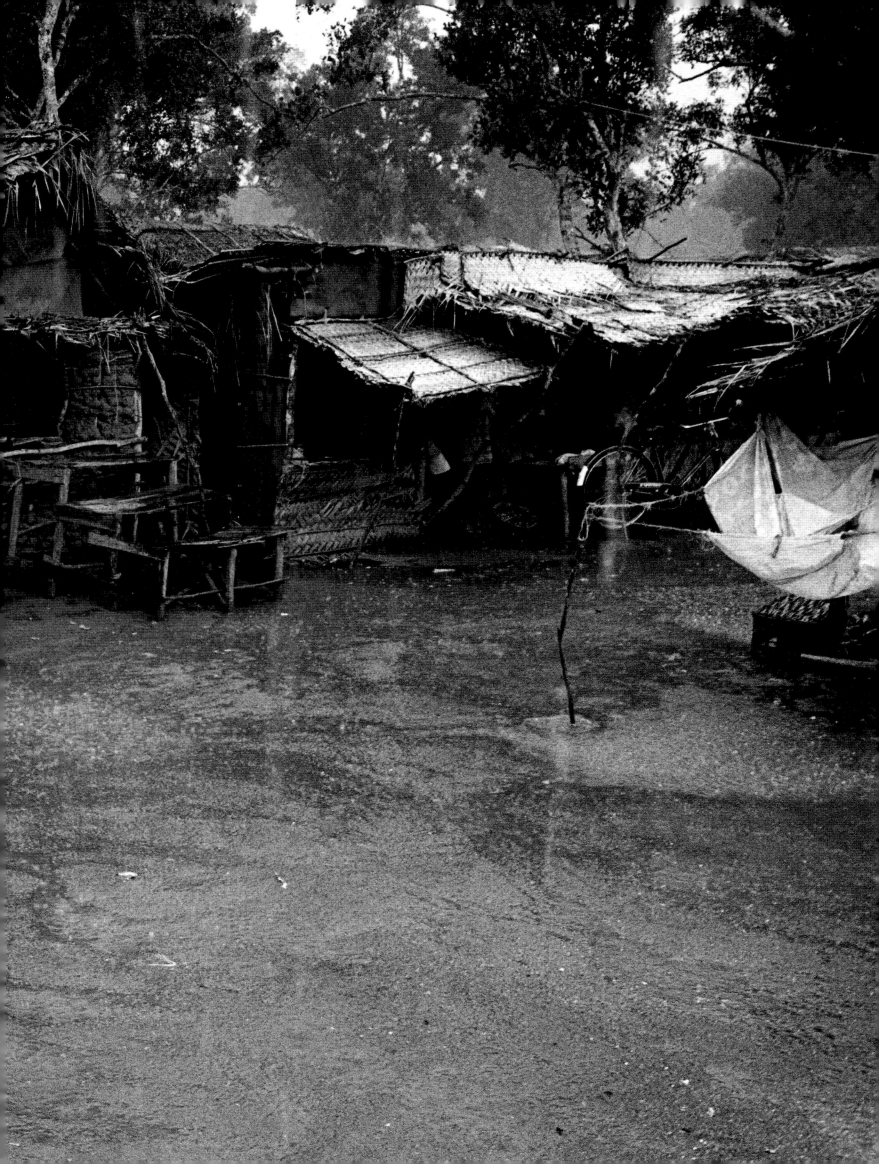

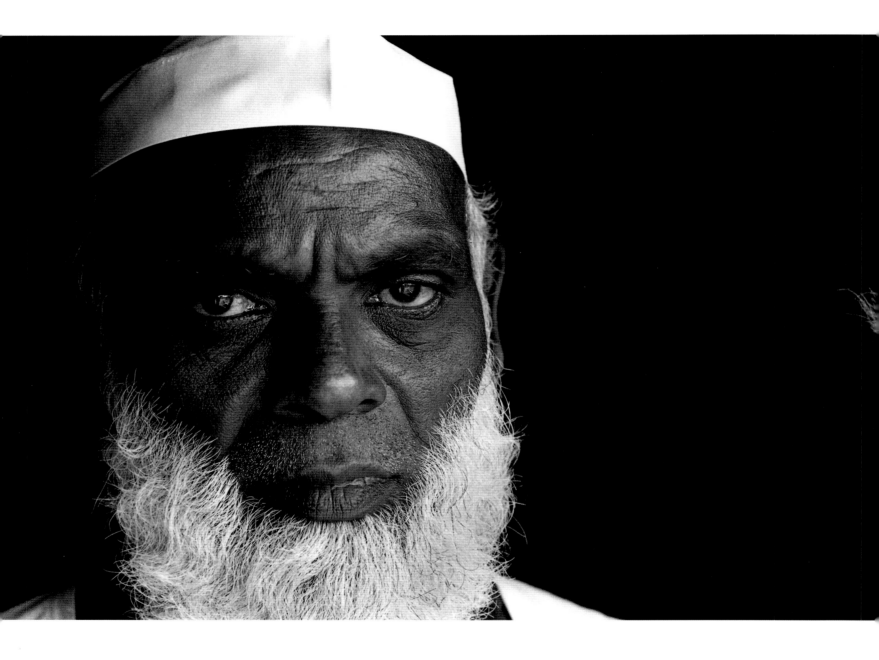

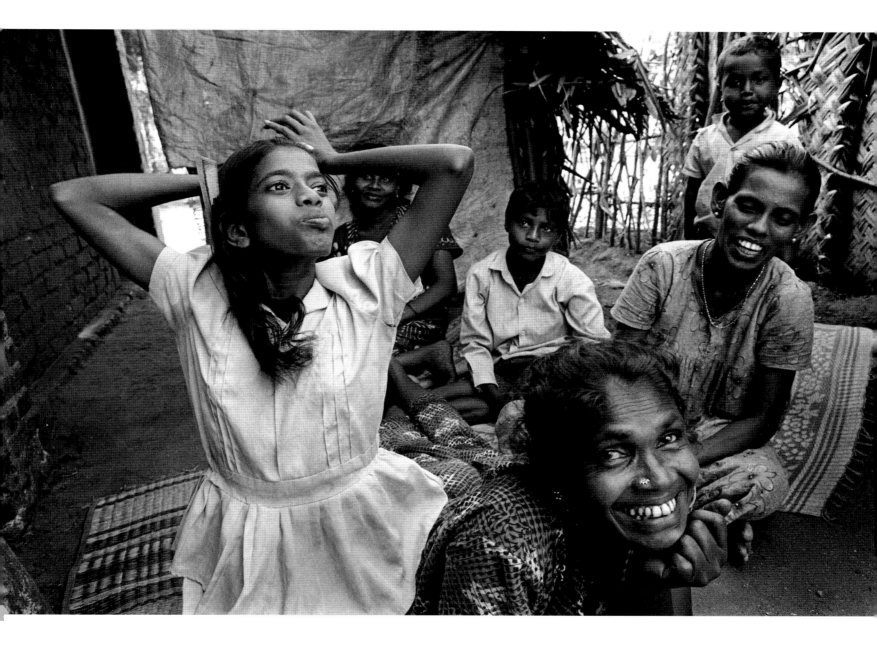

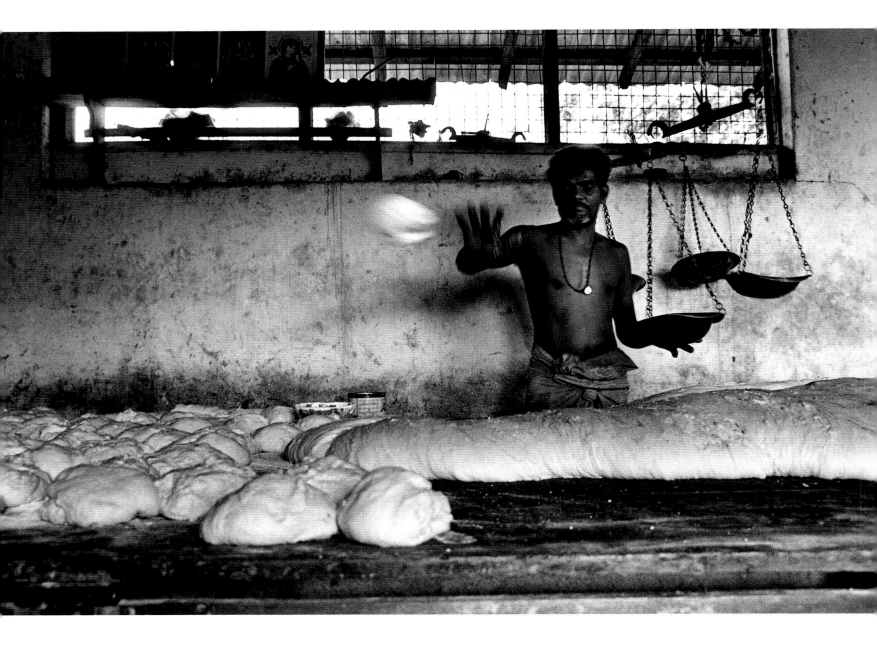

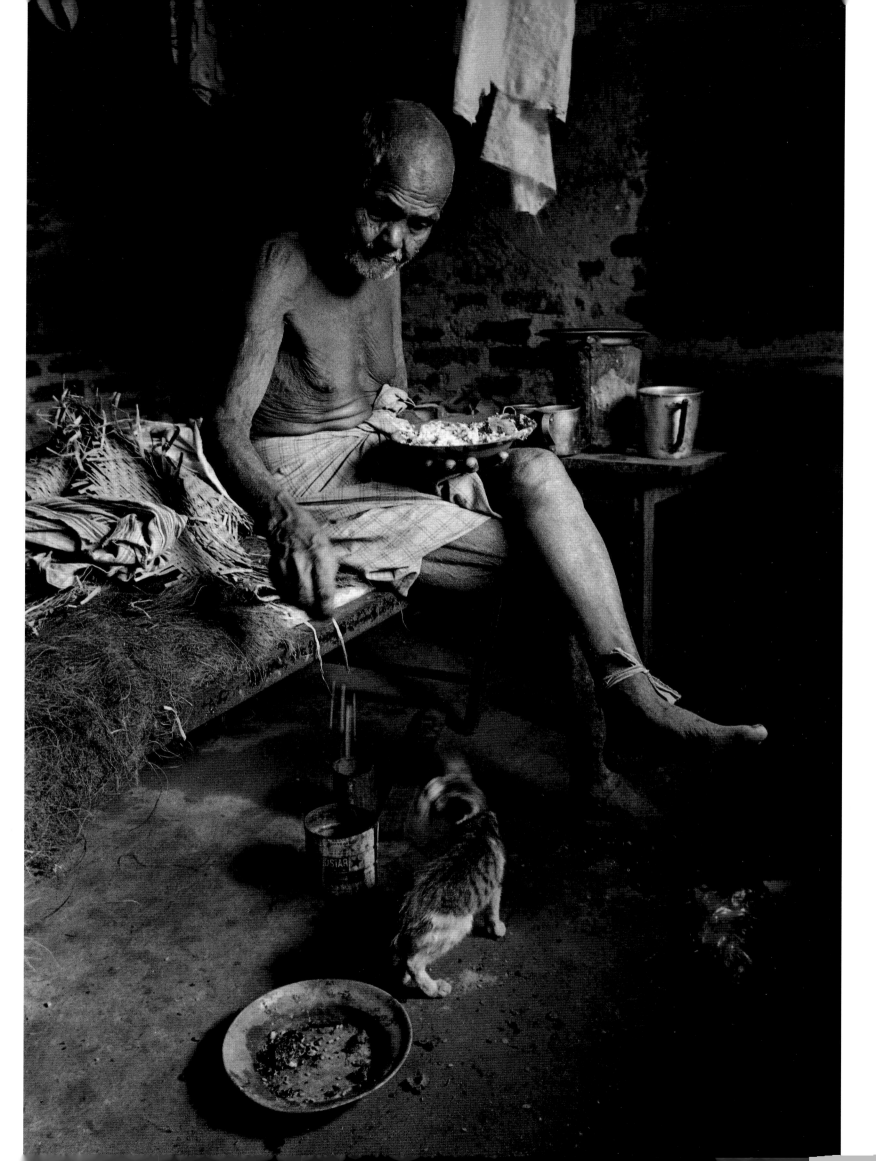

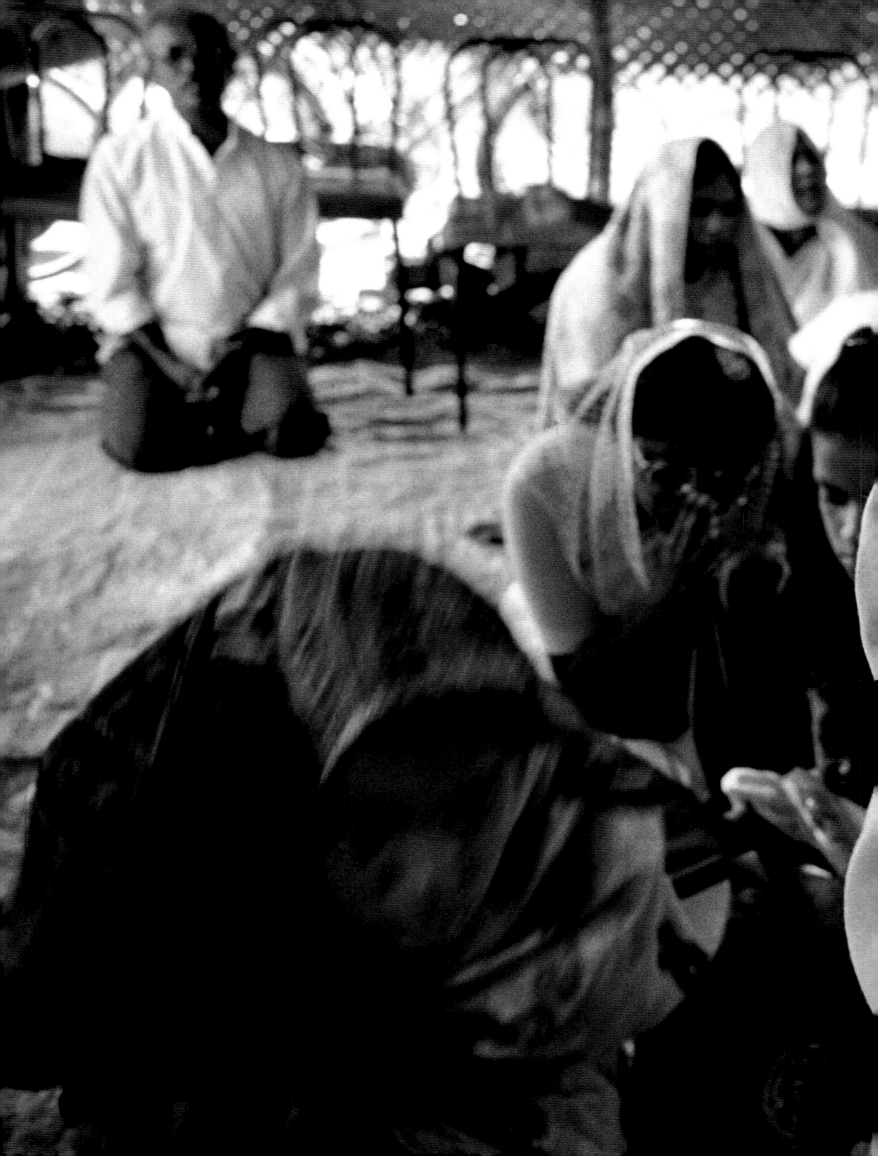

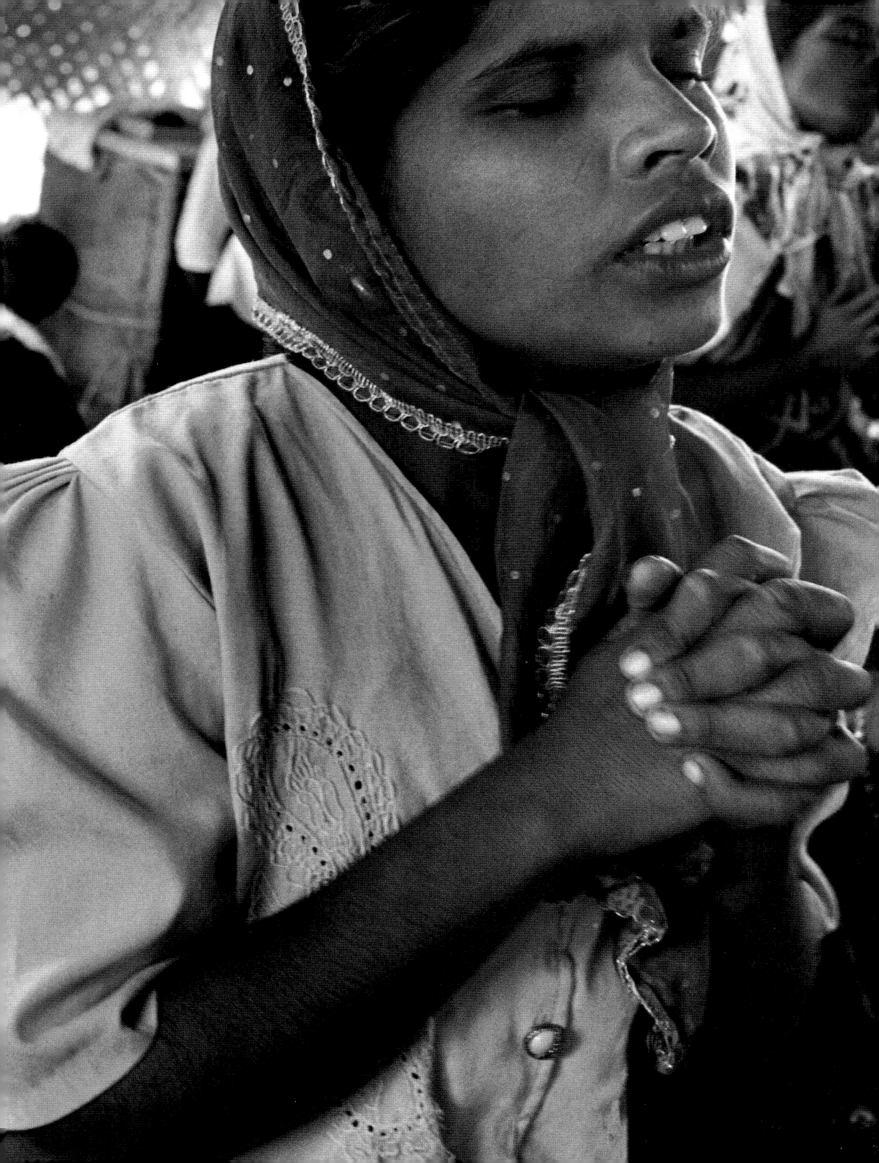

1989
The reunification of Germany and the collapse of the Soviet Union trigger a wave of East-West migration that surpasses all previous migrations in magnitude.

March 1991
Poland signs an agreement with the Schengen Treaty signatory countries regarding the return of refugees entering Schengen countries through Poland. In return, Polish citizens are exempted from visa requirements for cross-border travel.

February 1993
A conference of delegates from 34 European countries resolves that all European countries are to be classified as "safe third countries."

May 1993
Poland confirms the substance of the Refugee Return Agreement in a bilateral agreement with Germany. The number of refugees deported to Poland from Germany during the first year is restricted to 10 000. The German government commits itself to provide 120 million DM in aid during the next two years. These funds are to be used to improve the training of border control officers in Poland and to procure vehicles, radios and night-vision equipment for the purpose of enhancing border control measures. Roughly five million DM are to be invested to build accommodations for deported refugees.

1994
A total of 15 000 refugees from third countries are detained at the German-Polish border by Polish border control officers. Over 7000 people are returned across the border by German Federal Border Police, and 20 000 refugees are denied entry at the border. Only a very few refugees submit applications for asylum in Poland; most remain in the country illegally.

September 1995
Poland establishes the legal basis and the appropriate administrative structures enabling it to take illegal refugees into deportation arrest. One year later, some 500 persons are confined in deportation arrest centers, of which 100 have been returned by the German Federal Border Police to Poland in accordance with the Refugee Return Agreement.

Detainment of refugees at the Ukrainian border,
Chelm, Poland, 1996
Refugees being returned to Poland by German border police,
Bademeusel, Germany, 1996
Arrival of refugees from Poland, Eisenhüttenstadt, Germany, 1996
Persons arrested following an unsuccessful attempt to cross
the German border, Gubin, Poland, 1996
Accommodation for asylum-seekers at the Polish border,
Eisenhüttenstadt, Germany, 1996

**Photographed by Clive Shirley in August 1996**

The German-Polish border has been closed to refugees seeking to enter Germany through Poland
since 1993. According to the terms of a bilateral Refugee Return Agreement,
Poland has agreed to accept the return of refugees who have already entered Germany.
In addition, persons detained at the border can be returned immediately.
In return, the German government is equipping German-Polish border control units
with the latest technology and funding the construction of deportation
arrest centers in Poland.

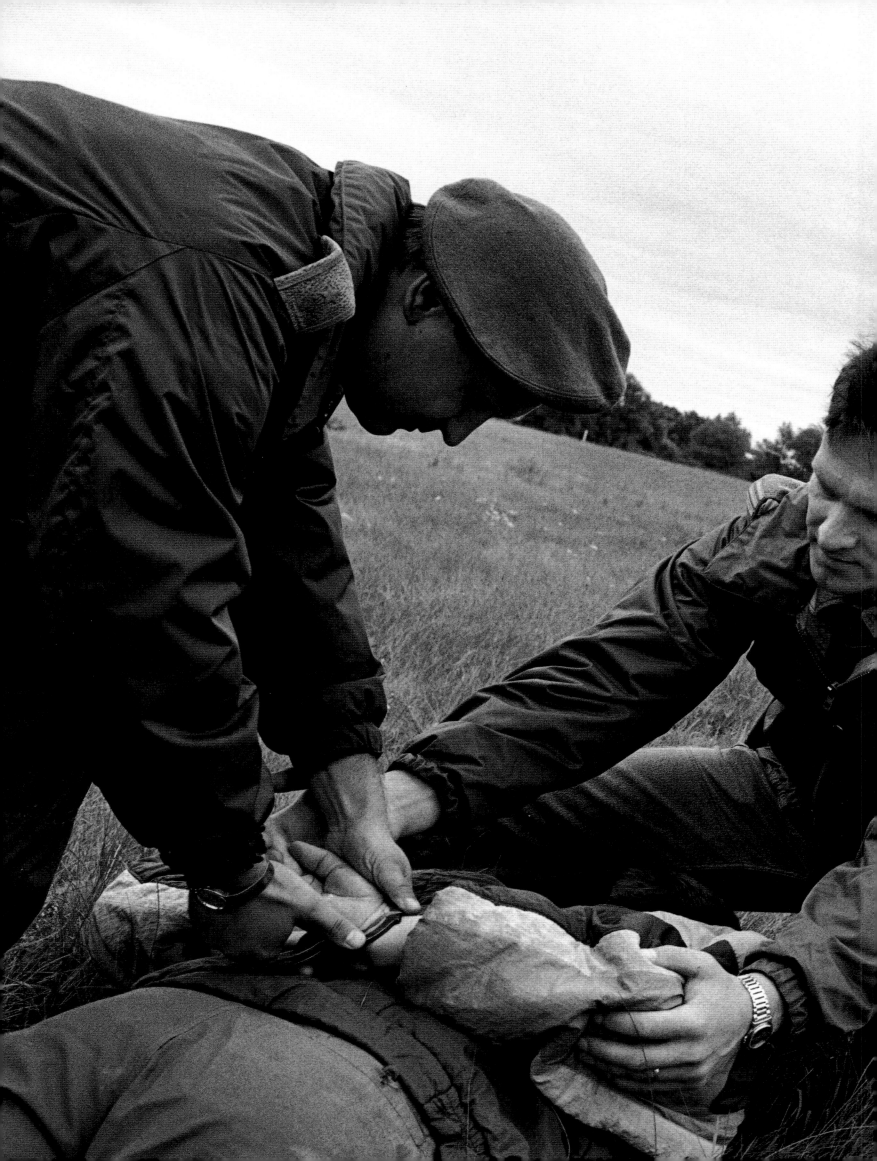

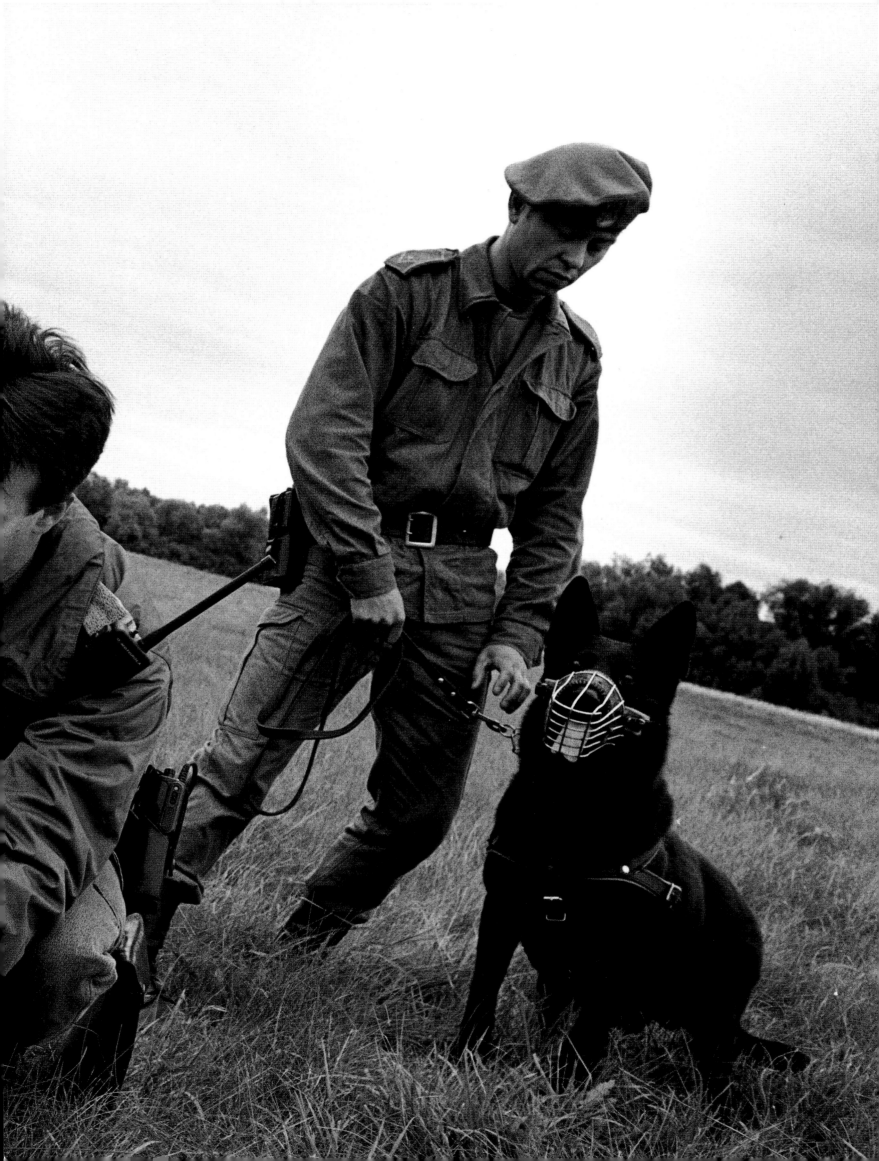

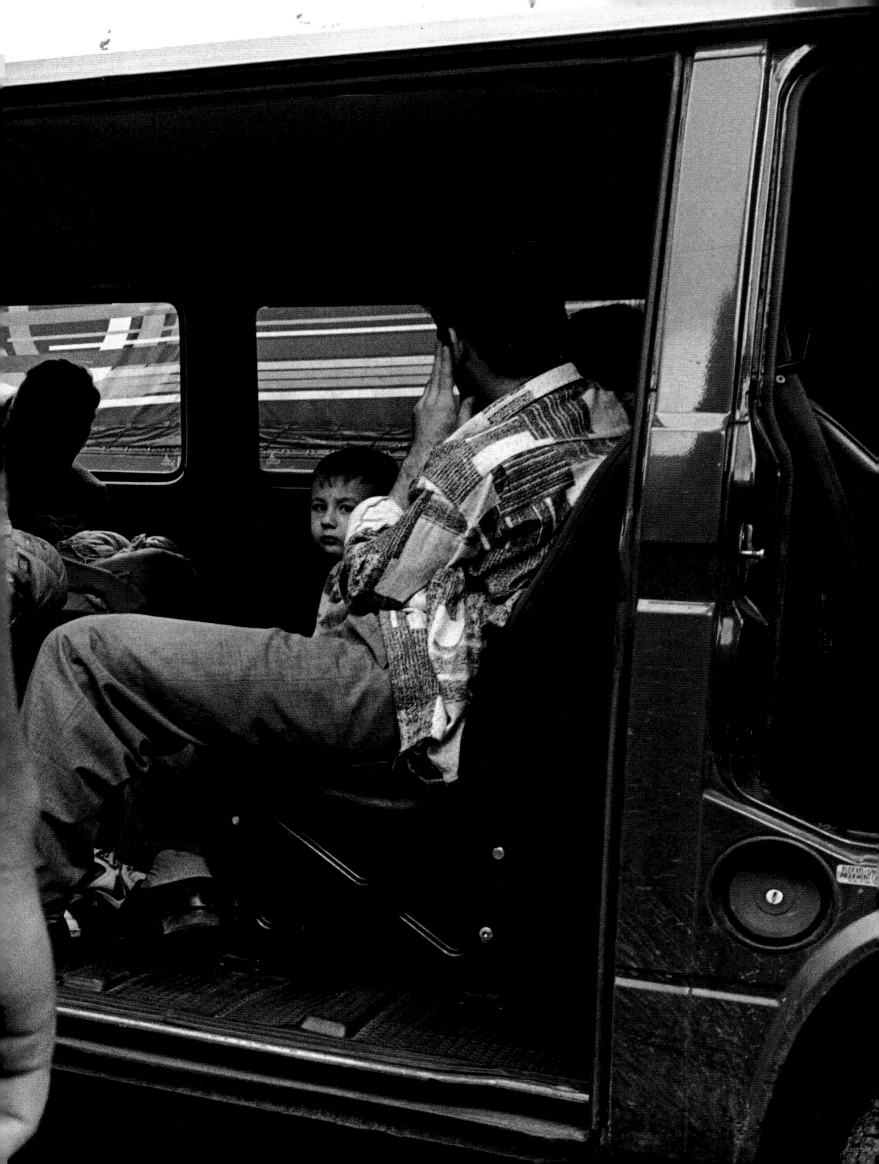

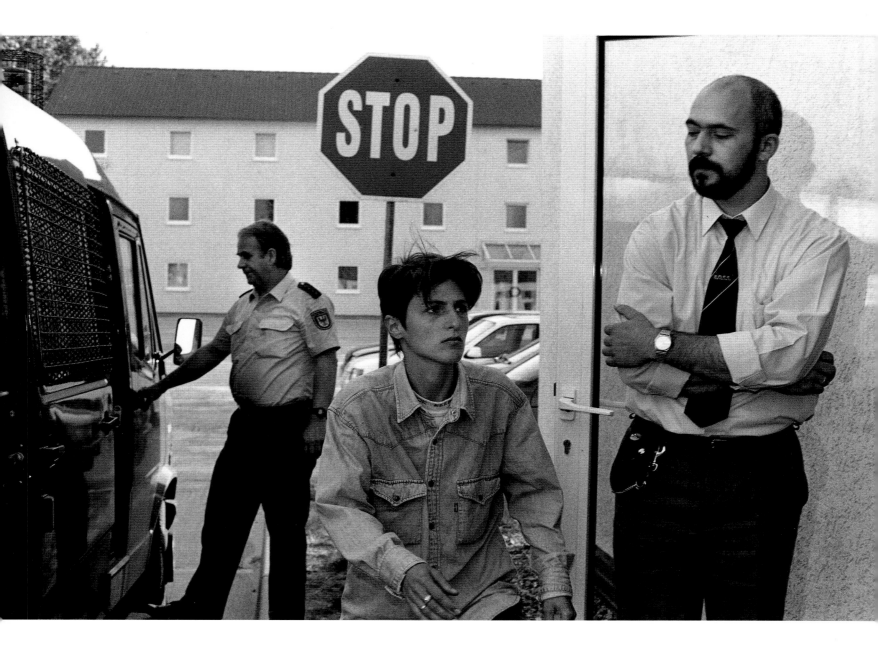

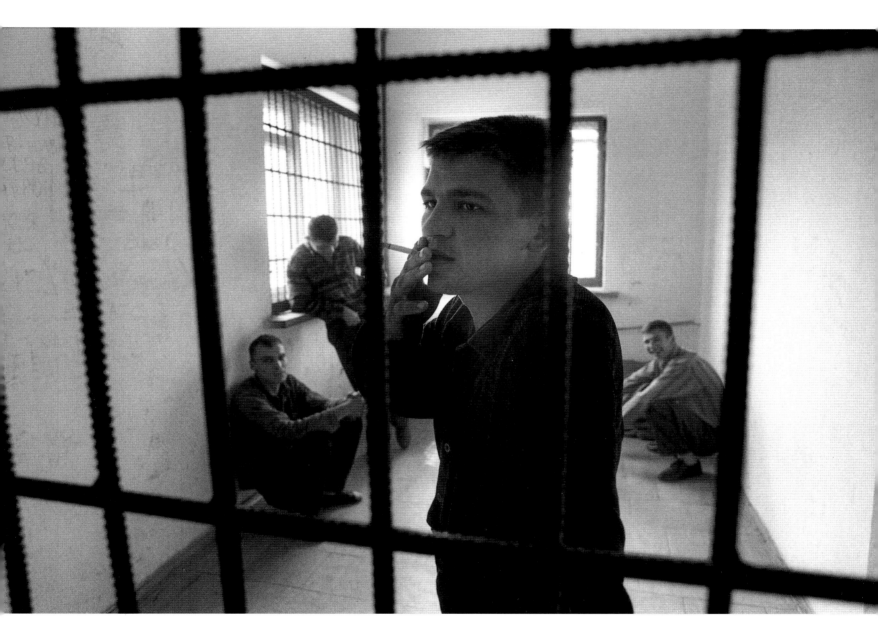

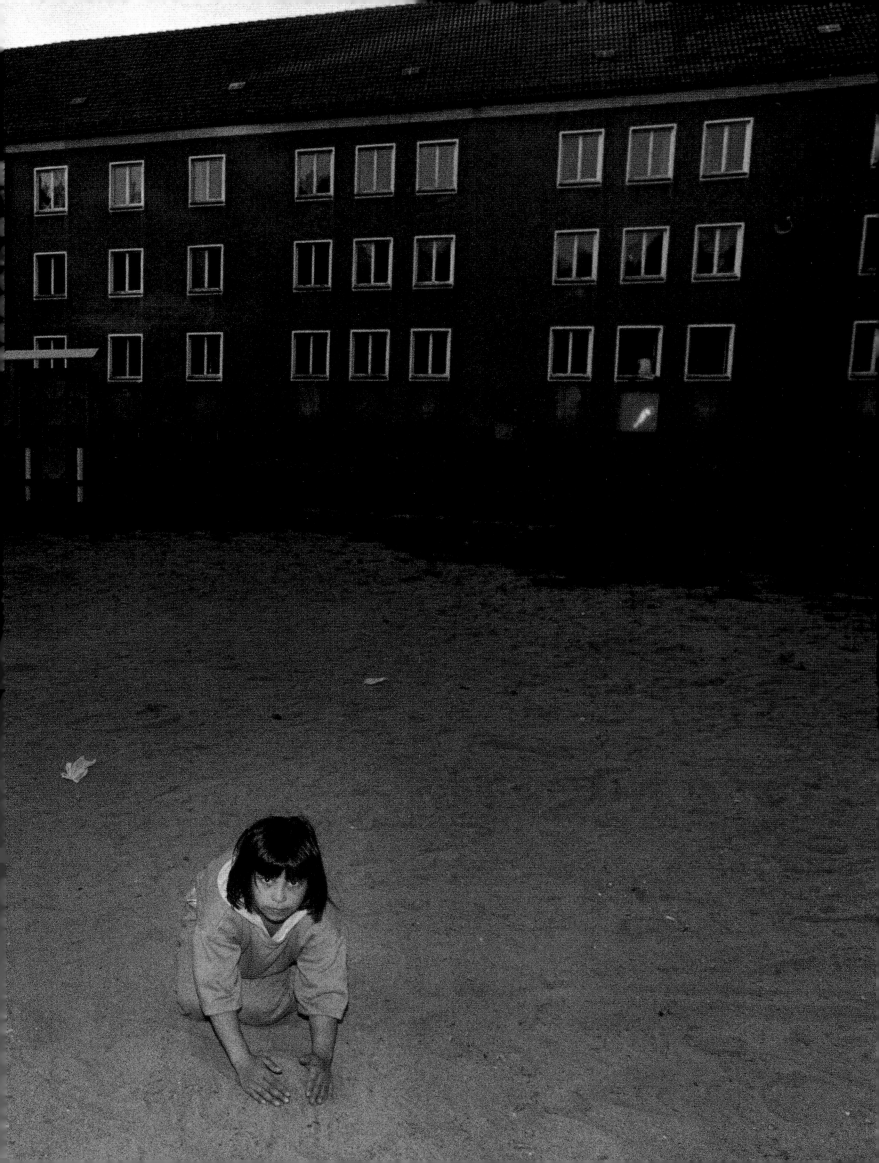

# DETACHED

**Mark Sealy**

Long term documentary photographic projects require a sense of purpose, conviction and determination. The photographers from SIGNUM have shown all these qualities in their project dedicated to the plight of refugees.

In a world saturated with images of suffering people, it is difficult to sustain one's objectives, to relay something meaningful that might have an impact on the way we, in positions of relative comfort, see those who are victims of tragic circumstances.

Self-doubt about the meaning and influence of what one is photographing are recurring nightmares when a photographer turns to focus on any given situation involving conflict. What SIGNUM have collectively produced is an important breach, a reflective surface, which provides us, the viewer, with the opportunity to look in on a world which is increasingly, for so many, a desperate existence heightened by the critical sense of wanting to escape the dire circumstances of forced displacement, loss of family, home, alienation and the threat of death.

What these photographs have in common, whether they be from Afghanistan or Mexico, is the prevailing sense of uncontrollable impotence and yet at the same time the photographs reveal humanity's amazing capacity to tolerate the harsh conditions that have been inflicted on people either through direct confrontational warfare or economic pressures.

The strength of these photographs lies in their capacity to tell us small stories, narratives, that give us, the viewer, the chance to piece together and contemplate the overall scenario. The work of Andreas Herzau in Rwanda in 1995 is typical of the SIGNUM approach. From Herzau's photographs we gain a sense of the tragic scope of the situation, but we are also introduced to more detailed human moments which show these people as dignified subjects in their own right. His photograph of the mother and child on the bed of the shelter staring back at the camera is both confrontational and elevating. Photographing the woman and child from below, he has empowered the mother and child by providing them with the opportunity to look down on us, creating an uneasy tension within the photograph for us to resolve (page 47).

It is this sense of unease that admirable documentary photographers often conceal within the frame. The photographs do not need to jump off the page and beat up on your sensibilities. That kind of visual experience is often graphically and visually brutal. The SIGNUM approach is more cerebral. The collective, yet separate essays work as a body because they are bound together by their overall empathy.

The photographic essays in *Exodus* do not feel as though they have been photographed hurriedly in six days on assignment for a magazine. They do not attempt to give us the definitive one-person global view. They belong in the more contemplative environment of the gallery. There is still a lot to be gained from the process of collaboration, not just between photographers but also in cooperation and empathy with the people and the situation to hand. This is the cement that binds this project together.

Western documentary photographers are often accused of being purely objective, of providing a cold snapshot of someone else's existence, photographed from a purely voyeuristic first-world perspective. In many respects this is true. However, it is crucial to document and record world events. It is essential that we get some sense of what these events look like above and beyond the immediacy of television. The photograph allows us to transfer our own meaning to the given situation in a quiet, considered manner.

Projects like *Exodus* provide the space for contemplation. They open doors to a world in which reality and meaning are contested, where the individual can choose to engage himself or simply to walk away. The photographs in *Exodus* are therefore catalysts. The combination of photographer, subject and viewer can crystallize and produce intense new meanings for the way in which we conceive our world and construct our futures.

Since the early 1990s, the SIGNUM photographers have focused their attention on the flight and forced displacement of refugees throughout the world. Their photographs document refugee life in Germany during a period characterized by growing hostility to foreigners as well as refugee movements and the causes of those movements in more than twenty other countries. Their photographs have been shown at numerous exhibitions and published in a wide range of newspapers and magazines. Moreover, the SIGNUM photographers have earned acclaim not only for their reporting of political, economic, social and environmental issues but for their work in portrait and reportage photography as well. Their photographs are available from a large photo-archive in Hamburg. SIGNUM is represented in Great Britain by Katz Pictures and in France by Editing. The six photographers have done work for national and international publications such as *Der Spiegel, Stern, European, The Guardian, Die Zeit, Brigitte, TAZ* and *Die Woche,* as well as other clients, including advertising agencies such as Springer & Jacoby and various international humanitarian aid organizations.

### Christian Jungeblodt

Born in 1962. Trained and worked in commercial photography in Rome. A free-lance photojournalist since 1990. Member of SIGNUM since 1994. Has worked primarily in reportage and portrait photography for newspapers and periodicals in Germany and abroad. Most recent projects include reportage and photo-essays on topics in Albania, Bulgaria, Afghanistan, Somalia and the former Yugoslavia. Has lived in Berlin since 1984.

### Andreas Herzau

Born in 1962. Trained as a typographer. Served as political editor for various newspapers and periodicals. A free-lance photojournalist in Hamburg since 1990. Founding member of SIGNUM. Has focused on reportage and essay photography for books and periodicals. Most recent photographic work in Germany and Africa. Has served as an instructor of reportage photography for several years. Lives in Hamburg.

### Michael Meyborg

Born in 1946. Studied Photography, German and Political Science in Hamburg. A free-lance photojournalist since 1977. Co-founder of *Arbeiterfotografie* magazine and a founding member of SIGNUM. Has concentrated primarily on reportage photography in the fields of business and social affairs. Work in recent years has included travel reportage, including features on Cuba, Eritrea and China. Lives in Hamburg.

### Russell Liebman

Born in 1966. Studied Marketing and Art in Colorado (US). Worked as a photographer for the Jewish Press Service and Yeshiva University in New York. Motivated by the political revolution in eastern Europe and the collapse of the Wall to move to Berlin in 1990. Member of SIGNUM from 1994 to 1997.

### Clive Shirley

Born in 1960. Trained in an advertising agency in London and as a photographer in Hamburg. Worked as a photo-reporter for Reuters and the Associated Press in Germany. Member of SIGNUM since 1995. International work as a photojournalist for newspapers, periodicals and environmental organizations. Lives in London.

The Authors:

### Mark Sealy

Studied at London University. Worked for three years with Network Photographers. Director of Autograph, the Association of Black Photographers. Curator of several major international Black visual arts and photography exhibitions. Lectures extensively in the UK and abroad. Member of the Arts Council of England's Photography Advisory Structure for several years. Has written for the *British Journal of Photography, Creative Camera* (for which he serves on the editorial board) and the *Independent On Sunday* newspaper. Photography coordinator for the prestigious *Africa 95.* Jury member for the World Press Photography Competition in Holland in February 1996. Photographic consultant for Steve Pyke, Nick Wapplington and Katz Pictures.

### Hans Christoph Buch

Journalist and writer. Has published novels, short stories and essays on third-world issues, particularly those concerning Haiti; most recent publications include *Die neue Weltunordnung – Bosnien, Burundi, Haiti, Kuba, Liberia, Ruanda, Tschetschenien* (Suhrkamp Verlag), a collection of reports which first appeared in the weekly newspaper *Die Zeit.*

Deutscher
Caritasverband

Caritas international is the international branch of Caritas Germany (Deutscher Caritasverband). This humanitarian aid organization provides emergency and disaster aid as well as structural social support in over 100 different countries. Caritas international works closely with local partner organizations in the planning and carrying out of specific programs. The permanent presence of local partners contributes significantly to the continuity and effectiveness of these programs. The primary objective of project work is to develop self-reliance among the people concerned. The lion's share of aid provided is funded through private contributions.
*Dt. Caritasverband, Caritas international, Karlstraße 40, 79104 Freiburg*

## Deutsches Rotes Kreuz

Comprising 19 state and some 500 local organizations, the German Red Cross (Deutsches Rotes Kreuz) is a part of the International Red Cross and Red Crescent movement which is dedicated to the prevention and alleviation of human suffering, the protection of human life and health and the achievement of respect for human dignity throughout the world. Refugee aid, one of its primary concerns, is provided within the framework of social welfare and foreign aid programs. In this area as well, the efforts of the German Red Cross rely for the most part on the work of volunteers.
*Deutsches Rotes Kreuz, Friedrich-Ebert-Allee 71, 53113 Bonn*

**German Foundation
for UN Refugee Aid**

As a contribution fund, the German Foundation for UN Refugee Aid (Deutsche Stiftung für UNO-Flüchtlingshilfe E.V.) supports the humanitarian aid projects of the UN High Commissioner for Refugees (UNHCR), the United Relief Works Agency for Palestinian Refugees in the Near East (UNRWA) and other aid organizations both in Germany and abroad. Emergency aid measures for those fleeing their homes, assistance in integration in the new country and reintegration programs for those voluntarily returning to their home countries serve to ease the plight of refugees. This is accomplished primarily through material support, psychological and social assistance and aid provided to women and children as those most vulnerable to the consequences of flight and displacement.
*Deutsche Stiftung für UNO-Flüchtlingshilfe E.V., Rheinallee 4a, 53173 Bonn*

German Agro Action (Deutsche Welthungerhilfe) was founded in 1962. Operating under the official patronage of the German Bundespräsident, the organization is politically independent and has no religious affiliations. In keeping with the principle of "Help for Self-Help," German Agro Action carries out development projects and provides emergency aid in countries of the third world. Its goal is to enable communities in developing countries to provide for their own food supply. The organization implements its projects in cooperation with local partners. It is committed to human rights and environmental protection. The work of German Agro Action is funded through contributions and public grants.
*Deutsche Welthungerhilfe, Adenauerallee 134, 53173 Bonn*

**PRO ASYL**

PRO ASYL is a national German association comprised of staff members representing refugee-aid initiatives, churches, unions and welfare and human rights organizations. PRO ASYL is advised in its activities by the representative of the UN High Commissioner for Refugees in the Federal Republic of Germany. The association is committed to the welfare of refugees in Germany and deals with matters of concern to them. The auxiliary support group Förderverein PRO ASYL e.V. was established in support of the humanitarian aid organization in 1988. The work of PRO ASYL is funded through contributions and membership dues received from more than 600 members.
*PRO ASYL, Postfach 101843, 60018 Frankfurt am Main*

**UNHCR**

The office of the UN High Commissioner for Refugees (UNHCR) has concerned itself with the welfare of refugees since 1951. In addition to providing international legal assistance, its primary functions involve emergency aid efforts in response to mass refugee migrations and the search for long-term solutions to refugee problems. To an increasing extent, the UNHCR has also provided humanitarian support for refugee groups in national internecine conflicts. Based in Geneva, the UNHCR has offices and field posts in 119 different countries. Aid programs are funded primarily through voluntary government contributions; private donations represent only a small portion of available funds.
*UNHCR, Rheinallee 6, 53173 Bonn*

**WORLD VISION DEUTSCHLAND**

World Vision was founded through an initiative on the part of the American Bob Pierce in 1950. This Christian humanitarian organization provides aid to people in need and has dedicated itself to the achievement of social justice and the protection of children's rights. In pursuit of these objectives, World Vision supports long-term development programs, particularly in rural regions in the third world, and also provides emergency assistance and reconstruction aid in response to natural disasters and armed conflicts. World Vision Germany currently promotes some 150 projects in 45 countries, most of which are funded through sponsorship arrangements.
*World Vision Deutschland, Am Houiller Platz 4, 61381 Friedrichsdorf*

Reproduction copyright by the photographers/signum-Fotografie, Hamburg-Berlin, Germany
Text copyright by the authors
Translation from the German by John S. Southard
Editing by Simone Westermann and Andreas Herzau
Editorial assistance by Marcus Höhn
Editorial direction by Mirjam Ghisleni-Stemmle
Art direction and typography by Peter Renn · Typografie, Teufen, Switzerland
Printed and bound by
EBS Editoriale Bortolazzi-Stei s.r.l., San Giovanni Lupatoto (Verona), Italy

ISBN 3-908162-80-7